No One Loved Gorillas More

DIAN FOSSEY Letters from the Mist

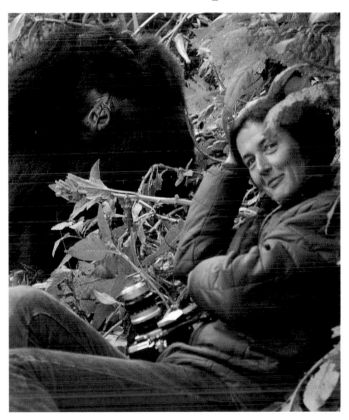

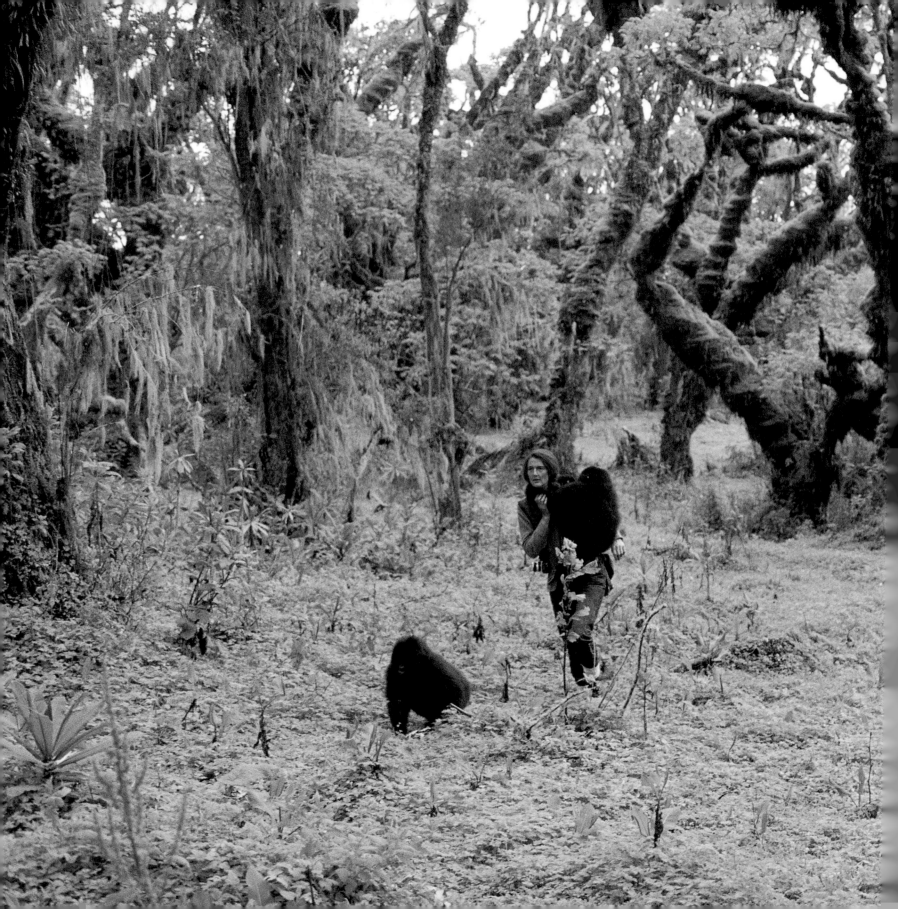

No One Loved Gorillas More

DIAN FOSSEY Letters from the Mist

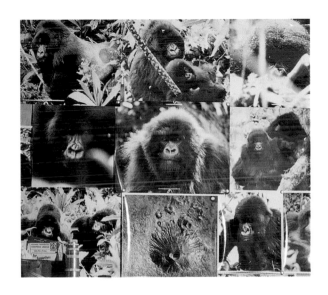

CAMILLA DE LA BÉDOYÈRE

with photographs by BOB CAMPBELL

NATIONAL GEOGRAPHIC

WASHINGTON, DC

Published by the National Geographic Society

Copyright © Palazzo Editions Limited 2005
Photographs copyright @ 2005 Bob Campbell (other than exceptions listed on 186)
First Printing in the United States, February 2005
Created and produced by Palazzo Editions Limited, 15 Gay Street, Bath, BA1 2PH.

Design by Nigel Partridge

Printed in Singapore

Library of Congress Cataloging-in-Publication Data available upon request.
ISBN: 0-7922-9344-4

One of the world's largest nonprofit scientific and educational organizations, the National Geographic Society
was founded in 1888 "for the increase and diffusion of geographic knowledge." Fulfilling this mission,
the Society educates and inspires millions every day through its magazines, books, television programs, videos,
maps and atlases, research grants, the National Geographic Bee, teacher workshops, and innovative classroom
materials. The Society is supported through membership dues, charitable gifts, and income from the sale of its
educational products. This support is vital to National Geographic's mission to increase global understanding
and promote conservation of our planet through exploration, research, and education.

For more information, please call 1-800-NGS LINE (647-5463) or write to the following address:

National Geographic Society
1145 17th Street N.W.
Washington, D.C. 20036-4688 U.S.A.

Visit the Society's Web site at www.nationalgeographic.com.

Contents

FOREWORD: Dr. Jane Goodall 6

PREFACE: A History of the Mountain Gorilla 9

INTRODUCTION: A Passion for Africa 18

CHAPTER ONE: 1967, First Base at Kabara 30

CHAPTER TWO: 1967–1970, The Camp at Karisoke 48

CHAPTER THREE: 1970–1973, Cambridge and Back 90

CHAPTER FOUR: 1973–1977, Power Struggles 132

CHAPTER FIVE: 1977–1980, The Death of Digit 152

EPILOGUE: Digit's Legacy 172

BIBLIOGRAPHY 186

ACKNOWLEDGMENTS 186

ABOUT THE DIAN FOSSEY GORILLA FUND 187

INDEX 188

Dr. Jane Goodall

My first impression of Dian Fossey, to whom I was introduced by Louis Leakey, was of a tall, statuesque and very handsome young woman, with warm eyes and a quick smile. We met at the Ainsworth Hotel in Nairobi, which served as the headquarters for most of Louis's visiting protégées and colleagues. I remember looking at Dian and thinking how absolutely fascinating it would be to learn more about the mountain gorillas. We talked about the chimpanzees and their personalities, our plans for long-term research and Dian's own plans. Little could any of us have dreamed of the course her life would take.

Looking back to that first meeting I find it hard to separate my first impressions of Dian from the picture that I built up during the 18 years that I knew her. Certainly, her somewhat tortured personality quickly became apparent. For all her tough determination and incredible courage in the face of danger, she was insecure in her human relationships. When we met her it was not far off Christmas. Hugo and I had made plans to go upcountry for the holiday and, knowing that Dian had had no time to make friends of her own, we suggested she might like to come with us. She did not jump at the idea. And when we pressed her she said she would only be in the way, she did not want to spoil our holiday, she did not want to receive our charity—she knew that we were only inviting her because Louis had asked us to. Which he had not. She wouldn't believe us, though she came anyway. During that Christmas we learned more about her complex personality: one minute soft spoken and considerate, and the next—if anyone did something wrong—furiously angry. It was disconcerting. But the charming side of her was the "real" Dian, always uppermost and reappearing after one of her rages as quickly as it had been temporarily lost. And she had a marvelous, if somewhat earthy, sense of humor.

After that Christmas Dian spent a few days at Gombe, as Louis wanted her to see how we did things, but I was very pregnant and spent little time with her then. I did not see her again for several years, but stories circulated about the conditions she worked in: the drenching rain, the cold, the stinging nettles, the dangers from buffalo and from poachers. Sporadically Dian and I wrote to each other over the years. But most of my news about her came either from Louis, who loved to boast of her achievements, or from my mother Vanne with whom Dian developed a lasting friendship.

I remember the year when Dian emerged, unwillingly, from the mists of the Virungas to work for her Ph.D. at Cambridge University. She struggled, as I had, to confine her rich knowledge of the gorillas into a form suitable for academia. For Dian it was a traumatic experience and it inhibited her to the extent that her thesis lacked a great deal of the qualitative information so important when it comes to understanding the behavior of complex beings. How fortunate for the world that she eventually wrote her own book, *Gorillas in the Mist*, and that Bob Campbell and other photographers worked with her so that she was able to share her wealth of knowledge and passion with a wide audience around the world. And fortunate too that the National Geographic Society published her adventures—for she so much wanted to raise awareness. That is why she would be so delighted with this book.

The time I felt closest to Dian was when she had temporarily left the field, and was teaching and writing her book at Cornell University. It was Dian's idea to arrange a mini symposium that would bring the two of us together with Leakey's third great ape "girl," Biruté Galdikas (we were all "girls" in those days!) I was welcomed into Dian's apartment, which she had made as African as she could: she had brought many things from her Rwandan cabin for her enforced exile, including Cindy, her dog. Seldom have I been so nurtured. Given a long, white nightgown of brushed cotton, brought tea in bed, catered for in every way. Then we really talked, and she revealed some of her inmost feelings about the people she felt were conspiring against her, who were jealous of her, who wanted her out of the way so they could take over, take her gorillas away from her. She always called them "my" gorillas. We went on some long walks in the woods, and went on talking. This was Dian at her most charming. The symposium with the "Trimates," as we were called (we were known as "Leakey's Ladies" too!) was so successful that it was repeated in a number of cities around America, organized by the Leakey Foundation. This was when I discovered an unexpected side to this woman of surprises—her passion for beautiful and elegant clothes. When she went out, dressed in classic suits and matching low-heeled shoes, with just a touch of jewelry, her dark hair sleek and shining, she looked stunning.

We talked a lot about our research methods. In many ways her approach was similar to my own: get the trust of the animals; observe as objectively as possible but without trying to suppress empathy with them; and allow anthropomorphic interpretations of complex behavior to serve as a baseline for rigorous questioning. I thought, though, that Dian might be biasing her data by the extent to which she communicated with the gorillas. But then, I had groomed David Greybeard and tickled Flo's offspring in the early days at Gombe, only stopping when I realized the study would be ongoing. And, though we tried to minimize contact, it was not easy to stop

youngsters from approaching and investigating our clothes and hair. (Though today we stay further away to try to prevent disease transmission between human and chimpanzee.)

I recollect my feelings of amazement and admiration when I first heard how Dian had put on a Halloween mask and raced toward a group of poachers. I knew I would never have had the courage to do that! But looking back, with hindsight, it seems that these confrontations were not the best response to the acts of local people. But I was not there. I was in conservation-minded Tanzania and did not have to face seeing the bodies of beloved chimpanzees butchered for their hands or skulls. So I cannot know how I would have behaved in her situation. And in the end there can be no doubt whatsoever that Dian did more to save the mountain gorillas than anyone. She brought information about their gentle personalities and complex social structure to people everywhere. All of us who care about these amazing beings, and their preservation in the wild, owe Dian a huge debt of gratitude.

Today all the Great Apes are in dire plight and many people feel that the mountain gorillas, in their shrinking habitat, surrounded by desperately poor people, are surely doomed. No! There are many reasons to hope for a less gloomy future. We must remember that nature is amazingly resilient, and even highly endangered species have been brought back from the brink of extinction thanks to protection in the wild and, sometimes, captive breeding. Today, recognizing the urgency, conservationists are working with governments, the private sector and the big donor agencies, to formulate plans to save the Great Apes and their forests. Thanks in great part to Dian, people travel from all over the world to see the gorillas and they are bringing money into desperately poor Rwanda, so that the government recognizes the value of live wild gorillas. More conservation organizations are realizing the importance of working with local people, improving their lives, offering them alternative ways of making a living so that they need not rely on destroying the natural world. Realizing, also, the need for good conservation education around the world, to help young people to become better stewards than we have been. And, thanks to NATIONAL GEOGRAPHIC, Dian's name is on the lips and in the minds of thousands of children. She is one of their heroes.

I believe that the greatest reason for hope is the indomitable human spirit. How can we despair when we are surrounded by amazing people who tackle seemingly impossible tasks and won't give up, and who inspire those around them. And surely, Dian was one of those indomitable spirits. She tackled insurmountable obstacles, and she never gave up, right to the end. On behalf of the gorillas whom you so loved, and for whom you gave your life, thank you, Dian.

JG, AUGUST 2004

A History of the Mountain Gorilla

"From our campsite we were able to watch a herd of big, black monkeys which tried to climb the crest of the volcano. We succeeded in killing two of these animals, and with a rumbling noise they tumbled in to a ravine, which had its opening in a north-easterly direction. After five hours of strenuous work we succeeded in retrieving one of these animals using a rope. It was a big human-like male monkey of one and a half meters in height and a weight of more than 200 pounds. His chest had no hair, and his hands and feet were of enormous size."

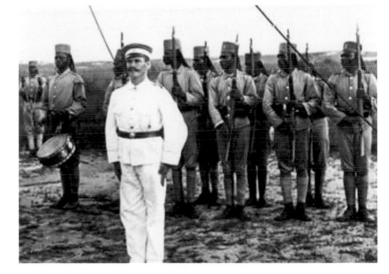

BELOW Captain Robert von Beringe, the first European to see—and kill—a mountain gorilla.

With a seemingly cavalier attitude toward his momentous discovery, Captain Robert von Beringe thus recorded the first sighting and killing of two mountain gorillas by Europeans. The first man to shoot these "human-like" creatures was subsequently given the honor of having them named after him. It was to be an inauspicious start for the subspecies of gorilla that eventually came to be known as *Gorilla beringei*, or the Mountain Kings.

The year was 1902, and Captain von Beringe was on no nature trek. He had been charged with the task of visiting German outposts and confirming good relations with the local people in a region then known as German East Africa. He was traveling with two companions, an escort of *askaris* (armed soldiers) and a team of porters when he decided on a detour. Looming ahead of the expedition was the awesome spectacle of Sabinio, a volcano standing 11,932 feet (3,637 meters) above sea level, one in a range of formidable volcanoes—the Virungas—that today straddles the borders between Rwanda, Uganda, and the Democratic Republic of Congo (formerly Belgian Congo/Zaire). Captain von Beringe took up the challenge that had been thrown in his path and led his

OVERLEAF A view of the Virunga Volcanoes in East Africa, as seen from the Kanaba Pass in Uganda.

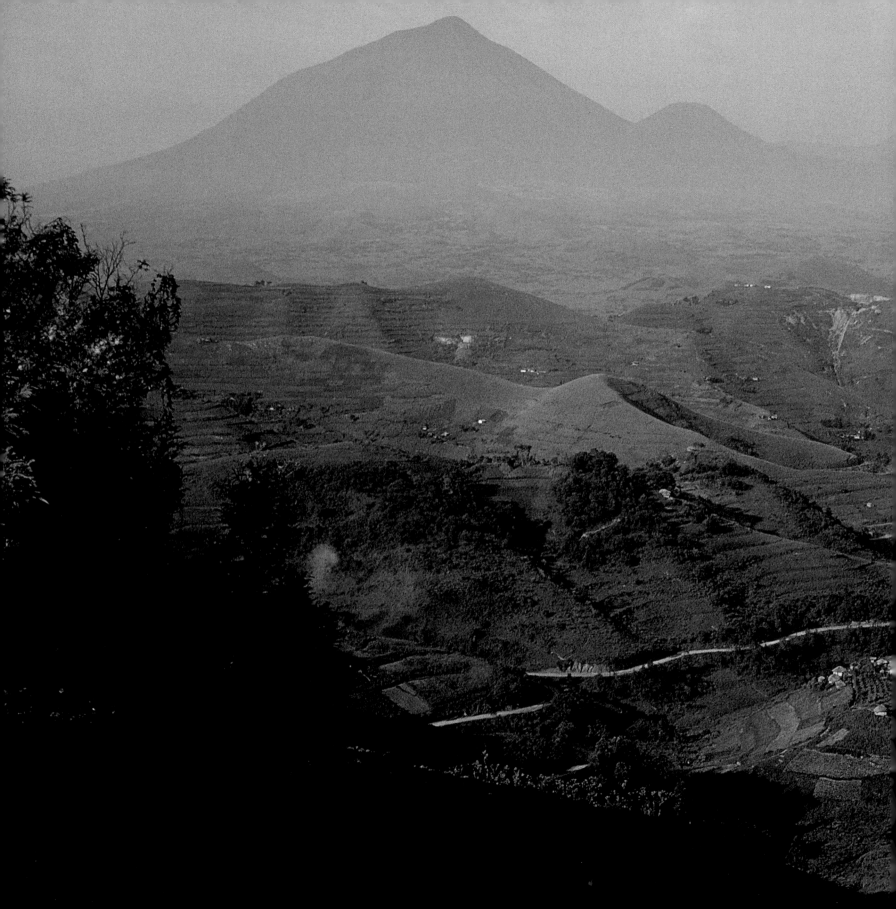

party on a steep climb along elephant trails and through thick undergrowth. The expedition stopped just 1,640 feet (500 meters) short of the summit and tents were erected on a narrow ridge for the Europeans, while the *askaris* and porters sought shelter from the cold biting wind in rock caverns. It was from this vantage point that the first Europeans caught sight of the great apes, shrouded in the heavy mist of a remote and magnificent setting.

The remains of the gorillas were taken back to Berlin, eventually arriving minus an arm and the skin, which had been taken by an opportunistic hyena en route. The mountain gorilla was first described as a new species, *Gorilla beringei,* in 1903. It is so similar anatomically to the western lowland gorilla, *Gorilla gorilla,* that it was later deemed to be a subspecies and given the name *Gorilla gorilla beringei.* Recently, however, genetic analysis has supported the original idea that eastern gorillas are a separate species from western, and so the Virunga gorillas are now known as *Gorilla beringei.*

THE DISCOVERY OF A NEW ANIMAL, particularly one that was viewed as a monster, was like a starting-gun being fired, and museum collectors raced to East Africa to kill the biggest and best specimens. Between 1902 and 1925 alone it is estimated that over fifty-four mountain gorillas were shot or captured. Amongst the horde of hungry hunters in 1921 was Carl Akeley, an employee of the American Museum of Natural History in New York City.

Akeley was a renowned inventor, photographer, sculptor, taxidermist, and hunter. He had invented the process of building anatomical models with tubes, wire, cloth, and plaster, which were then covered with tanned animal hides and transformed into graphic dioramas; they were given "lifelike" poses and set amidst naturalistic vistas, painted to imitate the animals' original habitats. In 1921 Akeley shot five mountain gorillas and used them to create one of his most famous dioramas, which is still on view today at the American Museum of Natural History's Akeley Hall of African Mammals in New York City.

When Carl Akeley returned to the Virungas in 1923, his view of the gorillas underwent a sea change. As he wrote at the time:

I'll never forget it. In that mud hole were the marks of four great knuckles where the gorilla had placed his hand on the ground. There is no other track like this in the world … there is no other hand in the world so large …. As I looked at the track I lost my faith on which I had brought my party to Africa.

Inspired by a new respect for the gorillas of the Virungas, Carl Akeley persuaded the Belgian Government to set aside 190 square miles (490 square kilometers) as a nature reserve: the first of its kind in Africa. This was later expanded to incorporate the entire Virunga range and was named the Albert National Park after the Belgian king who lent the project his support. In 1926 Akeley returned to the region, this time hoping to study the gorillas rather than kill them. Sadly, he died at the beginning of the expedition and was buried at Kabara, in a green meadow dotted with delicate flowers, which nestled between two volcanoes. He had described it as "the most beautiful spot in all the world."

ABOVE Walter Baumgartel, who first contacted Louis Leakey about the plight of the great apes.

Few scientists were subsequently interested in studying mountain gorillas. This is possibly owing to the poor press all species of gorillas had been given. While notoriously shy, gorillas were also said to be ferocious. Reports abounded of hunters being killed by "hellish dream creatures," their guns crushed in gorilla teeth. Local Africans apparently reported that one of their companions was hoisted into the forest canopy only to be dropped to the ground moments later, "a strangled corpse." Those who were brave enough to persevere with attempts to observe the gorillas were usually defeated by the creatures' refusal to cooperate. One expedition to study gorillas in 1954 failed miserably; not one gorilla was spotted. The presence of 120 porters may explain the gorillas' recalcitrance.

It was to be a layman, not a scientist, who took the next formative step in the gorillas' future. Walter Baumgartel was an itinerant adventurer who had, in 1955, bought a small hotel, finally hoping to settle down. The Traveller's Rest was situated in Kisoro near the borders of Uganda, Rwanda and the Belgian Congo, at the foot of Mount Muhabura in the Virunga mountains. Curious to find out more about his gorilla neighbors, Baumgartel took a guide with him to explore the forest and was rewarded with the rare sight of a gorilla family passing through a bamboo grove. Transfixed by the majestic sight, Baumgartel wondered whether the future of these vulnerable apes might be tied to that of his own faltering business venture. He envisaged a small, local tourist attraction that would serve to protect the gorilla population while also keeping his hotel busy—thereby laying the foundations of the concept of gorilla tourism as part of a conservation strategy decades before it became widely accepted. Baumgartel recognized the need to incorporate scientific research into his strategy, so he contacted the famous anthropologist and evolutionary scientist Dr. Louis Leakey, who was based in Nairobi, Kenya.

As a result of Walter Baumgartel's efforts, two minor studies of mountain gorillas were initiated. Unfortunately neither was to be totally successful. Rosalie Osborn had been helping Louis Leakey on an archaeological dig in Africa when he sent her to the Virungas to track gorillas. Osborn spent four months there, meticulously recording all her observations, before being recalled to Scotland. Jill Donisthorpe, a journalist, took over where Osborn left off. With minimal money, support or backup Donisthorpe monitored the dietary habits and habitat of the gorillas and even withstood a bluff charge from a large silverback (mature male). Meanwhile Louis Leakey was preparing a detailed proposal for a two-year survey of the Virunga gorillas. News of this reached Dr. John Emlen, Professor of Zoology at the University of Wisconsin, who discussed the proposal with his student, George Schaller.

OPPOSITE Every gorilla has a distinctive noseprint, and George Schaller used these to identify the individuals from different gorilla groups and assist in his census work.

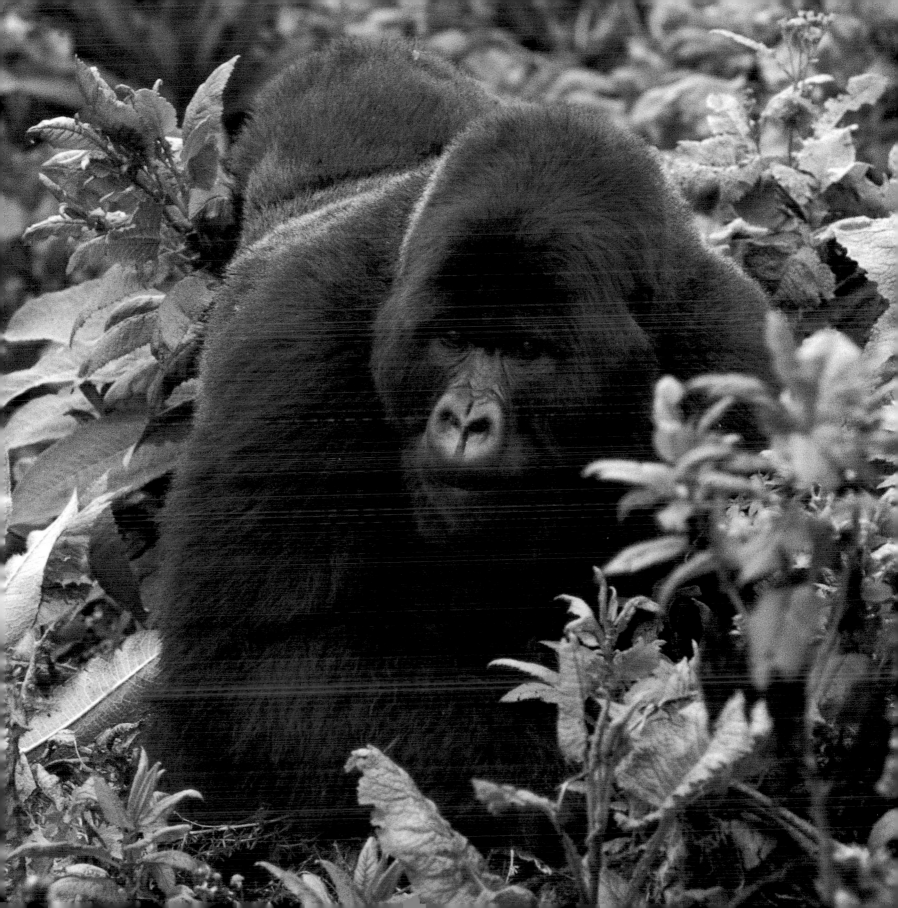

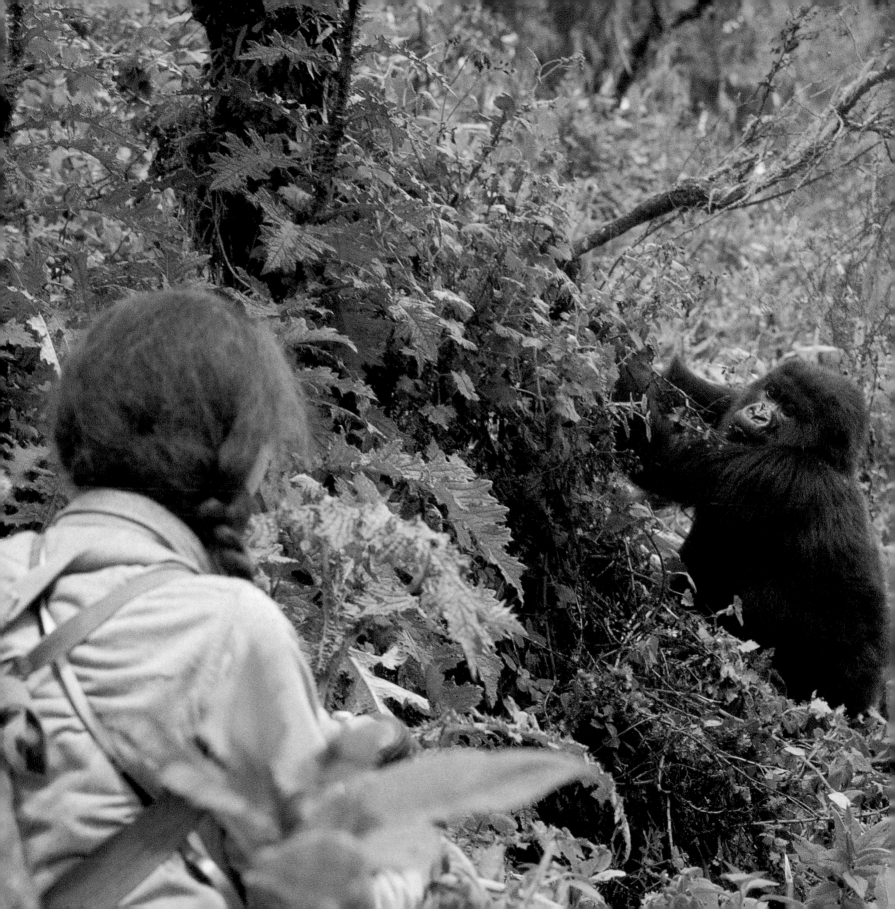

Schaller was a young American zoologist who had been following the story of Walter Baumgartel and the recent attempts by Osborn and Donisthorpe to study the gorillas—for he had been hoping to embark on his own behavioral study under the guidance of his mentor, Dr. Emlen.

Undaunted by the difficulties encountered by his predecessors, George Schaller and his wife Kay set off for the Albert National Park on February 1, 1959. Financial support had been provided in the form of grants from the National Science Foundation and the New York Zoological Society. They eventually established a base in Kabara, on the slopes of Mount Mikeno in the Belgian Congo, close to Carl Akeley's grave.

For the next year George Schaller was able to get closer to family groups of gorillas than had ever been achieved before. He discovered that, instead of hiding from the gorillas, it was best to make his presence known, despite the obvious disadvantage that the gorillas' behavior might be affected. Schaller would walk calmly toward the gorillas and climb a stump or branch where he was easily visible. He reckoned that the gorillas were astute judges of behavior and could tell that he was not a threat to them. His presumption proved correct and he was able to complete more than 400 hours of observation.

There was not enough time to conduct anything approaching a proper census, but when Schaller left the Virungas he estimated there was a population of 400–500 mountain gorillas. (When Dian Fossey completed her book *Gorillas in the Mist* 23 years later she estimated there were only 242 gorillas left.) Schaller's study on the lifestyles and habitat of the mountain gorilla resulted in a highly acclaimed scientific monograph *The Mountain Gorilla* and a book, *The Year of the Gorilla*—a personal account of the time he spent in the Virungas. It was this book that Dian Fossey would rely upon when she came to Kabara in 1967, to continue the work that George Schaller had begun. Like Schaller, Dian realized that becoming acquainted with the gorillas involved a process of habituation through which the gorillas came to recognize, and then ignore, researchers.

The Schaller study had to be cut short in 1959. Political instability led to the rapid decolonization of the Belgian Congo. In 1960 the country was renamed the Republic of Congo, and civil war began. Further studies of mountain gorillas in the region became virtually impossible in the short term—and proved to be extremely dangerous in the long term.

OPPOSITE Schaller's work would later prove invaluable to Dian Fossey, and she followed many of his techniques when she began her own studies, notably his method of habituation, by which she hoped the gorillas would become used to, and then ignore, her presence.

A Passion for Africa

OPPOSITE Mount Visoke, shrouded in the mist that provided the inspiration for the title of Dian Fossey's book.

When Dian Fossey came to write the story of her time spent living among "the greatest of the great apes," she called her book *Gorillas in the Mist*. The book was first published in 1983, and its title reflects the climatic nature of the Virungas, which are regularly veiled in mist and clouds of cold, damp air. It also hints at the difficulties encountered in discovering the true nature of the beasts. Dian's book is prefaced by an extract from *Carpe Diem* by Lord Houghton, a nineteenth-century poem that explains the title:

> *The hills of manhood wear a noble face*
> *When seen from afar;*
> *The mist of light from which they take their grace*
> *Hides what they are.*

To Dian the magnificence of the gorillas was clearly visible, but to the poachers and politicians who threatened their survival, their grace remained hidden. Dian Fossey, the woman, remains, like the gorillas she served, shrouded in mist; the circumstances of her death are not the only mystery that surrounds her story.

Although Dian kept journals and copies of her correspondence, she was not always reliable in her record-keeping. During bouts of ill-health, when she was fearful of death, Dian would burn the papers that she thought were sensitive and urged others to do the same with letters that they received from her. Furthermore, Dian's accounts of important episodes in her life were often at variance with those of the other people who participated in them.

Whatever else may be true, Dian was, without doubt, a woman with a complex personality and rare courage. People either loved her or loathed her, and she seemed to find friends and enemies in equal measure. It is no accident that such a woman should choose to live in a remote area with animals rather than people for companions. The roots of Dian's desire for solitude can be found in her early years.

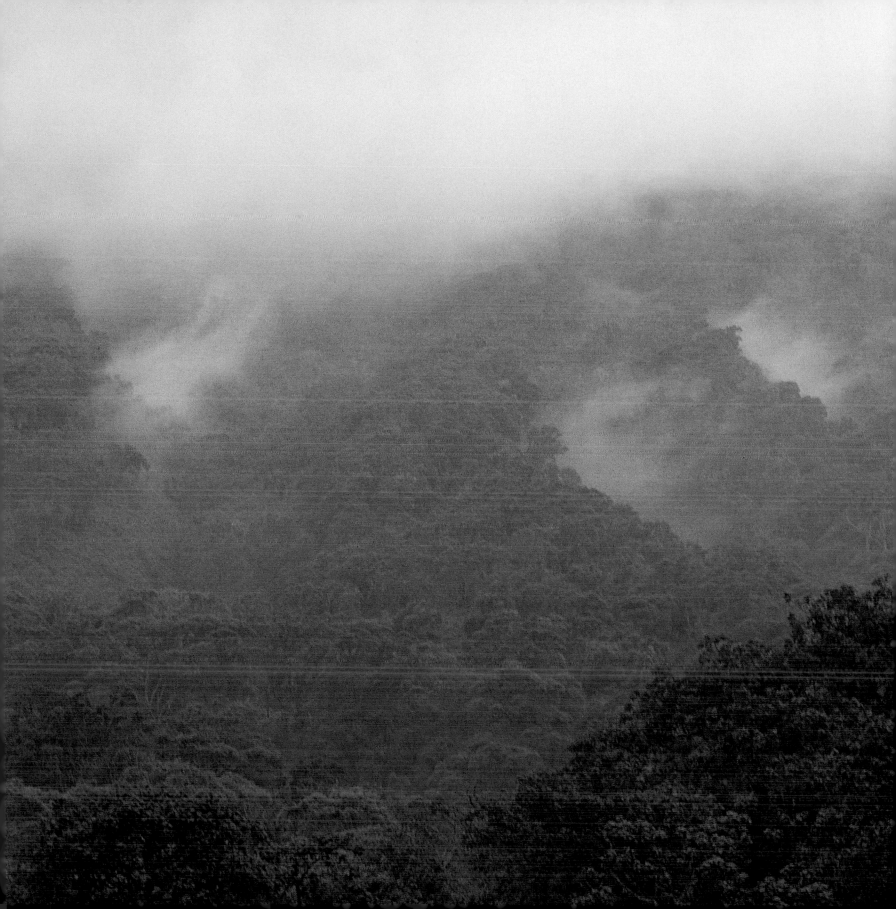

ABOVE Dian's mother and stepfather, Kitty and Richard Price.

Dian rarely discussed her childhood in California but would, when drawn, describe it as very unhappy. Her parents, George and Kitty Fossey, divorced in 1938 when Dian, an only child, was just six. George disappeared totally from Dian's life, to reappear many years later when Dian was an adult. A year after the divorce Kitty remarried, to a wealthy businessman, Richard Price; Dian later addressed him as "Father" in her letters. Price was a stern and imposing stepfather. The effect of such events on a young child can only be imagined, but at this time Dian began to develop her great love of animals, perhaps to defend herself from the pain and rejection she had suffered after her father's estrangement.

Dian's interest in animals during her childhood was not her only concern—there was a war going on. In 1977, while attending a conference in Germany, Dian wrote to a friend about a childhood memory. She had just been to visit a concentration camp that was open to the public:

It is only some 25 km from Brussels, had no gas chambers—some 200 out of 4000 prisoners were hung or shot; about 1000 died from disease or malnutrition. I can't really explain why I want to see concentration camps; you could not understand because you are not of my generation When I was about 12 years of age I ran away from home to come to Europe to help the children of the war—I was caught on the boat docks of San Francisco.

In 1949 Dian was encouraged by her stepfather to take up business, and she enrolled at Marin Junior College to study a suitable course. By 1950 she had begun to assert her own forceful personality; Dian decided to follow her heart and pursue a career with animals instead of business. She enrolled at the University of California as a pre-veterinary medical student, but failed the second-year exams.

Dian had to rethink her future. She opted to work with children and studied occupational therapy at San José State College, from where she graduated in 1954. Finally qualified, Dian packed her bags and left her home state of California forever, returning only for periodic visits to Kitty and Richard Price. She had secured herself a position at Korsair Children's Hospital in Louisville, Kentucky, thus taking the first steps on the road that would lead to Rwanda and the mountain gorillas.

In Korsair, Dian found a dilapidated cottage on a large country estate ten miles from the town. Despite protests from the landlord that the place was remote and therefore unsuitable for a single woman, Dian decided she would have it; it would be her home for the next ten years.

The work at Korsair suited Dian: she could spend most of her time in the company of children while avoiding that of other members of staff. There was one important exception: Mary White Henry, secretary to the hospital's administrator. Mary and Dian forged a close bond that remained despite the distance that eventually separated them. Over the coming years Dian was to spend much time with the Henry family and became extremely close to Mary's mother, Gaynee.

In her mid-twenties Dian was a formidable sight. Over six feet tall and slender, she had a good figure and strong features framed by thick, dark hair. Dian was rarely described as beautiful, but her appearance was striking. Now in her prime, men were showing more than a passing interest in her. One such man, a journalist, had traveled through Africa and told Dian exciting stories of his adventures. Another African connection came through the Henrys, who welcomed Franz "Pookie" Forrester into their home and introduced him to Dian. He was a Rhodesian whom Dian described as "a dream."

Pookie's feelings for Dian went further and, as he traveled around the United States and Europe, he deluged his sweetheart with letters. He wanted Dian to go to Africa with him, but her attention was already wandering—distracted by another man, Fr. Raymond, a Trappist Monk from Ireland and another close friend of the Catholic Henry family. Dian was totally captivated by him and eventually converted to Catholicism.

In 1960 Mary White went on an extended trip to Africa, staying with the Forrester family in Rhodesia (now Zimbabwe). When she returned home with stories and photographs of her journey, Dian was more than just enthralled. With her usual resolve and determination, she gave herself three years to save the money for her own safari; Dian intended to go to Africa before 1963 was out.

As the departure date approached, Dian completed her preparations. She had to supplement her savings with a bank loan to finance the trip. The debt would take three years to pay off but it meant that she would be able to travel in style, employing a personal guide to escort her through the game parks of Kenya and Tanganyika (now Tanzania). She then planned to fly south to Rhodesia, where she could stay with Pookie Forrester's

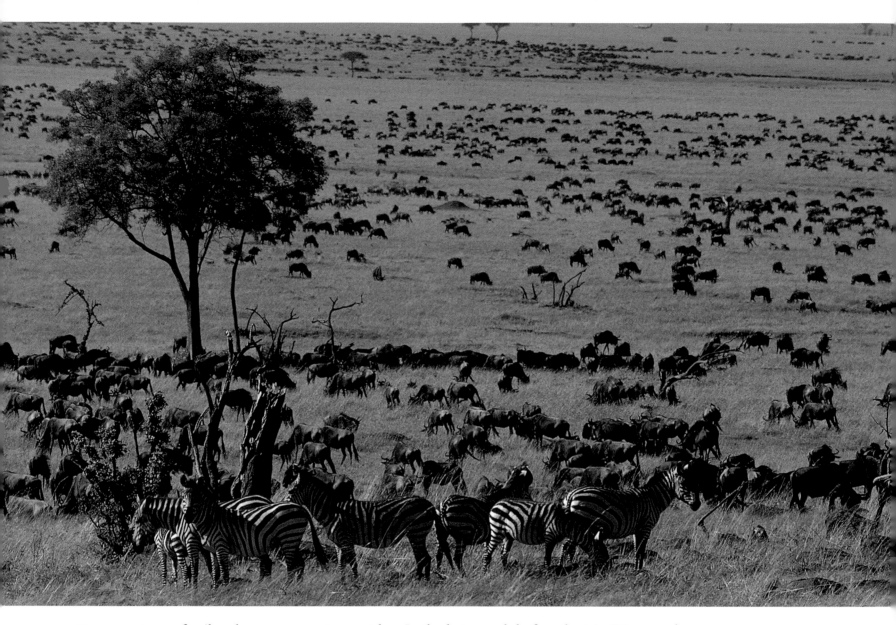

ABOVE Dian went on her first African safari in 1963. The trip fired her enthusiasm for the country and made her determined to return.

family, who were eager to meet her. In the last month before the trip Dian caught pneumonia and was forced to take time off work. This was an illness that she had suffered previously, along with asthma and allergies. Despite her susceptibility to episodes of ill-health Dian was, and remained throughout her life, a heavy smoker.

In late September 1963, Dian arrived in Kenya and luxuriated in the first-class facilities of the Mount Kenya Safari Club. She established contact with John Alexander, a British hunter and guide, whom she employed to drive her through the region's national parks. Alexander proposed a route that would take them through the scrubby, arid region

of Tsavo, Africa's largest national park, where they would see elephants and rhinos. From there they would drive to Manyara, where huge flocks of flamingos linger at the shores of a saline lake, and then to the Ngoronogoro Crater—famous for the dense populations of wildlife it can support upon its fertile crater-floor. The crater covers 100 square miles (260 square kilometers), and represents a microcosm of East African scenery and game: zebra, wildebeest, lions, cheetahs, leopards and black rhinos can be viewed at the crater. Dian and Alexander's journey would then take them west to the Serengeti Plain, passing Olduvai Gorge, before turning north and heading back to Nairobi.

By all accounts the safari was eventful. Dian kept a journal and wrote scathing comments about her guide, whom she considered lazy and dull, although she conceded that he was a good driver and expert at finding game. Alexander, in return, was no more enthusiastic about being forced to spend every day with Dian. Since she was not used to spending long periods of time in the company of one other person, it is possible that Dian was not an ideal traveling companion either.

In *Gorillas in the Mist* Dian wrote about the two main goals of her first African trip. She recalls her desire to visit Louis and Mary Leakey, who were researching pre-human history at archaeological digs in Olduvai Gorge, and a wish to see the gorillas at Kabara, in

LEFT Although Dian did not get on well with her safari guide, John Alexander, she fell in love with the country and its wildlife.

the Congolese part of the Virunga Mountains. There is, however, little evidence to support Dian's claims that she set off for Africa with these two destinations in mind. It seems more likely that circumstances and fate took Dian to Olduvai and Kabara, and thus determined her destiny.

Since the journey from Ngorongoro to the Serengeti passed by the Olduvai Gorge, John Alexander frequently suggested a stop-off to the tourists he escorted on safari. So it was that Dian was taken to visit newly excavated sites at Olduvai. Louis Leakey had been working in the field of anthropology for many years, and had been excavating at Olduvai since 1931. A few years before Dian and John Alexander visited the digs, Louis and his wife Mary, an equally respected anthropologist, had unearthed remains of *Homo habilis*, a possible ancestor of modern humans, together with their crude tools. The Leakeys and their work were world famous and it is no surprise that the ravine, which promised to yield even more insight to the origins of humankind, attracted many visitors.

When Dian recorded her visit to Olduvai in *Gorillas in the Mist* she described it as a seminal moment. Louis Leakey talked to her about the importance of long-term field studies with great apes, and the seed was planted in her mind. She decided she would return to Africa one day, to study mountain gorillas. The truth may be more prosaic; those who were there at the time do not remember events quite as Dian subsequently did. It is possible she did not even meet Leakey, much less discuss gorillas with him. The encounter may have been insignificant at the time, but Dian was right in one respect. Important events were to grow from this occasion, when Dian met Leakey again, several years later, back in the States.

BELOW A view across Olduvai Gorge, where Dian first met the anthropologist Louis Leakey, who was excavating a site there. Leakey was to play a large part in Dian's later association with the gorillas of East Africa.

FROM OLDUVAI, Dian and John Alexander drove to the Serengeti Plain. It is not clear at what point in the safari Dian decided to extend her journey to take in the Virungas, but there has been speculation that while staying at the Serengeti she met a biologist who had seen the gorillas. Such a meeting could have inspired Dian to embark on the next part of her journey, which took her back to Nairobi to restock, and then to the Congo.

The political situation in the Congo remained highly unstable, particularly in the vicinity of the Virungas.

LEFT Part of the Kabara Meadow, where Carl Akeley is buried and where Joan and Alan Root were studying the gorillas when Dian made her first trek into the Virungas. Beyond the remains of the old cabin stands the highest of the volcanoes, Mount Karisimbi.

Neighboring Rwanda had witnessed mass genocide (an event repeated in the 1990s on an ever greater, more horrific scale), and soldiers in the region were known to be trigger-happy. John Alexander agreed to take Dian into this threatening region of Africa despite his own misgivings.

On October 16, 1963, Dian Fossey and John Alexander drove up to the Traveller's Rest, Walter Baumgartel's hotel in Uganda, near the border of Rwanda and the Congo. Baumgartel recommended they cross the border into the Congo and make their way to the slopes of Mount Mikeno. He knew two wildlife photographers, Joan and Alan Root, who were trying to get some film footage of the mountain gorillas and suggested that they might be able to help Dian in her quest.

Fortunately there was little activity at the Congolese border, and they were able to cross into the country with relative ease. The Director of the Albert National Park supplied two armed rangers to accompany the expedition, which was further swelled by eleven porters who carried the gear. After six hours of hard trekking up the difficult terrain of Mount

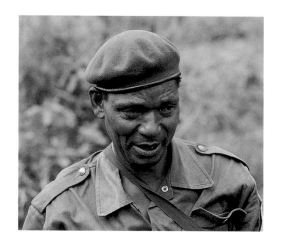

ABOVE Sanwekwe, the Congolese tracker who helped Dian at Kabara.

Mikeno, Dian finally reached Kabara Meadow at 10,000 feet, the site of Carl Akeley's grave, and the temporary home of Alan and Joan Root.

At the time the tall, gangly American woman and her entourage must have been unwelcome intruders on the solitude the Roots had sought—and needed—for their challenging project. After the initial shock had worn off, they suggested Dian set up camp behind the cabin in which they were housed. After a few days they took pity on Dian and offered to take her to find some gorillas.

Dian found the trek extremely arduous; she was suffering from an injury to her ankle, and the altitude made breathing difficult. Even the fittest people can find climbing through thick vegetation at height a great challenge; the fact that Dian persevered despite her scarred and damaged lungs testifies to her unstinting determination. The effort was well rewarded: the group came across a bedding place where a family of thirteen gorillas had slept the previous night. Suddenly, with little warning other than the vanguard of a musky, barnyard stench, the air was sliced by a series of high-pitched, terrifying screams. Dian's initial instinct was to turn tail and run. She was prevented only by the cook, Manual, who was behind her, and Alan Root and the Congolese tracker, Sanwekwe, who stood before her. They were rooted to the spot, knee-deep in dense stinging nettles and surrounded by an impenetrable wall of vegetation.

Advancing silently, Sanwekwe cut a hole in the foliage before them. Alan and Dian crept cautiously forward, peering through the gloom. The sight that met Dian set the course of the rest of her life. She could see, nestling in the dappled half-light of a forest clearing, a group of six adult mountain gorillas. The animals returned the curious gaze of the intruders, and Dian was able to see for herself that these beasts were not monsters, but beautiful creatures with thick, velvety fur, shiny black faces and warm brown eyes. While Alan filmed them, the gorillas beat their chests, yawned, scratched and broke branches. Dian focused on the individuality of each animal, captivated by the displays of behavior and their apparent interest in their audience.

It took more than three hours to return to the Traveller's Rest from Kabara, through foul weather and thick mud, but nothing was going to deter Dian from her next plan. She had decided that, one day, she would return to the Virungas and learn more about their shy, but captivating, inhabitants.

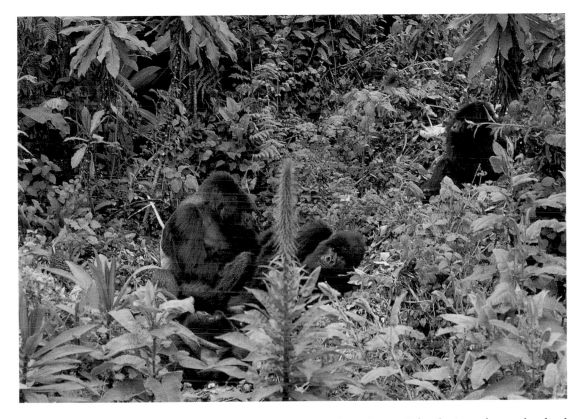

The final part of Dian's African experience was the trip to Rhodesia, where she had arranged to stay with the Forresters. Dian was hugely impressed by the lifestyle and obvious wealth of the Forresters, but it was Alexie, Pookie's brother, who made the journey south particularly worthwhile and her interest switched from one brother to the other. Alexie was better-looking than Pookie, arrogant and powerful in a way that brought out the passion in Dian. Alexie was no less affected by this tall and striking woman who was capable of plowing an entire field single-handed.

Dian returned to America and, tentatively, the two began a romance, fueled by letters that touched on a possible future together. In September 1964 Alexie came to America to study, attending Notre Dame University in Indiana. He was living more than 300 miles (500 kilometers) from Louisville, while Dian had settled back into a mundane routine at Korsair Hospital and was occasionally writing articles about her African experiences for local publications. In November the pair met up again, and the love affair began in earnest. Early in 1965 Dian and Alexie got engaged and were hoping to marry as soon as possible.

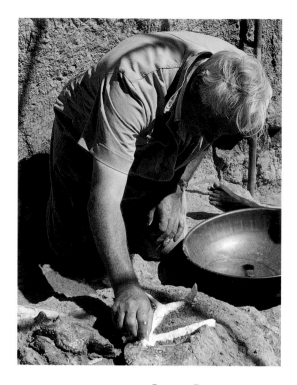

In reality, an early wedding was anything but practicable. Alexic had only just begun college, and as reality sank in it was decided that marriage should be delayed until he graduated, in 1968. Dian was distraught. The trip to Africa had wrought huge changes in her life, experiences and outlook, yet she now found herself back where she had been before leaving America. She was still working at the same job, and the exciting prospect of marriage to the man she loved seemed as far away as ever.

The marriage never took place. In early 1966 Dian wrote to her mother and stepfather, saying that she had decided not to hang around waiting for Alexie any longer. In April of the same year Louis Leakey was on a lecture tour. His itinerary brought him to Louisville.

LOUIS LEAKEY WAS A MAN ON A MISSION. He was an irrepressible advocate of field studies and had instigated the search for pre-human remains in Africa. His interest in the field of palaeoanthropology had propagated a desire to see the great apes studied in detail. Leakey believed that greater understanding of our closest relatives would provide an insight into the development of mankind. He had helped establish the Gombe Stream Reserve in Tanzania with Jane Goodall, who was studying chimpanzees to great acclaim and international interest. In 1966 he was looking for researchers who could set up similar projects to study mountain gorillas and orang-utans.

Leakey's lecture tours were fundraisers, but they also gave him the opportunity to tell the world about his discoveries. Given his reputation, enthusiasm and celebrity, it is no wonder that the auditorium at the Louisville University was packed when Dian turned up. When the talk was over she joined the queue of hopefuls who wanted to grab a few minutes of the great man's time. In her hands Dian was clutching some of her published articles, one of which was entitled "I Photographed the Mountain Gorilla." Leakey's attention was caught.

During the brief conversation that ensued, Leakey ascertained that Dian had been to Mount Mikeno, met up with the Roots and greatly desired to return to the area. Leakey preferred untrained women to study primates, believing that they were better able to connect to the animals in an unthreatening way. He was an empiricist and believed that all

knowledge comes from experience and observation rather than logical deduction. And he felt that modern scientists were over-reliant on recording every tiny phenomenon and on statistical analysis. An untrained woman was more likely to conduct the study the way he wanted it done. Leakey arranged to meet Dian early the next morning before setting off on the next leg of his tour.

The meeting went well. Although Leakey knew very little about this woman, he did know that she had managed to make her way to Mount Mikeno and observe the mountain gorillas. It was enough for him to make some promising noises and Dian was sent on her way with a single piece of advice: if she was serious about returning to the desolate Virungas she should have a precautionary appendectomy.

BY MAY 1966 DIAN was still waiting to hear more from Louis Leakey, and was beginning to lose patience. They had been corresponding about a possible expedition to the Congo, but the financial details were not sorted out. Leakey still had to find a sponsor, so Dian took the next step, committing herself irrevocably to the project. She arranged for her appendectomy to take place in June.

In *Gorillas in the Mist*, Dian wrote that when she returned home from the hospital she found a letter from Dr. Leakey telling her that the operation would not be necessary after all: he had been merely testing her resolve.

Dian handed in her notice at Korsair while recuperating from the operation, then traveled back to California, where she would stay with her mother and stepfather while the final arrangements were to be made.

Once Dr. Leakey had arranged funding for Dian's trip, she traveled east, via Louisville to say goodbye to her friends, and then on to Washington to meet up with the National Geographic Society staff, who were busy arranging the sponsorship to provide financial support for the expedition. Dian left America on December 19, 1966. She flew into London, and then on to Kenya, where she would have an opportunity to meet Jane Goodall for the first time.

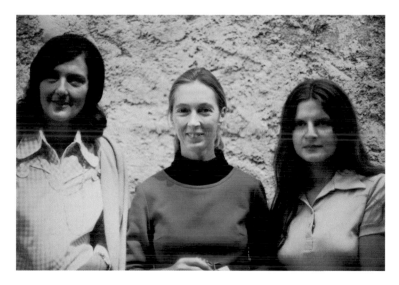

BELOW A photograph Dian sent to her parents, years later showing Leakey's three "ape girls." The note accompanying the pictures reads: "The sexy one is Biruté [Galdikas], the orang girl. ... [in the middle] is the Grande Dame of the chimps [Jane Goodall]. The jaundiced, dissipated one is your own darling Dian."

First Base at Kahara

London: December 21, 1966

Dear Mother and Father

Well, I've seen enough of London to last a lifetime. It is the dirtiest, busiest most congested place I've ever been in—it makes S.F. [San Francisco] seem an island paradise.

I hired a driver today—had him from about 10:30 until just now as he took me over to the airport—he was quite young and an excellent guide—it all came to £4.00 or approximately $11.20 and since the airport is quite a distance from the city I don't think this is too expensive. All I can say is we saw everything from the Changing of the Guard to Carnaby Street—all in the rain! The people are unbelievable—absolutely unbelievable. The hemlines stop where the hair styles end—everyone wears fur coats—quite a few are imitations of one sort or another but fur is the thing to wear. The women are all very smart looking but the men all tend to look alike and terribly British. As for the boys— well, there is nothing in S.F. to equal them. They all wear boots, huge flowered ties, pastel pants and hair longer than mine. I've never done so much staring—it was impossible to know which way to look at first. Also saw Princess Anne at the window during the Changing of the Guard—she is quite a bit prettier than her pictures. Then when we walked by the gates Prince Philip drove in—I didn't get a very clear glance at him though. Carnaby Street was disappointing in a way … the shops are a bit dumpy BUT the people are fascinating … .

… Please don't worry about anything—if I lived through Washington, New York and London—I can survive anything!

I will write soon.
Love, Dian

Dian spent two days in London. She was at Heathrow Airport awaiting her flight to Nairobi when she heard a Mrs. Root being paged over the loudspeakers. Dian glanced up and saw Joan Root rushing toward a phone. She and her husband, Alan, were the film-

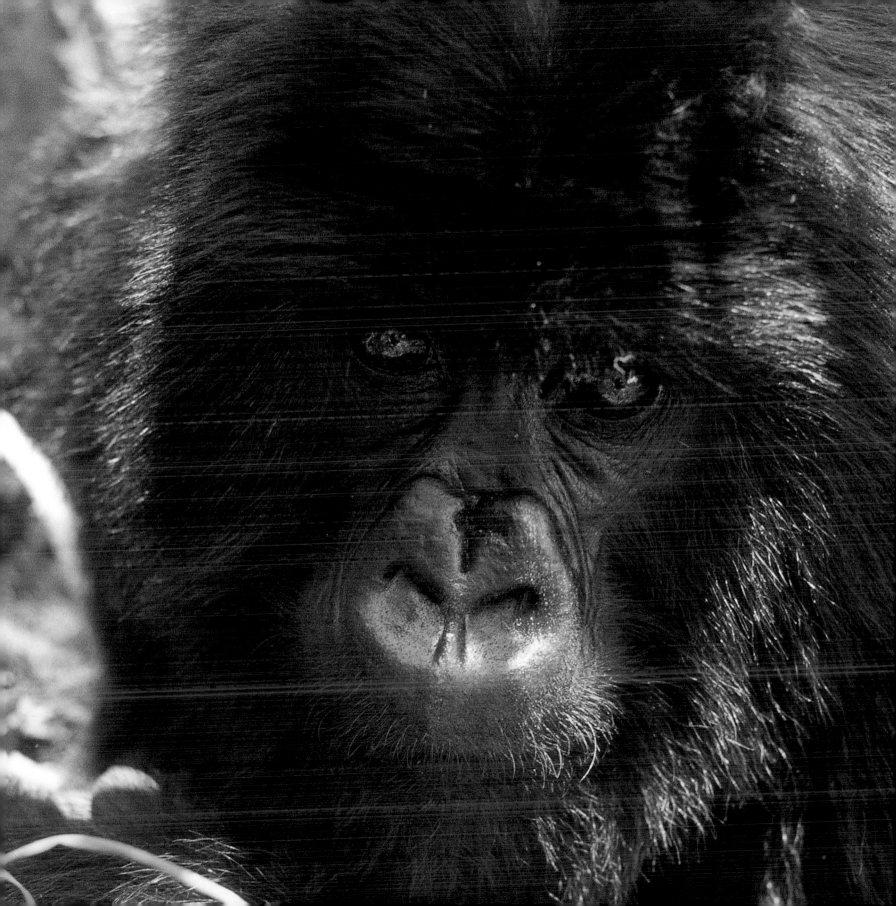

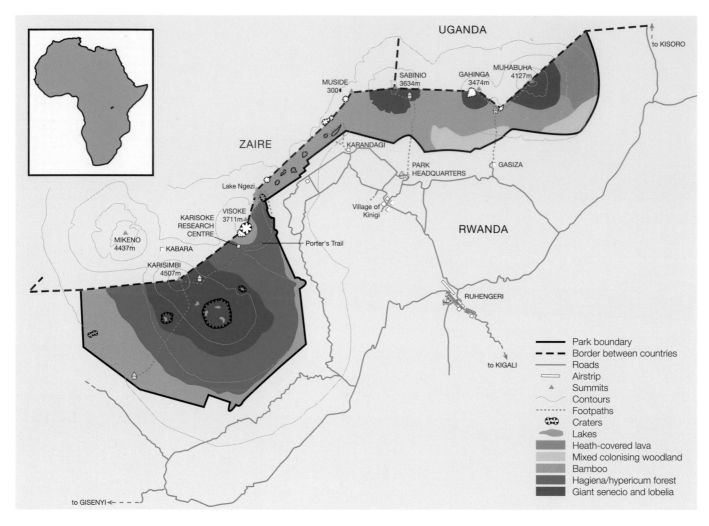

UGANDA

to KISORO

SABINIO
3634m

MUHABUHA
4127m

GAHINGA
3474m

MUSIDE
300

ZAIRE

KARANDAGI

PARK
HEADQUARTERS

GASIZA

Lake Ngezi

KARISOKE
RESEARCH
CENTRE

VISOKE
3711m

Village of
Kinigi

RWANDA

MIKENO
4437m

KABARA

Porter's Trail

KARISIMBI
4507m

RUHENGERI

to KIGALI

Park boundary
Border between countries
Roads
Airstrip
Summits
Contours
Footpaths
Craters
Lakes
Heath-covered lava
Mixed colonising woodland
Bamboo
Hagiena/hypericum forest
Giant senecio and lobelia

to GISENYI

LEFT The area of the Virungas in which Dian lived and worked. Kabara lies between Mount Mikeno and Mount Karisimbi in Zaire.

makers who had shown Dian the gorillas at Kabara Meadow in 1963. Joan was surprised to see Dian at the airport—but was shocked to discover that the naive American tourist she had met four years earlier was to be Louis Leakey's new "gorilla girl."

Joan discovered that Leakey had arranged for Dian to undertake the research project with remarkably little preparation. When Jane Goodall had begun her chimpanzee study she had already spent one year working with Leakey and another year studying animal behavior before going into the bush. Dian had no such experience: she was expected to learn on the job, alone and on the hoof, in one of the most dangerous parts of the world, characterized by political instability, where drunken, armed soldiers roamed at will.

While Dian had professed to be learning Swahili, the lingua franca of East Africa, she was inept at languages. She did not speak French, the colonial language of the region, nor any of the East or Central African dialects. As if an inability to communicate with the locals was not going to be enough of a hindrance to her work, Dian was also totally ignorant of the customs and way of life of the indigenous African people upon whom she would later depend: the Watutsis (Tutsis), Bahutus (Hutus) and pigmy Batwas (Twas). These people spoke the same language and had co-existed for centuries in a complex caste-like society, but sometimes tensions between them ran high.

The climate was another problem for which Dian was little prepared and ill-suited. The Virunga volcanoes are wrapped in mountain rainforest: wet, cold, and foggy. Steep muddy slopes, sliced into sheer ravines and coated in a pervasive damp chilly air were hardly an ideal environment for a woman with scarred lungs and a propensity for catching pneumonia. No wonder Joan Root was taken aback when she learned Dian was flying to Nairobi to start a census of the mountain gorilla. In Kabara in 1963 the Roots had taken pity on Dian and shown her the animals she so desperately wanted to see. Once again, they took pity: they invited Dian to spend Christmas with them and arranged for Alan to accompany Dian to Kabara and help her set up camp.

In Nairobi Louis Leakey welcomed Dian enthusiastically; both were eager to get the study underway. He decided that, instead of spending Christmas with the Roots, Dian would benefit more from spending some time with Jane Goodall and her husband Hugo van Lawick, who had invited Dian to join them on a family trip "upcountry."

BELOW Joan and Alan Root, with a hippo called Sally, at their home by Lake Naivasha in Kenya.

ABOVE A Hutu tribesman (top) and a Twa tribesman (bottom), who were both part of a large group of local men who would work for Dian, carrying her equipment to camp and bringing up mail and food supplies.

Kenya: December 25, 1966

Dear Mother and Father

Merry Christmas …. I wish I could be with you more than I am, which is just in spirit.

It's 3 p.m. here—here being on the shores of Lake Baringo in the Northern part of Kenya. I am "on safari" as a guest of Jane Goodall and her husband …. Dr. Leakey suggested it in view of the fact that I will now only have 10 days at her study center and at that, they will only be there 2 days.

Dr. Leakey has been very nice and has really gone out of his way so far …. The plan now is for me to fly from Nairobi on the 30th to Kigoma, near the chimp reserve in a small plane with Jane and her husband. From there we take a boat on to the reserve where I stay 10 days and they leave after 2. Then I fly back to Nairobi and spend 6 days storing my Land Rover (yes, I have my own Land Rover much to my sorrow) …. I'll really be happy to get there—it'll be good to be cool and sans bugs.

Safari food has been great! Roasted chicken last night with mashed potatoes (no, not like yours Daddy), fresh tossed salad (no, not like yours Mother), and … fresh strawberries and whipped cream. Tonight we're having roasted duck with almond, baked potatoes, fresh peas, salad, peach pie and some things Jane won't let anyone see. She has put up a small tree in the VW camper and strung balloons and crepe paper around (custom here). I bought 1 little present for each person here on the way up but had to wrap them in Kleenex and tie them with a vine—not very pretty I'm afraid ….

Dian

BELOW Dr. Louis Leakey took control of Dian's plans after her arrival in Kenya; a forceful character, he nonetheless showed the young woman much kindness.

In fact, the trip to Jane Goodall's chimp reserve in Tanzania was delayed, then cut from ten days to only two. Dian busied herself with shopping and planning—helped enormously by Joan Root who had considerable experience of living in the bush for long periods of time. Dian named her Land Rover "Lily" and learned how to drive it, as she described to her parents on New Year's Eve.

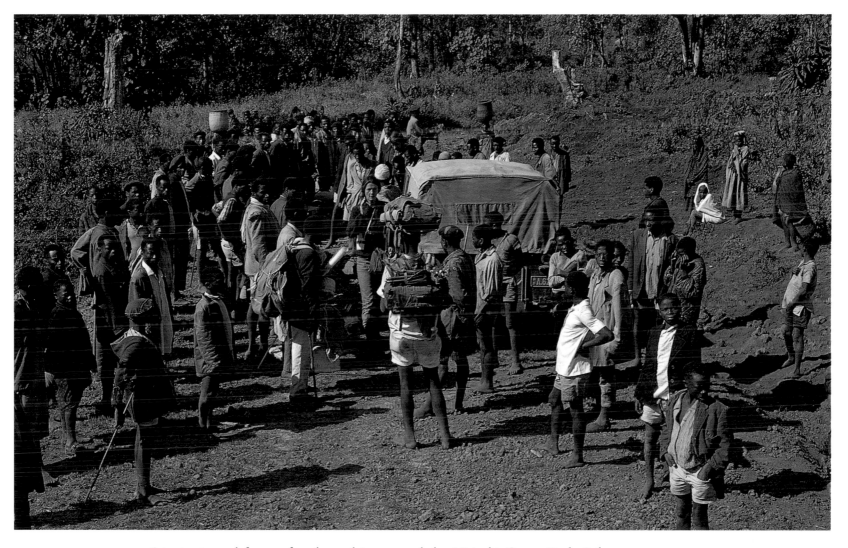

I just returned from a four hour drive around the Nairobi Game Park. I drove my very own Land Rover! Dr. Leakey bought it for me last week and it was delivered today along with a non-English speaking "boy" to teach me how to drive it. What a way to learn how to drive! Stripped gears Swahili style. He gave instructions a mile a minute so I had to constantly stop the car and get out the dictionary to understand what he was saying.

I will drive this Land Rover to the Congo in consort with Joan and Alan Root, the couple I met there before. They will stay there a while until everything is running smoothly. They have been really nice as have everyone else. I feel like I have known Jane

ABOVE Local men gathered round Dian's Land Rover in the hope of porter work up the mountain. The Land Rover was a gift from Louis Leakey, and Dian named it "Lily."

Goodall (the chimp girl) and her husband all my life—everyone has done so much for me and helped me out a million times without my asking. I must have met at least 50 or 60 people by now … all intent to come up to "the mountain" in the near future.

I will be going to Tanzania on Tuesday for two days … it is certainly not the length of time I'd hoped to spend there, but we have covered every aspect of [Jane's] field work during this past week and I have also read her thesis and had detailed instructions in plant pressing, reading a complex compass, registering longitude and latitude and operating the various stoves, lamps, etc. Leakey gave me a book of blank checks, drove me down town, pointed out some stores and left me to outfit myself! I must say, this was an experience equal to the driving lesson. According to my friends, I was too miserly, but it really bothered me to spend so much money. Honestly I think I'm well supplied and equipped—time will tell ….

January 1967: the next phase of Dian Fossey's great adventure was beginning. Alan Root led the way in his own Land Rover, while Dian followed close behind in Lily. They traveled northwest 700 miles (1,000 kilometers) through Kenya and across Uganda to the southwest of the country, where they stopped at the Traveller's Rest in Kisoro. Walter Baumgartel welcomed them warmly, delighted to see Dian again. But he was horrified to discover that Alan was taking Dian across the border into the Congo and tried to persuade them to seek an alternative research area in a less risky place. He had seen many whites leave the region because of the dangers posed by fighting and political uncertainty; setting up camp there to study mountain gorillas seemed like madness. Dian may have been exercising her characteristic obstinacy or displaying a grave ignorance, but either way, she was not to be deterred. Alan and Dian drove on toward the Ugandan border along mud roads, negotiating treacherous ravines and goat trails. At the border Alan helped Dian gain the documents required to enter the country and pass through numerous customs posts and police barricades. He also managed to get Dian the papers she would need to begin her study in the Albert National Park. Alan's experience was invaluable, and it is hard to imagine how Dian could have even entered the Congo without his help.

At the foot of Mount Mikeno, a small group prepared for the ascent: Dian and Alan Root, two Congolese park guards, and two camp staff. Alan employed several dozen porters to carry the camping equipment and stores to Kabara Meadow, and off they set on the 4,000-foot (1,200 meter) climb.

Alan took control of the camp immediately; he had only two days to get Dian organized, and he did not take the responsibility lightly. He supervised the digging of a latrine and drainage ditches, he placed water-storage barrels around the camp, then he showed Dian the basics of camp life. He took her into the forest and gave her a crash course in tracking wildlife: following spoor (signs of an animal's recent presence) and trails of broken vegetation. They were not lucky enough to see any gorillas, but they could hear distant vocal interchanges between two gorilla groups. Then the time came for Alan to leave Kabara—Dian briefly panicked, but her eagerness to get out into the forest and start her work soon drove away feelings of isolation and fear. The gorillas were waiting

RIGHT There was no easy way to and from the camps, either at Kabara or later at Karisoke, and Dian relied on local porters to carry her equipment up and down the mountain.

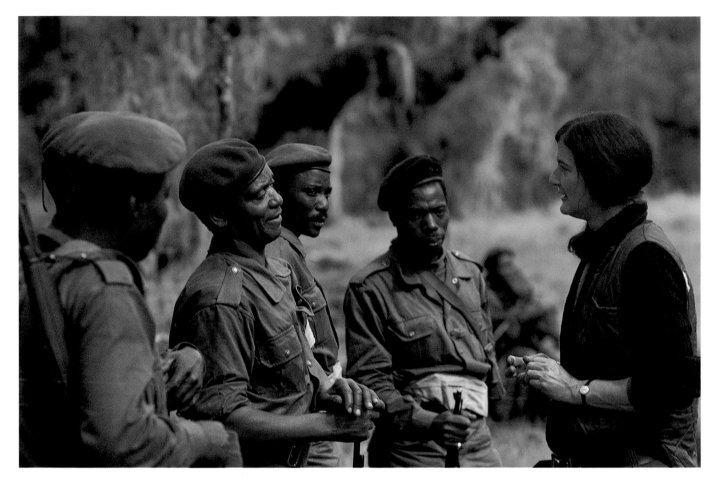

ABOVE Dian in conversation with Sanwekwe, the tracker who became a trusted companion and guide. This picture was taken at a chance meeting, several years after Dian had left the Congo, when Sanwekwe was a member of the Congolese Ranger patrol.

Shortly after her arrival at Kabara, Dian was joined by Sanwekwe, the guide who had helped the Roots track gorillas in 1963. He had also assisted George Schaller in 1960 and, as a boy, Sanwekwe had even accompanied Carl Akeley on his hunting expedition to the Virungas: he was highly experienced and capable. Sanwekwe shared his knowledge of the gorillas with Dian, and she quickly learned how to find and follow gorilla trails on the slopes of Mount Mikeno.

By the end of January, Dian had achieved 24 hours of gorilla study. She had identified and named one family group—Group 1—and made extensive records of its activities. Every evening Dian would sit in her damp, dark tent, hunched over her typewriter— paperwork was to be the bane and backbone of Dian's life in the field. She was meticulous in her habit of typing up each day's notes, which covered everything from weather

conditions to poaching activities and, of course, detailed accounts of the behavior of every gorilla she observed.

Dian's living conditions were basic; she slept in a seven-foot by ten-foot tent, which housed her bed, her papers, drying clothes and all her belongings. Meals were prepared in a nearby ramshackle cabin where the staff also slept. The men ate sweet potatoes, beans, corn and vegetables, but Dian shunned this diet, preferring tinned spam, corned beef and hot dogs. Dian disliked vegetables and claimed to be allergic to fruit.

Once a month Dian drove for two hours to Kisoro, in Uganda, and stocked up on camp supplies. Tobacco for Sanwekwe's pipe and cigarettes for herself were always high on the shopping list. Fresh eggs were supplied by Dian's hen, Lucy, who was prolific in her output. Lucy and her mate, Dezi, were given to Dian by Sanwekwe, who fully expected them to be fattened up and roasted. Instead they became Dian's first and much-loved camp pets.

GRADUALLY DIAN BECAME ACCEPTED by the gorillas she encountered; she had learned from George Schaller's book that it was important to remain visible to gorillas in order to gain their trust. She developed this bond further; she began to mimic their feeding and scratching activities, and copied the murmurings—vocalizations—of contentment that

BELOW The chickens Lucy and Dezi, two of the original camp pets, who later went with Dian to the new camp in Rwanda.

they made. Dian called these encounters "open contacts" and the process of habituation that she began in Kabara was largely dependent on these. Dian also chose to observe the gorillas while she was concealed from view; she was confident that, in this situation, she was able to watch and record behavior that was not altered owing to her presence.

On one occasion, Dian and Sanwekwe inadvertently startled two gorillas: a silverback and a female. The gorillas screamed, roared and then charged the pair who stood fast, expecting the charge to be a bluff as they commonly are. But

OPPOSITE The silverback leader of Group 5, Beethoven, showing the distinctive nostril shape and pattern of lines on his nose, which Dian used for identification purposes.

as the furious beasts pounded toward Dian and Sanwekwe, baring their fangs, it became obvious this attack was for real. A last-minute dive into the bushes saved Dian and the tracker. The gorillas plowed past, crashing through the undergrowth, carried by the force of their own momentum.

After six months at camp, Dian was settled into the lifestyle and had become a confident and competent tracker. She had been able to identify many individuals, even though gorillas are so similar that it can be difficult even to distinguish young males from females. Dian followed George Schaller's example and used the pattern of lines on a gorilla's nose and the shape of its nostrils to identify each individual. Dian gave the gorillas names, a practice that obviously amused her; she called one teenage male Alexie.

There was little time to relax away from the mountain, but when the opportunity arose, Dian welcomed it gratefully:

Congo: June 6, 1967

Dear Mother and Father,

Well, I'm back up on my mountain after a really wonderful relaxing trip down this last time thanks to my friends [who had] to entertain some VIPs that had flown in from Belgium. One was a Prince (truly a Prince), one was Belgium's leading architect, one a writer and the fourth just a count. On the First, they had a scrumptious luncheon with about twenty white people from Goma and afterward had the Watutsi dance troupe, the group that toured America, come to their home and dance for at least an hour.

The next day we drove to Rwindi, which is the camp site of the Prince Albert Park, and, considering that it's run by Africans, it is very attractive and clean. We took the dusk tour around the watering places and saw hundreds of animals on an almost perfect evening before enjoying a long and leisurely dinner. The next morning, somehow, we were up at six for not so delicious breakfast—the Belgians left the Africans with the horrible inheritance of strong cheese, rancid meat and hard bread for "tropical European breakfast." While we were eating a Land Rover and bus drove up with thirty four American children and four American adults. I was completely stunned!!! You'll never know what a thrill it was for me to hear all these American voices and I was seriously inclined to kidnap a couple of the children

... I went on to Kisoro the late afternoon of the Third, picked up my mail, did my

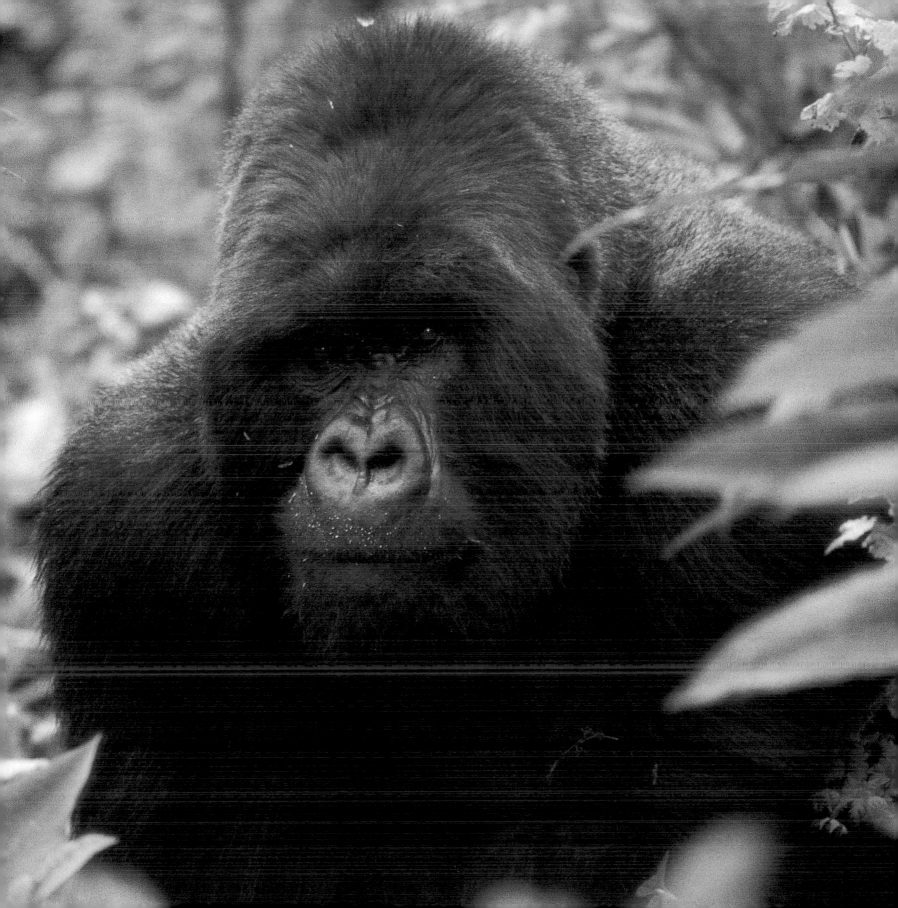

shopping and spent another nice evening in the company of people staying at Traveller's Rest who spoke English. For some reason, and bewilderment not conceit prompts this remark, everyone seems to know all about me and my task. This includes blacks as well as whites from the Southern Sudan to West Africa thus far, and I'm at a loss to know how the information has been spread. Even Alan Root wrote from Nairobi, and in a somewhat chastizing tone told me that everyone he met in Nairobi were full of questions about the American girl who lived up on the Mt. and studies gorilla. I find it very difficult to believe that people are that curious about someone they know nothing about, but maybe it is so

... Must close, with love.
Dian

Back at camp, Dian began to experience difficulties with her African workers. They had become unreliable, uncooperative, and often disappeared for days at a time, leaving her alone, vulnerable, and lonely. She wrote to Louis Leakey, requesting his help.

Coping with recalcitrant staff soon proved to be an irrelevance. Dian had never been interested in local politics, but she was about to be forced to take notice. On July 7, 1967 Dian received a letter from the park director, Anicet Mburanumwe, who had sent armed

guards and porters to escort her off the mountain. White people were no longer welcome in the Congo.

AT THE BEGINNING OF THE TWENTIETH CENTURY the ironically named Congo Free State—a vast Central African country—was ruled as a personal fiefdom by King Leopold II of Belgium. During his rule an estimated ten million Congolese died from starvation, genocide, or as a result of slavery. Human rights abuses on a massive scale had produced international condemnation, and Belgium was forced to make the country a colony.

Fifty years later huge riots had prompted Belgium to decolonize rapidly. In 1960, without a properly organized and coordinated handover, the country celebrated independence and was plunged, almost immediately, into anarchy. Soldiers mutinied and embarked on an orgy of rape and murder aimed mainly at the European population.

By the time Dian had come to the Congo, President Joseph Desire Mobutu (later known as Mobutu Sese Seko) was in power. The army was still prone to mutiny, so the president had brought in white mercenaries, known as the White Giants, to train the soldiers and keep them in check.

On July 2, 1967, the White Giants turned on the Congolese army, killing without mercy. On July 5, President Mobutu broadcast a warning to the nation that foreigners—white people—were trying to take over the country. A state of emergency was declared, and the borders were closed.

After receiving Mburanumwe's letter Dian had no choice but to break camp, and on July 10, she headed down the mountain to Rumangabo, where she was detained by the military. On July 26, Dian escaped from the Congo to the safety of the Traveller's Rest and from there to neighboring Rwanda. She was later to maintain that she was the last white person to leave the country alive during that period of unrest.

When the American Embassy staff in Rwanda subsequently questioned her about her ordeal, Dian admitted to losing many of her possessions and camp gear but maintained that she was not physically abused in any way. Years later, however, she told several trusted friends and confidantes that she was kept in an open cage and repeatedly raped. The truth of this version will never be known, "unless," as Bob Campbell (the photographer who later worked with Dian in Rwanda) now says, "there are men still alive who were in Rumangabo at the time Dian was there, and who could be questioned." Dian certainly never spoke of being raped to Bob, nor to Rosamond Carr, one of her closest friends in

Rwanda. In her autobiography, Rosamond says that although there were rumors of a gang rape, Dian herself denied them, saying enigmatically "I think they were saving me for their Major."

There is no doubt, though, that Dian had a traumatic and terrifying time in Rumangabo, where drunken soldiers rampaged through the streets. Dian had no idea how, when—or even if—she would escape. Whatever happened during those days in captivity one thing is certain: Dian displayed great courage in putting the events behind her. In her next letter to the Prices, written on August 2, 1967, she gave no hint of the desperate time she had had, but she did make it clear that she had absolutely no intention of giving up and going home.

Dr. Leakey flew me to Nairobi yesterday—am here trying to figure out next move …. … Will probably go to Rwanda to work on that side for about 5 months if we can work everything out. If there are no gorilla there then I'll go to Spanish West Africa as the Lowland Gorilla study there is no good.

Everything is fairly jumbled up now to put it mildly. Will write more when I know more.

ABOVE An excited note from Dian in Kenya to her parents about her plans to work in Africa, dated August 2, 1967.

While briefly in Rwanda, en route from the Congo to Nairobi, Dian made contact with Rosamond Carr, who owned a plantation on the slopes of Mount Karisimbi. Dian was convinced that by establishing a base at Mrs. Carr's plantation in Mugongo she could continue studying the gorillas.

Although they were to become firm friends, their first, brief, meeting—just after Dian's escape—left Rosamond mystified by the younger woman. Dian had appeared wearing a beautiful lilac linen dress and filthy tennis shoes, her thick hair plaited and worn loosely over one shoulder. As soon as they sat down to eat, Dian pulled out a long list of

questions about the plantation and Rwandan gorillas and proceeded to interrogate Rosamond; she had no interest in pleasantries or small talk. Rosamond told Dian there were no gorillas on her side of the mountain but failed to convince her. Rosamond, and others present, concluded that this brash woman was "quite peculiar."

Notwithstanding her reservations about Dian, Rosamond agreed to supply whatever help she could and decided to introduce Dian to Alyette De Munck. Alyette had been brought to the Congo by her Belgian parents when she was only five years old. She was an adventurer, explorer, dedicated naturalist, and—if that wasn't enough—she had also raised seven children. After independence Alyette and her husband, Adrian, were robbed and harassed many times by soldiers and eventually decided to leave the Congo and establish a plantation in Rwanda, near Mugongo. Alyette's husband had died suddenly in July 1967, and Rosamond thought that these two headstrong women might find support and help from one another in pursuit of a common interest—animals.

Her intuition was accurate: the two women met in Nairobi and instantly formed a close bond that was to last for years. Alyette introduced Dian to her son, her nephew and a college friend of theirs who were on safari. Alyette was planning on going ahead to her plantation to prepare it for the boys' arrival; they would follow on in a few days. Tragically, they never arrived. After dining at the Traveller's Rest in Kisoro, the boys set off on their journey, but instead of taking the same road as Alyette, they took a more scenic route through the Congo at a time when, as Walter Baumgartel described it, "all hell was breaking loose." The three young men were arrested as "white mercenaries" and killed by the Congolese military.

When Dian arrived at Mugongo, Rosamond gently broke the tragic news to her. Rosamond later described Dian's state of mind at the time as "on the brink of nervous collapse." The ruthless execution of the boys brought home to Dian how close she had been to death while detained in the Congo; it was almost the final straw. According to Rosamond, Dian went wild after hearing the news, screaming at the houseboys and gardeners on the plantation and offering them money to go and find the murderers. Rosamond began to realize just how deeply scarred Dian had been by events in the Congo and believes it was at this time Dian began to develop "an unfavorable opinion" of Africans.

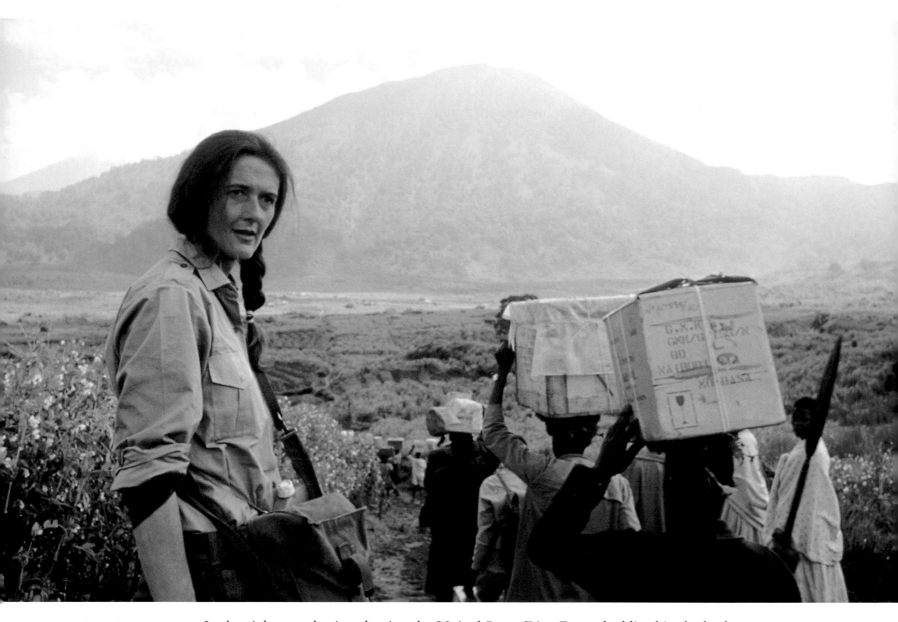

ABOVE Dian embarks on the next phase of her adventures—pausing near the base of Mount Visoke, before facing the steep climb to where she would set up camp.

In the eight months since leaving the United States Dian Fossey had lived in the bush with minimal support or companionship, been forcibly removed from camp by armed soldiers, detained, and possibly raped. She had, by her own ingenuity, escaped from an extremely dangerous situation and was preparing for a fresh start with new friends when this latest disaster struck. Dian offered all the comfort she could to Alyette, while shouldering her own grief and despondency.

The two women, both strong-willed and determined, focused their energies on establishing the new research camp. Dian quickly discovered that Rosamond was right: there

were no gorillas on her side of Mount Karisimbi. The quest continued and Dian found an ideal vantage point from high on Karisimbi's alpine slopes. From here she could see the entire range of Virunga mountains, swathed in the persistent mist. Dian spotted a saddle of gently rolling terrain between Mount Karisimbi and Mount Visoke and realized it was ideal gorilla country and a perfect spot for the new base.

Alyette was instrumental in helping Dian establish the Rwandan research station; accompanying her on exploratory trips and translating for her when necessary. Together the two women set up the new camp at 4.30 p.m. on September 24, 1967. Two tents were erected, one for Dian and one for her staff. The camp (first called Campi ya Moshi—Smoky Camp—but eventually named Karisoke Research Centre, after the two mountains it nestled between) represented a new beginning for Dian. She was to remain there, on and off, for the rest of her life.

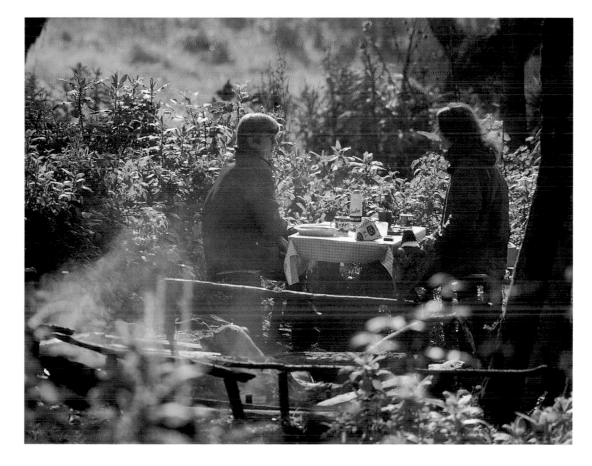

LEFT Dian and Alyette De Munck enjoying breakfast together at the new camp in Rwanda, which was later christened Karisoke.

The Camp at Karisoke

The events in the Congo had, naturally, caused great concern to Dian's family back home in the States. Dian had been in irregular contact with her father, George Fossey, since 1959, and when he heard about the uprising he had contacted Louis Leakey to enquire about his daughter's welfare. Alexie Forrester had received a letter from Dian and was sufficiently worried to meet up with Kitty and Richard Price. They decided that Alexie would go to Rwanda on a "rescue" mission. Alexie's plan was to bring Dian home and marry her.

The meeting took place in New York at the end of September 1967, just after Dian and Alyette De Munck had set up camp below Mount Visoke. While Alexie was picking out an engagement ring, Dian was beginning the next stage of her research into the lives of the mountain gorillas. She had long since abandoned any thought of a relationship with the handsome Rhodesian—but it took a trip out to Rwanda for Alexie to be, finally, disabused of the idea.

At the time of Alexie's visit, Dian was established at camp but also kept a base down the mountain, courtesy of Alyette. The meeting between Dian and Alexie at Karisoke on October 9 did not go well, and he was quickly sent packing. In the aftermath, Dian had to write a conciliatory letter home to her mother and stepfather.

I am deeply grateful to you both for the love that prompted your action in regard to Alexie's request. I realize this involved sacrifice, inconvenience and was upsetting as well. I can only say in all sincerity that I fully regret the unpredicted results my confidences have cost both of you—emotionally and financially. It does not seem right to me that you both should have to bear the consequences of my own inability to perceive or predetermine the immature, selfish and highly over-dramatic reactions of people I considered trustworthy.

Dian's letters to her mother and stepfather frequently served a conciliatory purpose: Kitty and Richard Price were apprehensive about Dian's choice of career. Many of her letters

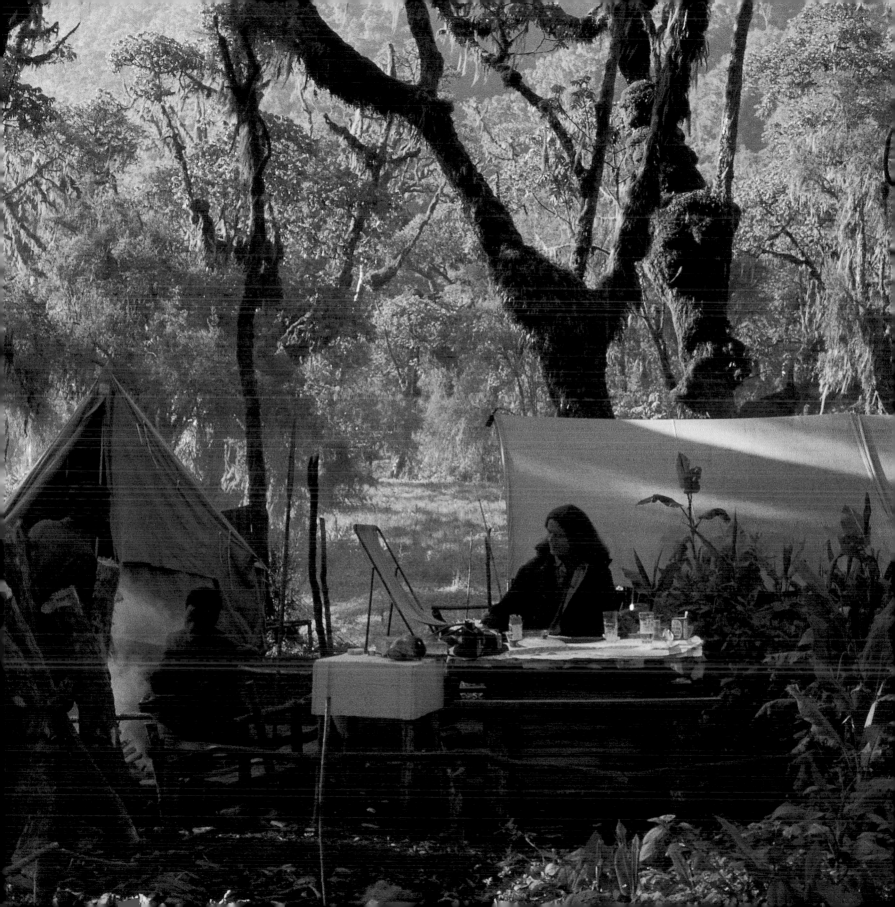

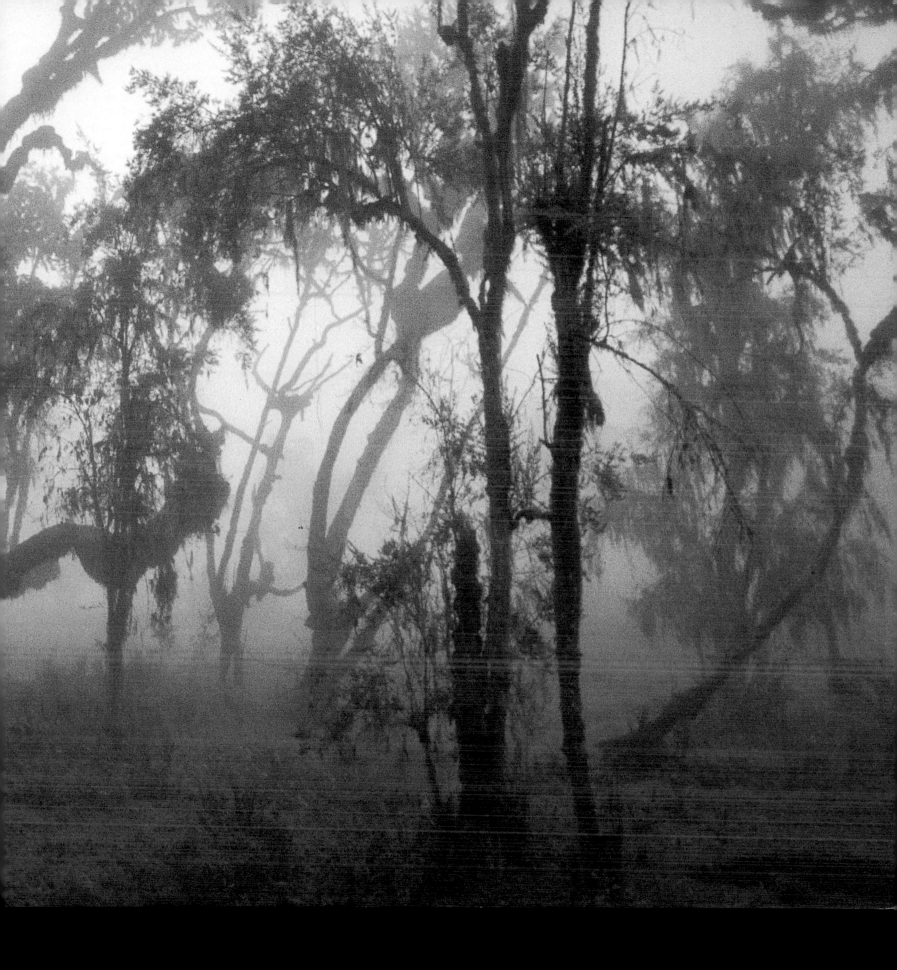

are filled more with her comments on their mundane news than with details of her own, more exciting days. She often painted a rosy picture of her camp when she wrote to them, presumably to soothe their worries. Occasionally, her descriptions bordered on fantasy:

My work is continuing under very favourable circumstances on the Visoke Mt. in Rwanda. There is absolutely no danger here of any kind and camp life is too ideal to be true compared with the Congo. My tent is perched right above a rocky, fern-covered bubbling creek in the middle of a flower-filled meadow that goes on for about three miles between the two volcanoes of Visoke and Karisimbi. I can see all 3 volcanoes from my tent—Mikeno, Visoke and Karisimbi—and the view is so beautiful, I don't know where to look first. The meadow itself looks like an English park with all the huge moss-laden trees and the lovely brooks, deer [actually antelope—there are no deer in sub-Saharan Africa] *and elephant seem out of place. The slopes of Visoke are teeming with gorilla all the way down to the outskirts of the villages below—this will be the first time a survey has been done here simply because no one thought there were gorilla here. I must say it is good to get back to work again.*

Also, aside from the unbelievable beauty of the surroundings, my physical set-up is vastly improved. I have fresh meat every week, along with bread, cake and all kinds of goodies … friends bring up personally. In all the time I was on Mikeno, people were only able to ascend twice, but here, due to the accessibility of my camp, I have company about every five days—a little too often I'm afraid. I also have a real bed, courtesy of Madame De Munck, lots of tables and chairs, a hammock and so much "luxury" equipment I hate to leave camp in the morning! Although there is no hut here, I can do all my cooking and most of my writing outside because there is no wind and the weather is quite pleasant—most unlike Mikeno.

The accessibility of Dian's camp to visitors ("idle rubber-neckers" was her term for them) became a recurring theme; she greatly resented the intrusion and distraction caused by people (who often invited themselves) staying at Karisoke. They would expect to be taken to see the gorillas, which cost Dian valuable research time, upset her routine, and caused her great frustration; she had always been a solitary person, and even when the cabins were built, she sometimes had to resort to hiding under the table when tourists, cameras at the ready, peered through her windows.

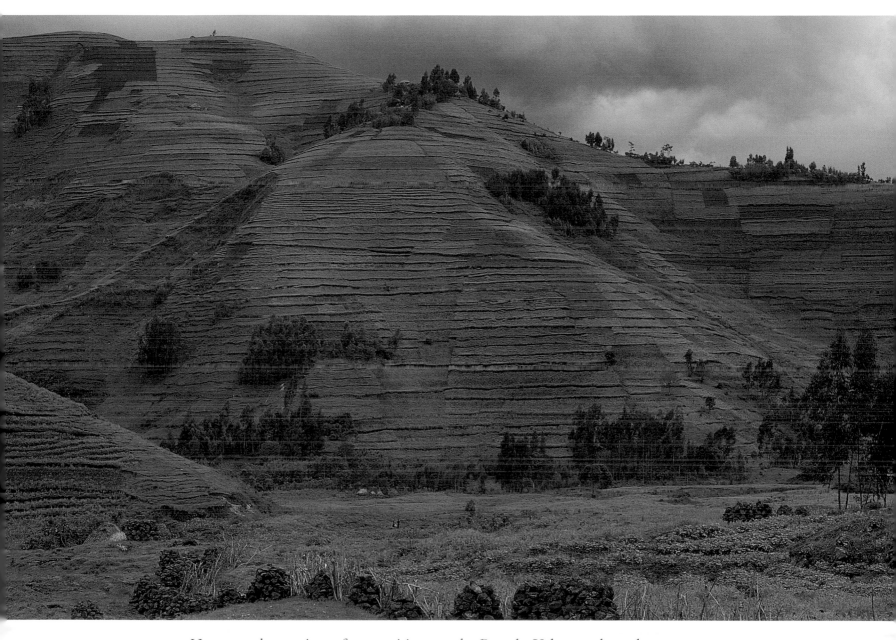

However, the motives of many visitors to the Parc des Volcans, where the camp was situated, were not so benign. Dian was horrified to discover that, although the park was meant to be a refuge for its dwindling population of mountain gorillas, its boundaries were meaningless to the local Watutsi people. Rwanda is a tiny but hugely overpopulated country and any available land is, unsurprisingly, exploited by farmers to earn a meager living. Cattle were regularly illegally herded through the forest, crushing the vegetation and driving the gorillas higher up the mountain slopes.

ABOVE A typical Rwandan landscape, showing intensively cultivated steep hills with anti-erosion contour ridges.

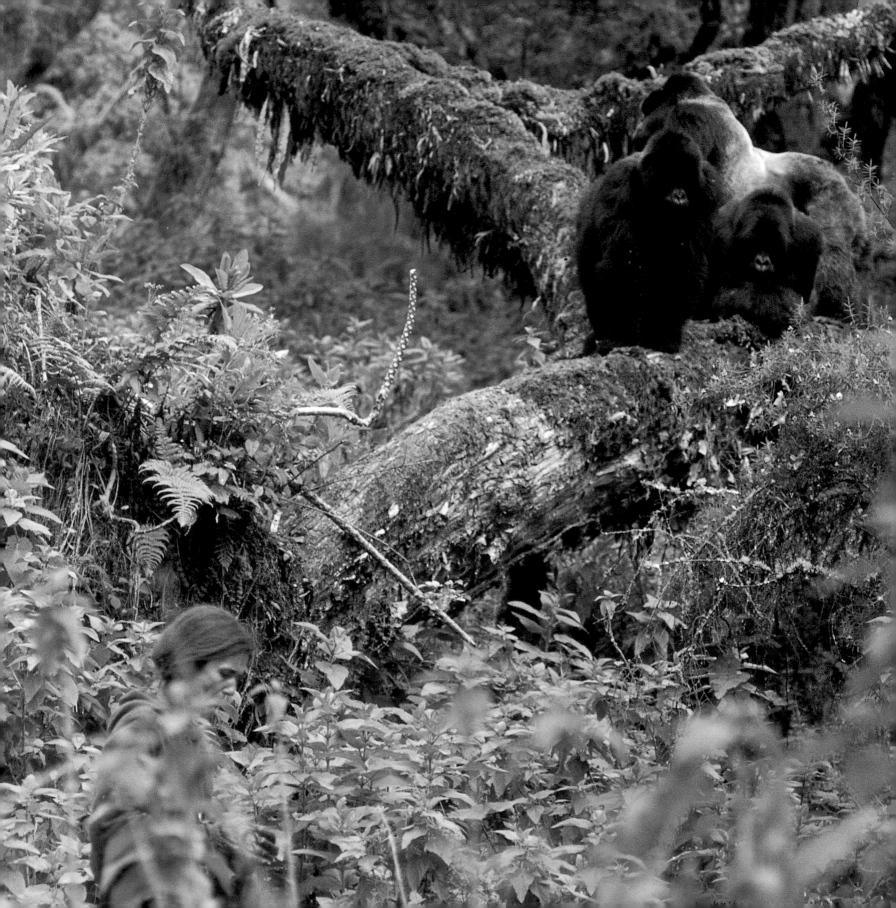

The Batwa people had been hunting hyrax and antelope within the forest for centuries, and continued to do so once the region became a national park; their wire snares were responsible for maiming and killing gorillas. Then there were the poachers, who sought gorillas for private collectors, zoos, or for trophies: European and American tourists were notoriously fond of souvenirs made from gorilla body parts, and traditional African "sumu" (a kind of black magic) sometimes called for parts of dead gorillas.

Dian adopted a "zero tolerance" policy toward intruders in the park. She determined to enforce the boundaries and cut snares despite fierce condemnation from her good friends Alyette De Munck and Rosamond Carr. These women had lived in the region virtually all their lives, and they argued that it was wrong to deny these people their livelihoods. Dian conceded that "Africa belongs to Africans," but always remained inflexible on the question of the park. There were laws to protect the precious habitat from any such infringement, and she was going to see that those laws were enforced.

Dian harangued the staff at L'Office Rwandais du Tourisme et des Parcs Nationaux (ORTPN)—the government department that was responsible for the Parc des Volcans—and eventually a commitment was made to increase armed patrols of the area and enforce the boundaries. It was a small, insignificant step; the guards only patrolled once a month or so, and if they encountered poachers, they could easily be bribed—or beaten up. Local government officials were not interested: live gorillas were of no use to either the local community or the national economy. Spending precious money to protect them at the expense of the farmers was seen as pointless at best and counterproductive to any political aim at worst.

DESPITE THESE PROBLEMS, Dian threw herself into her work. While at Kabara she had encountered and named three groups of gorillas: Groups 1, 2 and 3. During her first year on Mount Visoke she concentrated on four main groups: 4, 5, 8 and 9, occasionally encountering other, fringe groups. (Groups 6 and 10 were fringe groups, and Group 7 was a mistake—a failure to recognize members of Group 5 who had been feeding apart from the others.) Tracking the groups would involve following the gorillas' knuckle-prints in the soft earth, and finding trails of vegetation that were bent and squashed in the direction of the gorillas' travel.

The textbook advice on observing primates, including gorillas, was simply to sit and watch, but Dian had learned at Kabara that any animal being observed by an alien

OPPOSITE Dian imitates the feeding motions of the gorillas, watched by members of Group 8—Peanuts, Samson, and the silverback Rafiki.

ABOVE Typing up notes in the first cabin at Karisoke, helped by pet monkey Kima.

creature was unlikely to act naturally. A trusted and accepted "insider," however, could be part of a group and therefore study it without affecting normal behavior. Dian developed the habituation techniques that made her presence acceptable to groups of gorillas. After carefully approaching a group she would find a suitable position to sit and observe—a site that enabled the gorillas to see her as she imitated their feeding and self-grooming activities. She copied some of their vocalizations, particularly their deep-throat rumbling sounds, which appeared to indicate a state of contentment or satisfaction; she called these "belch noises." Using these unconventional techniques Dian was able to partially habituate four gorilla groups by the summer of 1968, and had given names to many of the fifty-four individuals contained in them.

Alyette De Munck had continued to support Dian, and during the early part of 1968 she built a cabin at Karisoke. It was made of timber posts and corrugated sheet metal and, by February 1969, boasted two rooms, yellow curtains, rush matting and a very effective wood-burning stove in each room. Dian loved the evenings at camp and later described how buffalo and a lone elephant would gather nearby, apparently drawn by the sight of the campfire. They would drink at the creek then mosey through the camp and on to the meadow, snorting and bellowing as they went.

In the summer, the photographer Alan Root joined Dian at camp for a brief reconnaissance; he had been commissioned by the National Geographic Society to create ciné film of Dian with the gorillas and take still photos suitable for publication in their magazine. National Geographic was Dian's main sponsor at Karisoke, and the Society's financial support was essential for the continuation of the research project. Alan was accompanied by Professor Robert Hinde of Cambridge University, who had come to observe Dian's research. Dian had been accepted as a postgraduate student at Cambridge; she did not have any formal qualifications in zoology, and for her research to be taken seriously by the scientific community she would need proof of sound academic study.

Professor Hinde was keen to embrace the work at Karisoke. By helping Dian achieve

her doctorate he would, he hoped, be able to send other research students out to Rwanda —this would be a real coup for the university. Both Alan and Professor Hinde were critical, however, about Dian's methods of data collection. It was apparent to them both that, although the potential for a long-term study was great, it would need to be conducted properly. And that meant Dian would have to be trained as a behavioral scientist.

PRIOR TO ALAN ROOT'S ARRIVAL AT CAMP, Dian had been preparing to go to the United States, her first visit home in two years. The trip would take in a stop in Nairobi, so Louis Leakey could catch up on her progress, and England, where she would meet Robert Hinde to discuss the doctorate. She would then go to Washington to visit the Research Committee of the National Geographic Society and discuss future funding of Karisoke. When the chores were all done, Dian would be free to visit her friends in Louisville, and the Prices in California. High on her list of "things to do" was sorting out her teeth. Plagued by toothache she had been desperate to return to the States as much to visit a good dentist as to see her mother and stepfather. Dian delayed her trip in order to be with Alan Root while he planned his photographic assignment at camp. In return, he offered to find someone trustworthy to supervize camp work while Dian was away; failing that, he offered to provide cover personally.

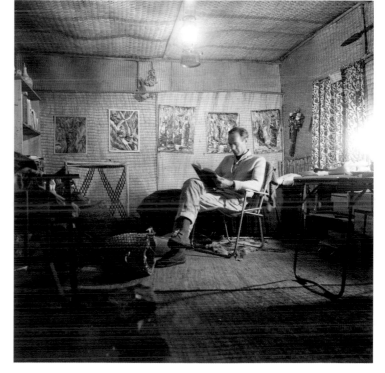

BELOW Bob Campbell relaxing in the cabin during his caretaker period at camp in 1968, before the second room was added.

After his preliminary visit to Karisoke, however, Alan Root traveled to Meru National Park in Kenya. While filming there he was bitten by a puff adder. Thankfully, Alan survived what could have been a fatal bite, but he was out of action for a considerable time as a result. Aware of his obligations to Dian, Alan asked his friend Bob Campbell to consider staying at Karisoke during Dian's absence. Campbell was a respected and experienced photographer and filmmaker, and he was on a break from his current assignment: he had been working at archaeological excavations in northern Kenya with Richard Leakey, son of Dian's patron Louis. Bob leapt at the unique opportunity to film wild gorillas.

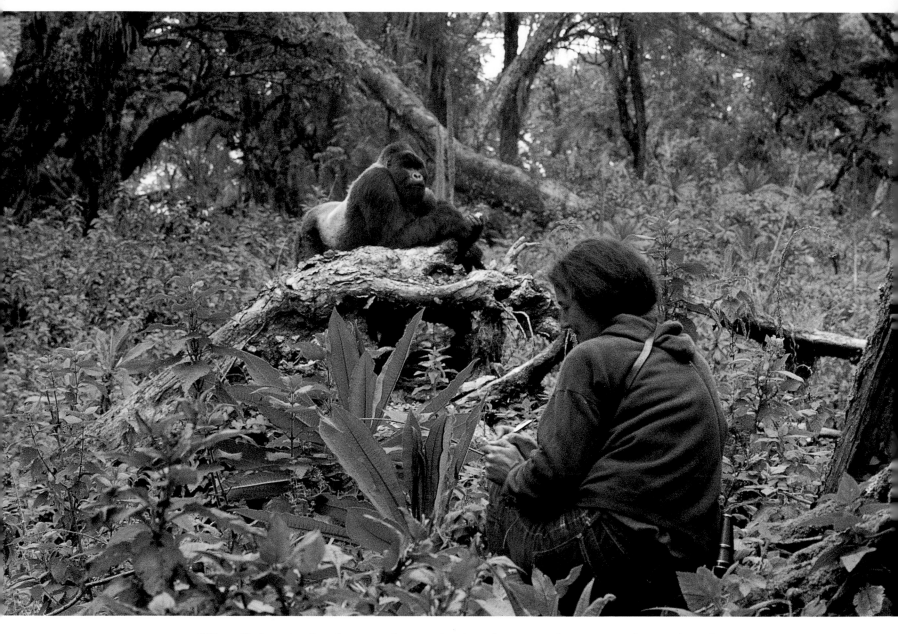

ABOVE Rafiki, the silverback leader of Group 8, shows no concern as Dian observes his behavior.

When Bob arrived at the camp he was intrigued to meet the woman about whom he had heard so much. Dian's greeting was as cool as the chilly mountain air, and as the clouds began to gather that evening, the photographer established himself in one of Dian's now old and rotting tents and went straight to bed.

The next morning, Dian took Bob into the study area and across the invisible border into the Congo; they were tracking Group 8—a collection of four immature males led by the large male silverback, Rafiki (meaning "friend"). This group, having no youngsters or

females to protect, had tolerated Dian's presence in their vicinity; Dian showed Bob how she would settle close to the gorillas and, from a safe distance, observe their behavior. Climbing a tree often gave her a better vantage point since the dense foliage often obscured gorillas when viewed at ground level. Bob Campbell quickly discovered that his camera and film equipment were ill-suited to the working environment: little light penetrated the moss-laden *Hagenia* canopy, and the thick, black fur of the gorillas was hard to pick out among the shadows. Bob realized the assignment was going to be more challenging than he had expected, but now that he had seen the elusive gorillas for himself, he was impatient to get started.

The pair tracked gorillas again the next morning, returning to camp as the mail arrived; there was a cable. When Dian emerged from her cabin some time later she was red-eyed and clearly upset. Eventually, she told Bob that the cable bore the news that her father, George Fossey, had committed suicide. Bob made himself scarce, and Dian, once more struck by tragedy, coped on her own. It appears that she never discussed this event with anyone. The following morning, she left Rwanda for her trip home.

ONCE BACK AT CAMP, in November 1968, Dian began a regular correspondence with Bob, who had returned to his home in Nairobi, apprising him of news and events. In November 1968, she wrote:

Group 5 has completely accepted my presence without hardly any response behavior on the days they are aware of my presence. However, their range is so dramatically altered that I've been trying to remain obscured on most contacts so as to observe completely normal behavior. They have been zig-zagging across the main foot trail from Kinigi, remaining in the saddle zone for the past seven days and nesting in the same area for two nights at a time. On the one day when there was partial sun, they traveled a good mile and a half toward the foothills belonging to Karisimbi (Group 10's route) before turning around and

BELOW Members of Group 5, including Bravado, who became one of Dian's favorites.

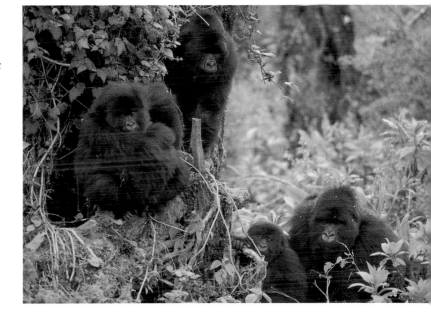

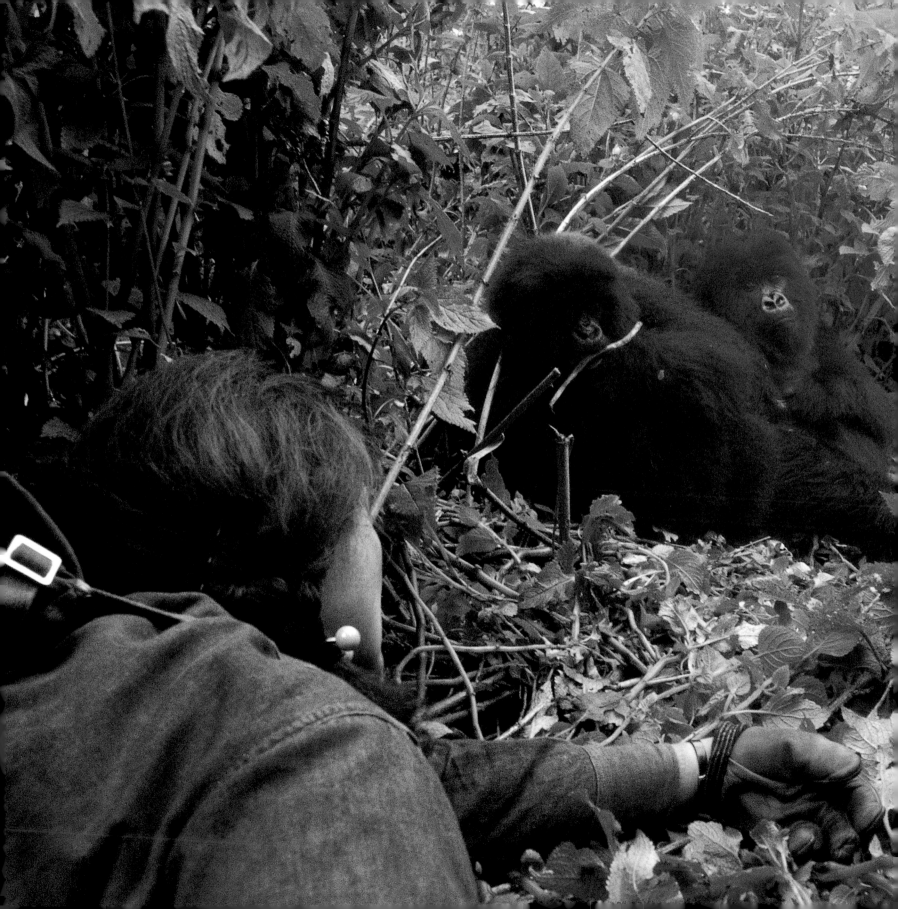

crossing the meadow! What I wouldn't have given to have seen that.

Since the 17th, there has been continual rain and fog here from morning until night without let-up, thus observations have been hampered of Group 5.

Dian complained once again about visitors to the camp, who "besieged" her. She greatly resented the time she felt obliged to spend on cooking and caring for the comfort of these uninvited guests.

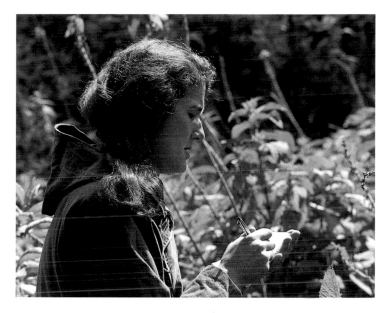

The next time she wrote to Bob, only four days later, she described the difficulties she was having in locating gorillas; she had only been able to find Group 5. She vented her frustration and fury on some poachers she blamed for disturbing the animals:

Yesterday was just horrid Bob as this group, a band of 15 poachers, their dogs and the buffalo they were tracking all came together at the same time. The poor gorilla just scattered in all directions, dropping almost buffalo type dung as they were chased away. I don't know when I've been so mad and went after [the poachers] with sheer hate wearing my gorilla type horror mask with a camera in one hand, a water pistol in the other and the tear gas cylinder in my pocket. I must say, the results were spectacular and they ran like hell, but by then the damage had been done, and I've been trying so hard to go slow and easy with this group so they will feel "welcome" and safe in this saddle area which they only use when the cattle are out of the area in the heavy rains.

As the number of gorilla groups Dian encountered increased, she became aware that she would need some help. One of the primary aims of the research project was to conduct a census of the gorilla population, but it was soon apparent that Dian would not be able to do this alone; her health was not good enough for long treks, and she also suffered from a fear of heights. Although Dian did not discuss these disabilities with Bob Campbell he could not help but notice how her work was affected by them. A census, nevertheless, was essential: Dian speculated that the gorilla population in three study groups had halved since Schaller's time in the region. If this was true for the wider population, then

the species was in grave danger of extinction. There was, simply, too much work for one person to do—especially when some gorilla groups proved elusive and there were poachers to deal with.

Dian had been concentrating on the four habituated groups closest to camp: 4, 5, 8 and 9, but she was in danger of over-extending herself. Groups 8 and 9 were located over the border in the Congo, at least one to two hours from camp. Group 4 spent half of its time over the border while Group 5 ranged on or below the southern slopes of Visoke. Locating a gorilla group could take hours, and even then observations would be difficult; the gorillas could only be seen intermittently in the dense foliage, and interesting pieces of behavior would be cut short or obscured as the individuals moved or shifted position. It is no wonder that when her all-too-many visitors interrupted this essential field research, Dian became gradually more difficult and uncooperative. She admitted to being rude to those who came up to camp knowing they were not welcome.

Rwanda: December 24, 1968

Dear Bob,

… I had one hell of a "tourist" today—and, an American at that. He showed up this morning to announce that I was to show him the gorillas; instead I pointed to the mountain and said, "help yourself." He said that he was prepared to spend several days here and would follow me when I next went out! I must say quite a heated discourse followed during which I insulted everything from his manhood to his mother, and he didn't exactly shower compliments on me either. It was quite a day for he and his porters were following false trails set by my men and finally gave up and left just before dusk. Heh, heh!

You won't believe it—it seems incredible even to me—but I have yet to see my beloved Group 8 or 9!!!!! Group 5 has been leading the most fantastic trail below camp toward Karisimbi and I don't dare leave them for one day which makes it impossible to finish with them and then go to the other side of the mountain to deal with Groups 8 or 9. I'm not all pleased with the situation but since it is a learning one there isn't much else I can do. In the meanwhile, they have become MUCH too accustomed to me especially the infants and juveniles who now approach ahead of the silverbacks in their playfulness. Unfortunately, this has had disastrous effects on the silverbacks who think

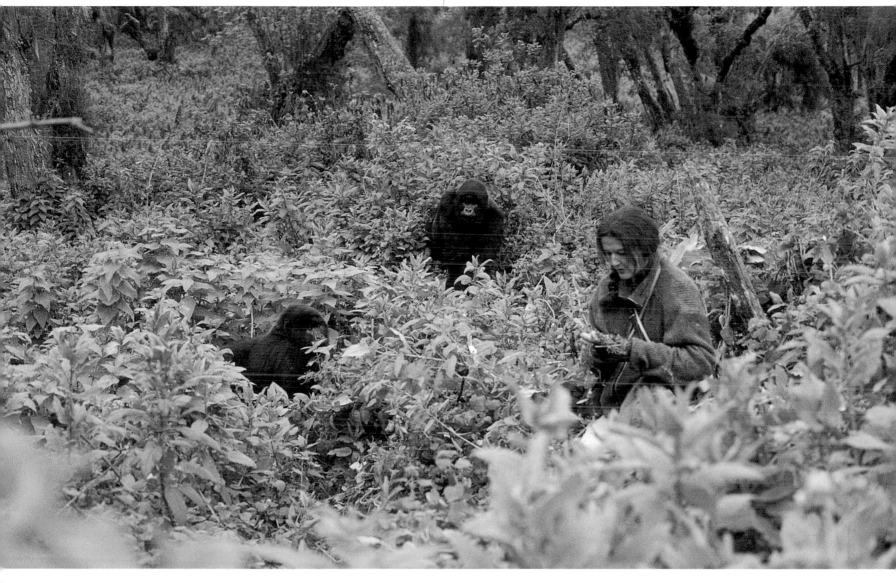

I'm about to kidnap their young and they have become *exceedingly aggressive*—something I never thought possible, but this has never happened before. Have had two contacts that I didn't think I would walk away from but keep going back for more since it is a new situation and unlike anything I've ever come across.

Am still having poacher problems galore but did something rather drastic yesterday so maybe things will quiet down for a while ….

Yours sincerely,
Dian Fossey

ABOVE Wary blackback gorillas, Peanuts and Geezer, half hidden by the thick nettles, watch Dian pretending to feed.

Friction between Dian and the poachers and cattle herders continued into the New Year and Dian, having discovered that drastic measures seemed to produce results, showed no restraint when her beloved boxer dog, Cindy, disappeared. She wrote to Bob Campbell in February 1969, making her confession.

So much has happened here Bob, it is difficult to know where to begin. On the 7th of this month Bambuti poachers kidnapped Cindy, but since I didn't know if it were Bambuti or Watutsi, I kidnapped 8 Tutsi cattle, built a string and pole corral and issued the proclamation that I would kill a cow each day until my dog was returned. (This kind of worried me for with my usual lack of forethought, I sealed the entrance shut with tin sheets and nails, thus had visions of the bodies piling up inside!) However, the Tutsi were concerned enough to come to our aid and led my men to the hidden poacher camp high on Karisimbi where Cindy was being held, thus she was recovered.

Dian told Bob how, once again, she had been searching for Group 9, but without success. She did, however, have memorable encounters with Peanuts, Group 8's youngest male, and members of Group 5.

The other day Peanuts took my French book, by chance holding it right-side up, and flipped through the pages more impressively than any African could. That same day he also tried to pull my boot from the tree which proved frustrating as I was wearing it and hanging onto the tree for dear life. Then after days of these exciting proximal contacts, they refused to have anything to do with me—I think they were just bored ….

I had a number of great contacts with [Group 5] as the young, both infants and juveniles, would leave the silverbacks and other adults to approach me, and this brought out the protective instincts in the silverbacks in a most threatening manner—bluff charges etc. There is also a mother with a new infant in that group who is not in the least shy thus affording good observations of new infant.

ABOVE Dian demands the release of her dog, Cindy, who had been kidnapped by Tutsis. In retaliation, Dian kidnapped eight of the Tutsi cattle.

OPPOSITE Peanuts, the youngest in the all-male Group 8, won Dian's heart by becoming the first wild gorilla to make physical contact with her.

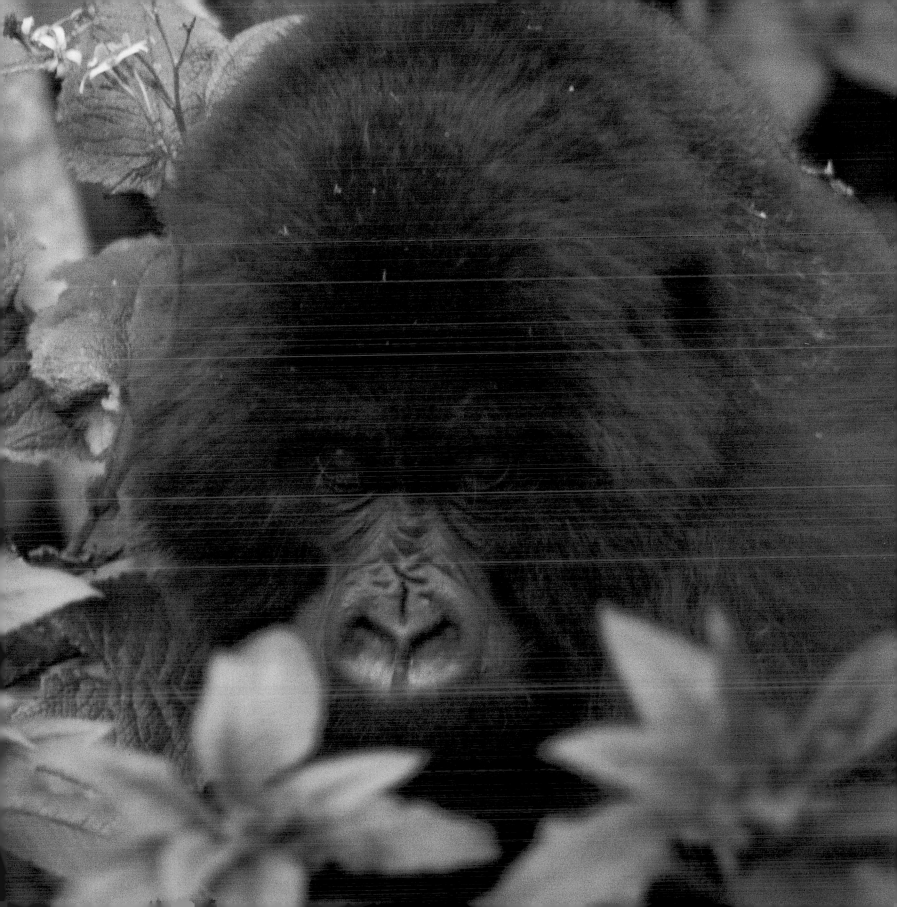

Meanwhile, Alan Root's injured hand had failed to heal properly, and it was clear that he was not going to be able to take up the photographic assignment at Karisoke. Unbeknown to Dian, Robert Gilka (Head of Photography at the National Geographic Society) contacted Bob Campbell and asked him to consider taking on the project on a "long-term basis." Bob agreed and arrangements were made, but perhaps owing to the slow and unreliable passage of mail between Africa and the United States, Dian had not been consulted about the choice of photographer, nor informed of the imminent arrival of a new census worker. The strain was beginning to tell in Dian's correspondence. She wrote to Bob Campbell on February 14, 1969:

I received your letter of the 5 some 20 minutes ago, so have let that much steam blow-off before writing to you—please believe that none of my wrath is directed toward you.
As you correctly surmised, I've not been consulted or informed about anything
I dislike enormously this "mother knows best" policy as exhibited by the N.G. and Dr. Leakey concerning my work of which they know next to nothing. It is quite one thing to "supervise" this work from a desk in either Washington or Nairobi and another to have mucked about in these mountains for two years. It would seem quite obvious from their closeted policy that I am only their lackey, a role I've never played well.

There was much confusion over the identity of the new census worker: Dian believed Louis Leakey had approved an American student to come and conduct the census, when she got a telegram telling her that Leakey was now sending someone else entirely—"one Shackford"—who was due any day.

What the hell—if that man can't take five minutes to sit down and scribble out just a note to let people know what's going on—merde.

Lack of information was not Dian's only problem. She had been effective in keeping poachers and herders out of her study area, but found another intruder threatening her work.

I believe I wrote to you concerning the ugly American who came to camp last Dec 23rd. I learned today that he returned last Sunday with 3 other "white" men, hired guides from the village for 300 francs a day (!), set up a lower camp and found Group 5. According to

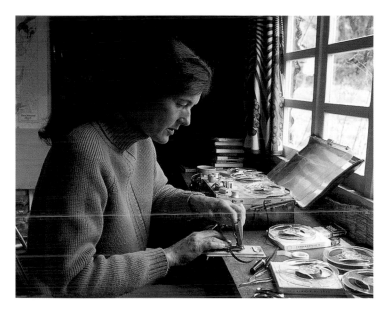

reports I received … he tracked them the entire day, then took pictures with both ciné and still cameras and he is planning a semi-permanent camp near the summit where he can work the whole mountain ….

This has me really upset—I simply cannot cope with this kind of problem, so will be very happy when someone of the assortment of photographers or survey workers can lend some moral support.

ABOVE Working in her spare room, Dian splices sound tapes of gorilla vocalizations.

On a more positive note, Dian was now taking her tape recorder into the field and spent three hours every evening splicing up tapes so that all chest beats, alarm barks and hoot series were on one tape—she was extremely pleased with the results. Dian's work in this field was ground breaking and would eventually form a large part of her doctorate.

Meanwhile, the question of a photographer had been finalized. On February 17, 1969 Dian wrote to her parents:

Bob Campbell, the photographer that was here during my absence, is the one coming in a few weeks and Leakey writes to say an American has also been chosen by N.G. but won't be able to come immediately. The two of them are going to end up taking pictures of each other I think! In the meanwhile I'm trying out new hairstyles and going heavy with the face cream around the clock—it doesn't help a bit!

Finally, things were beginning to look up; Dian expected to be able to crack on with her research, coordinate a comprehensive survey and supply the National Geographic Society with plenty of good material to publicize her work. Then, on February 24, 1969, Dian received word that a baby gorilla was being held at the park headquarters.

Dian fetched the baby and brought it back to Karisoke. A week or so later, another baby gorilla was brought to her. It transpired that the park authorities had arranged for the capture of the babies, who were to be sent to Cologne Zoo in exchange for a Land Rover and a large sum of money. The babies had been badly looked after and were seriously ill—Dian's help was needed to get them into a fit state to travel to Europe.

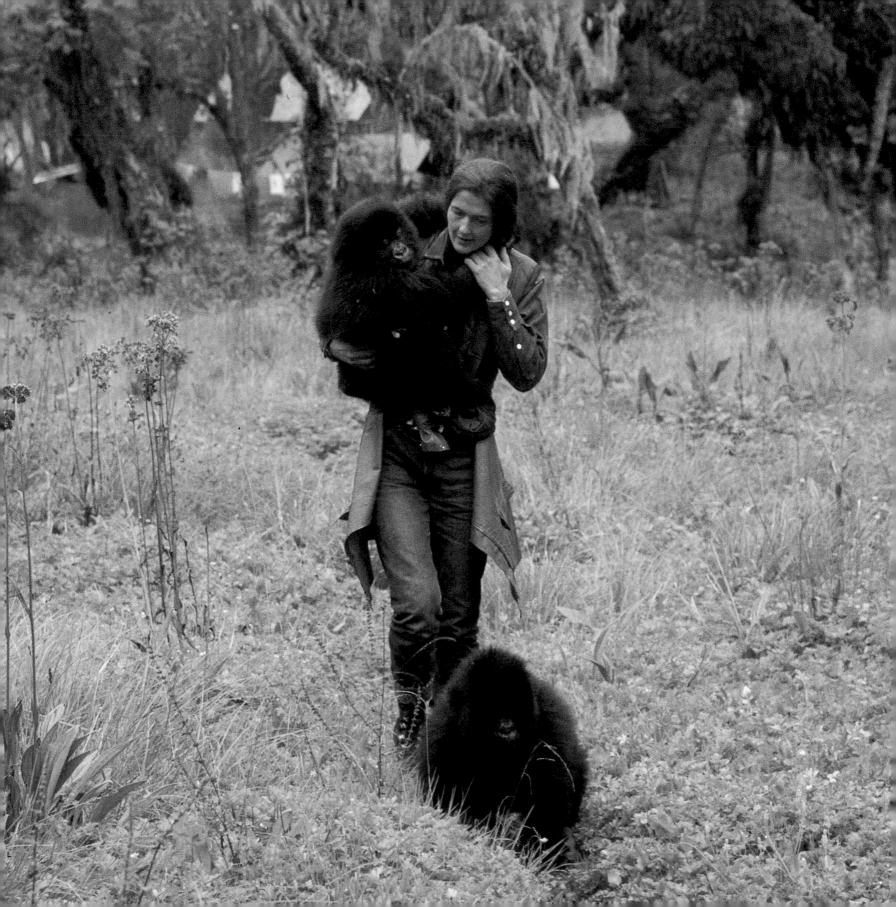

Meanwhile, the National Geographic Society had contacted Dian and told her that they would not be financing her studies at Cambridge University. Without their money Dian had to put plans for her Ph.D. on hold.

OPPOSITE Dian leaves camp to exercise the two baby gorillas, Coco and Pucker, that were captured by the Rwandese guards.

Rwanda: March 7, 1969

Dear Bob,

… Now as you may or may not know, I've completely gone around the bend with the 24 hour a day care of two gorillas captured by the Rwandese guards, thus if God himself were coming to photograph my work followed by Jesus to do the survey work—they wouldn't even get a nod from me.

Briefly, the first animal, some 2 years of age, was captured by these bastard guides on the 27th January and kept in a dark, cold box for 3 weeks and five days until I learned of it and went down to collect it—half-dead. The second one was captured on the 26th or 27th of February and kept 5 days in the same condition in a small, cold box out of doors and being fed on bread and bananas, so that one is also here now ….

At any rate, both my correspondence, my field work and all sense of organization have gone to pot here since the 24th February thus I am behind terribly in correspondence which doesn't really matter to me as much as the care of these two animals ….

My [tape recorder] is broken so haven't been able to use it upon receipt of two babies which is sickening since their vocalizations were really something, especially the heart-breaking crying and wailing at first. Bring yours if you can—never hurts to have two of anything at this camp.

Dian finished her letter with a shopping list. Living in a remote spot she was dependent upon visitors and workers bringing her a regular supply of equipment such as camera film, boots, batteries, lamps and stoves.

Won't be able to send you any money for any of the things I asked for from Nairobi as I'm flat out of money and still another month to go.

Dian named the young female gorilla Pucker Puss and the young male Coco. She became, to all intents and purposes, a full-time mother to two young babies, and all other

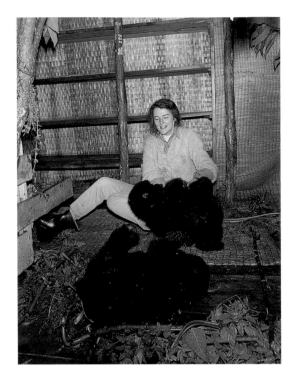

work came to halt. Dian did, however, find time to write to wildlife organizations, Cologne Zoo and anyone she thought might help prevent the removal of Coco and Pucker to Germany. Dian was well aware that a gorilla group will defend a youngster to the end, and she believed that other individuals probably died before the babies were captured. She was, understandably, outraged.

When she wrote to her parents in March, Dian's tone was noticeably fractious and she was unable to contain her envy at the attention Bob Campbell was receiving in the States, while she fought her battles with little success.

Life has become very complicated here on this mountain top, but I guess a lot of the fault is my own for I have spread the story of the captures of these two infant gorillas far and wide, expecting some kind of a response from proper conservation authorities, but not the hysterical type of response that I've received from photographers, movie people and press. It is all rather wearisome and I long for the nice quiet days spent at Kabara in the Congo ….

In the meanwhile the new photographer [Bob Campbell] is cocky as hell, excuse my description of him, but it is so, as the N.G. paid for him to fly to America for two weeks in that horrid hotel just to brief him in this job. He had never been to the States before and now, have just received a letter from him after two days back in Nairobi, he really thinks he is big time and is completely spoiled by all of the attention lavished on him by the N.G. and doesn't seem to realize that this is just part of their business policy.

Hope it wears off by the time he gets here—next week.

Toward the end of April Dian was feeling more hopeful about the young gorillas' futures and, although they were booked on a flight to Cologne on May 1, she held out a remote hope that conservation agencies would intervene and the infants could be returned to the wild. Back at Karisoke, Bob Campbell had taken

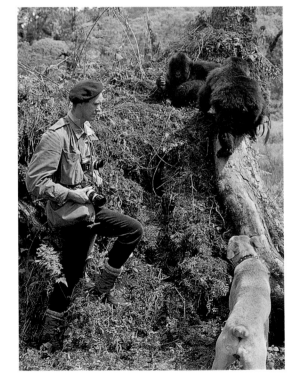

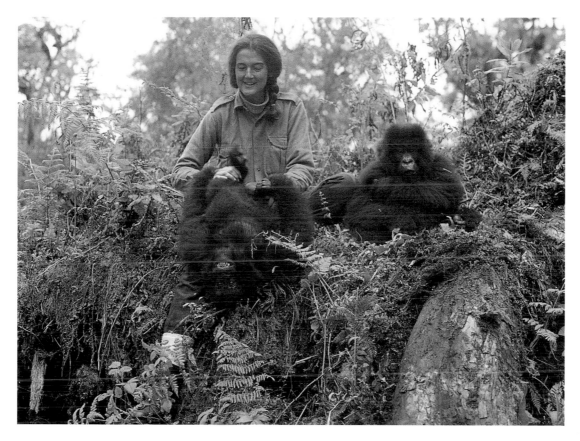

LEFT Dian expended great energy writing to authorities and campaigning to let the babies be released back into the wild, but it was to no avail.

lots of photos and ciné of Coco and Pucker, which pleased Dian, even if his presence at camp irritated her. She wrote to her parents:

Well, Campbell the photographer is now beginning to adapt this routine somewhat so that he isn't in the house every two seconds. I know you must think I am a real crab, but honestly he is the biggest bore I've ever met and his dull, old-lady ways really have had me going around the bend especially now that I'm confined to camp because of the babies. He absolutely refuses to go out on his own even though a group may be within ten or 20 minutes of camp, and quite honestly I think he is afraid of facing the gorilla alone, especially now that they have become so used to me and come so close I don't think two more incompatible people could have been thrown together. I use you both as a sounding board simply because it would be unethical to write about him to anyone else The next ten days will [bring] the departure of the babies ... and the arrival of two

doctors who wish to spend an extended period of time studying the "excrement and parasites" of wild gorilla. Quite honestly I am wondering if I will cope with it all properly.

Must close for now as a wild duck that one of my Africans brought me, thinking it was a fine gift, is about to tear his cage apart. The man who captured him … chopped off his wings with a panga [machete] *so that he can't fly away from* [me].

Bob Campbell did not enjoy this period either. Dian had not made him welcome because, he now believes, she was disappointed that Alan Root, of whom she was very fond, was not able to undertake the photographic assignment. Bob knew that he was a poor replacement in Dian's eyes.

Coco and Pucker finally left Rwanda on May 3, and the seasonal rains brought gloomy, wet weather to match Dian's mood: she was totally distraught—"an emotional wreck" is how Bob Campbell later described her.

The young gorillas survived for only nine years in Cologne Zoo, dying within one month of one another. (Wild gorillas may live for 30 years or more.)

Dian's faith in conservation agencies was destroyed; they had proved impotent when it came to protecting two young animals that belonged to a highly endangered species. The effect of this became obvious later in Dian's career, when she showed little respect for official conservation organizations and their proposals to protect the gorillas. She was

to adopt what she called "active conservation" methods: confronting poachers —and anyone else who threatened the survival of the mountain gorillas—head-on.

Rwanda: May 17, 1969

Dear Mother and Father,

… Mrs. De Munck is now here for the first time since the end of December and this time she is building a kitchen—she still feels the need to work or keep busy, but other than that she has improved immensely as it has been a long time since I've seen her. The kitchen will be a big improvement over the one I "built" last year for it will have a big storage room that I can lock up …. At the moment camp is really ugly what with my looooong cabin, the old rotting tent which is huge, the tent of the photographer plus his outhouse and mine and the "kitchen" ….

Twinkletoes [Bob Campbell] received another batch of film from N.G. some of which were quite good …. I had to literally beg him to see the first batch of slides simply because that's the kind of person he is ….

All my love,
Dian

Dian returned to work in the field, accompanied by Bob Campbell. Bad weather conditions greatly hampered them, and the gorillas proved elusive. The loss of the two young gorillas weighed heavily on her mind and affected her moods. She had become very depressed and sought to control Bob Campbell's work, forbidding him from seeking

ABOVE Dian and Alyette De Munck look over the framework for the new kitchen.

contact with the gorillas without her. He was thus hindered in his work and could only film when Dian's health and fitness permitted. It was the first glimpse of a professional jealousy that was to afflict Dian throughout her time at Karisoke.

There was some good news though. Word came from Dr. Leakey that a final decision had been made about a graduate student to work on the census. The "Shackford" he had earlier recruited went home, and it was arranged that Michael Burkhart, a student of animal behavior, would arrive at camp in early July.

Bob Campbell persevered with his work, taking stills and ciné-film of Dian and the gorillas whenever possible: it was neither a straightforward task, nor an enjoyable one. Being with Dian was, simply, very difficult and he had to learn how to adapt to her ways, defer to her methods and manage her. The assignment was not what he had expected and was in danger of foundering. On May 23, 1969 he wrote to Robert Gilka at the National Geographic Society, to share his concerns:

For sometime now, I have been promising to write to you and "put you in the picture," as it were, regarding the situation up here.

Now—I am addressing this letter to you personally, as it is not for the files and for all to see, in fact, when you have read it I would prefer that it be torn up. If Dian Fossey receives even a hint of the fact that I have revealed some of her thoughts and worries to others, my presence up here would become untenable.

In the first place my arrival coincided with the peak of the turmoil, difficulties and deep worries that were affecting Dian over the situation concerning the baby gorillas—the worst time in fact. She obviously maintained considerable control over her feelings for the first few days, but couldn't keep it up, and I was the unfortunate witness to the full range of her emotions, from violent outbursts of temper to fits of crying—an embarrassment to me, and maybe to her, although she didn't show it. She can be abrupt and rude,

BELOW Dian sprays a cow with green paint in an effort to discourage the illegal cattle herders, whose activities threatened the gorillas and other wildlife.

then a few hours later, as sweet as you like. I can assure you, on occasions I have had to exert every ounce of self control to avoid having a row with her …. I guess I'll have to grin and bear it.

Bob went on to explain that Dian was often broke and, since the National Geographic Society had refused to fund her doctorate, she worried constantly about money. She had also been waiting for months to hear who would be undertaking a census—something that should have been straightforward had been bogged down in difficulties. He also wanted to give some hint of Dian's personality. He was restrained in his description.

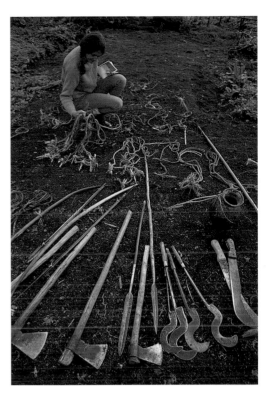

ABOVE A display of snares, axes and weapons confiscated from poachers and herders.

I could say a lot about her character as I see it, but I'll avoid the temptation, suffice it to say, I think she is (to put it mildly) the most unusual and mixed up person I have come across in years!

To give you a better idea, I think I should mention some of the more recent problems affecting Dian. The affair of the captured gorillas goes pretty deep, she created a big stir both in Rwanda and in International circles. She touched the fringes of official displeasure here, and only "cleared her name" as it were by making a personal visit to Kigali [capital of Rwanda] to talk to the official concerned—though the main purpose of her visit, to stop the export of the gorillas, failed. The local Conservateur was upset on many occasions … who knows what further troubles will arise from this affair ….

At times, Dian has created many problems for me, whether intentional or not I couldn't say, but when I return from Nairobi I will have to be better prepared to be independent and avoid having to rely on any of her camping gear. I thought that after the gorillas had departed and routine returned to normal, she would relax and become more amenable … but I fear all the difficulties and troubles are on her mind all the time and she remains aloof—though perhaps "melting" a little. For anyone who hasn't visited this area, it is truly impossible to visualise the unusual conditions. I think too many people tend to recall Jane Goodall and the chimps and vaguely try to equate the conditions of the two studies, when in fact they couldn't be more diverse. Dian is under great physical strain —quite apart from all the other troubles. The altitude, weather, walking conditions, temperament of the gorillas and many other things, make this study a particularly hard

OVERLEAF A view of Visoke volcano's permenent crater lake. In all the years Dian spent in the Virungas she never mustered the strength to climb to the rim of the crater.

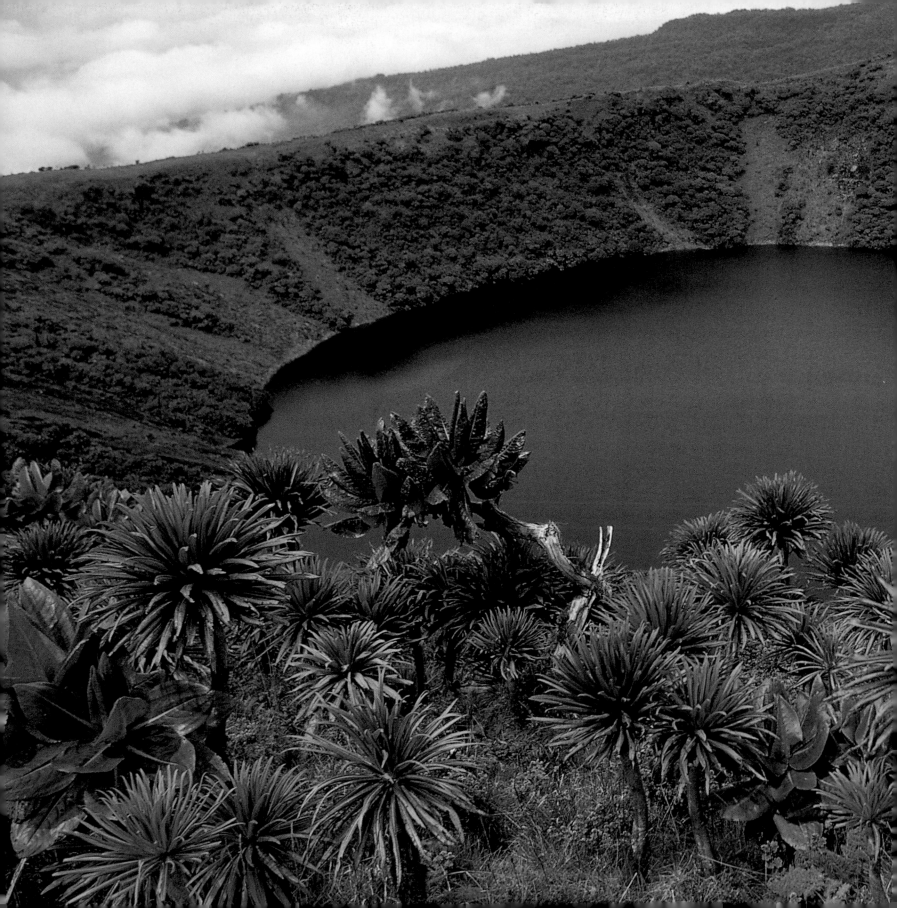

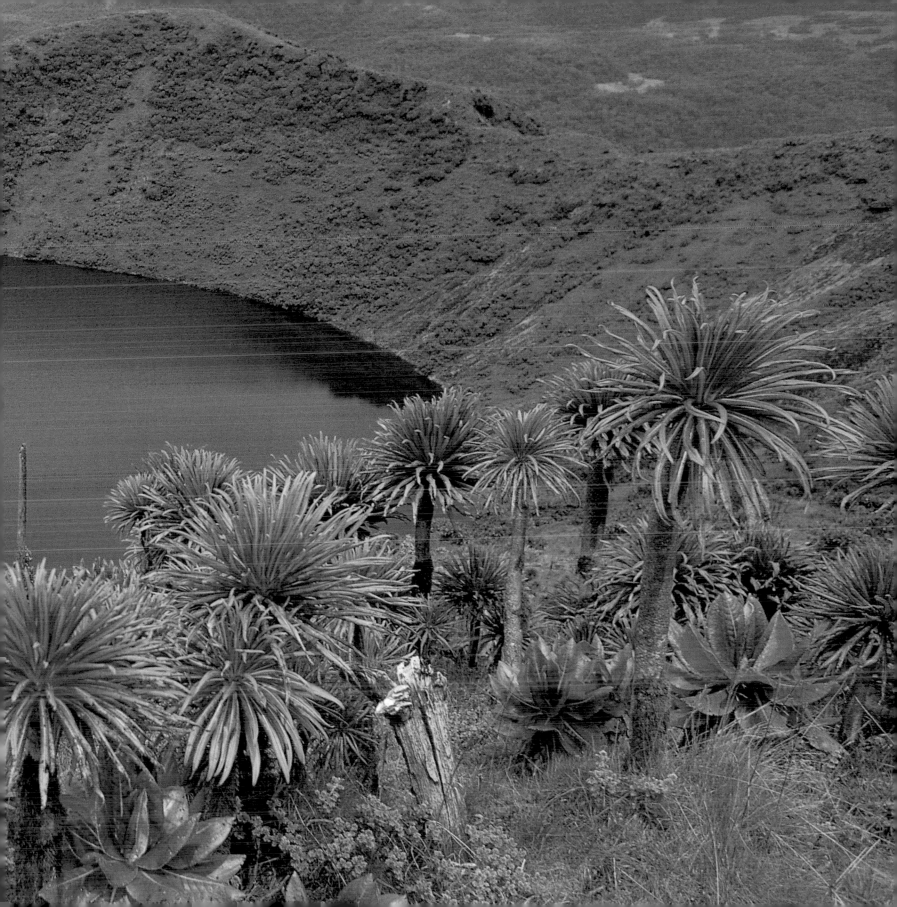

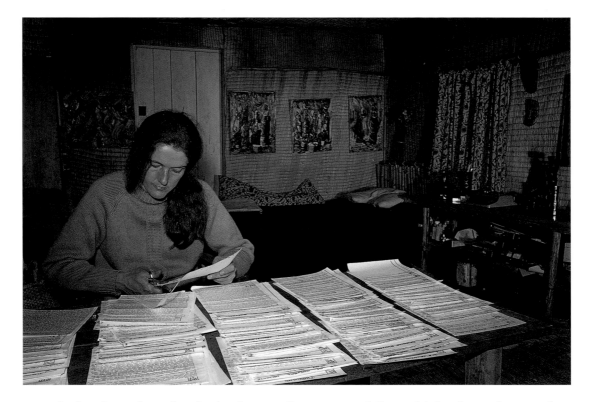

one, she has been through a lot in the past few years, and I can think of very few people who would have had the guts to carry on as she has done.

While Bob was away on leave in Nairobi, deciding whether or not to continue the mountain gorilla assignment, Dian finally heard that Robert Hinde of Cambridge University had found an organization willing to support her during her doctorate. In June, Dian was busier than ever. The National Geographic Society wanted to publish an article by her, about her work, in their magazine.

Rwanda: June 15, 1969

Dear Mother and Father,

Yes, I know I've been less than diligent, but oh my let no man say to me, "You at least could have sent a postcard!" I was given a week's deadline to complete the article for the N.G. This in addition to all else has me befuddled and terribly tired.

As usual, Twinkletoes had the story all wrong. N.G. wanted this introductory article to be written by me, not as he informed me, by someone else. It will consist of 18 pages and will be published in the December issue in fact. They've sent me a "tentative dummy" consisting mainly of planned photos and sub-captions. It makes for grim reading—gorilla are called "savage" beasts etc. Also the pictures of myself are even more threatening that those of the gorilla! I just hope my article will contradict the misinterpretations they have conveyed of the animal and my work

My "environment" will be unhampered for another 3 days and then the American and French Ambassadors arrive avec families and attachés, and the following day Twinkletoes returns after three weeks of absence. It will be like the return of the plague!

Love, Dian

A day before the scheduled visit of the Ambassadors, Dian sacked her entire staff because she "couldn't tolerate their attitudes any longer." She chopped logs, hauled water and prepared camp alone—but still the visit was an utter failure—as she described to her parents on June 23.

We simply couldn't locate gorilla as the lack of rain, 4 weeks now without a drop, has them all changing routes and seeking the peaks of the mountains where some moisture is available. Also I had a difficult time trying to track gorilla, cook, fix up tents, bedding, and play hostess all at the same time. Also, because of the lack of rain, the elephants have been on the rampage invading camp each night in herd. The attaché, who was bedded down in one of the tents, was terrified, so all night long I was awakened by, "Dian, do you hear what I hear?" "Dian, they're coming this time for ultimate destruction" His fear was real although it seems rather comical now.

It seemed that life at camp was destined to never run smoothly but when Bob Campbell returned to camp on June 20 he was fully equipped to be entirely independent, which pleased Dian.

The photographer returned the day they left and I must say that he has returned with some sense of independence, and is almost a joy to have around. He is now prepared to do his own thing regarding cooking, food ordering and post and has even spent the last

two days looking for gorilla for me which is a real service. He has also lent me some slides … some of them are really spectacular—showing me in proximity with the huge males of Group 8, and I am so happy to have them. Perhaps this stay will go better ….

Must close for the moment. Thanks to Twinkletoes, I'm able to get caught up on a lot of work and it's a small price to pay to have a meal ready for him when he returns from the field. I'm really a domestic sort aren't I?

Sunny, dry weather lifted the mood at camp and improved Dian's attitude toward Bob Campbell: they spent 19 consecutive days in the field together. She helped him get good photographs of herself with the gorillas for the upcoming NATIONAL GEOGRAPHIC article and conceded that he could go into the field alone. Gradually, Dian's natural reserve began to wane, and she took Bob into her confidence. She told him of her fears that, after two years' research, she had little new material to add to George Schaller's work. She also confessed that the physical nature of the study was placing a huge strain on her health— a fact obvious to all at camp.

The new atmosphere of tolerance and cooperation was abruptly halted when, on the night of July 20, disaster struck. Bob Campbell was listening to the live radio broadcast of the landing of the "Eagle" Lunar Module on the Moon, when Dian began shouting, calling for his help. Fighting back the tears, she told him that a small case had been stolen from her cabin; it contained all Dian's money and the jewellery she had inherited from her late father. The next day she went down the mountain to report the theft and to collect Michael Burkhart, the student who was to count the gorillas. Dian was in a black mood and the relationship got off to a bad start.

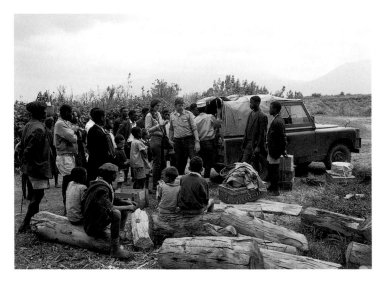

BELOW Michael Burkhart with Dian, the Land Rover Lily, and a group of local men hoping for porter work.

Burkhart's time in the Virungas proved to be an unmitigated disaster. After a few days' introduction to tracking, nest-counting and observation techniques, given mainly by Bob Campbell, he was set up with a tent and equipment on the other side of the mountain. After two days' assistance from Bob and Dian, and suffering from altitude sickness, Burkhart was left to get on with

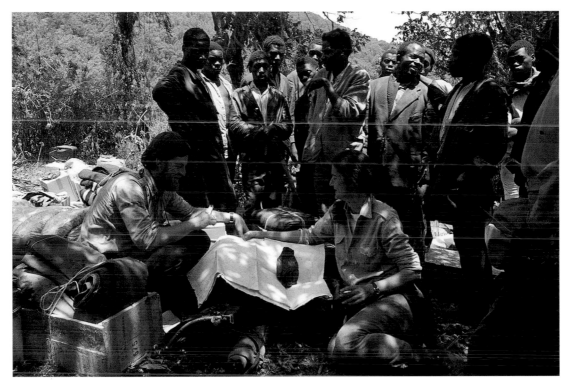

LEFT Burkhart and Dian look over a map at his camp site at Ngezi, the opposite side of the mountain to Karisoke.

BELOW The poachers set their snares mainly to capture the beautiful red duiker, of which there were many on the mountains. Sometimes they could be saved, but frequently Dian and her staff were too late. Unfortunately the gorillas occasionally fell foul of these snares, sometimes with dire consequences.

the survey by himself. Dian had been able to cope when she first arrived in the Congo with minimal training and no experience, but few of her students were endowed with the same drive, obstinacy and determination. Burkhart proved to be the first of many researchers who found themselves totally unprepared for the conditions in which they were expected to work.

On August 18 Dian wrote to her parents about her own troubles:

Just a note to let you know I'm still alive somewhat. Caught a very mysterious bug when last off the mountain, and since I've really been sick I'm furious at Campbell who seems to believe no one could possess such a list of symptoms and not be faking it.

Tomorrow the ex-governor of Rwanda-Urundi before Independence is coming to Camp for several days …. Campbell has been trying to keep track of one group of gorilla to show him, but with this continuation of dry weather they are almost impossible to find. The one group available is

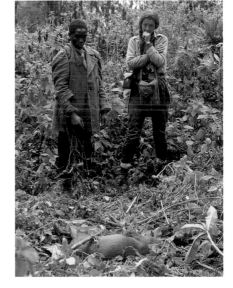

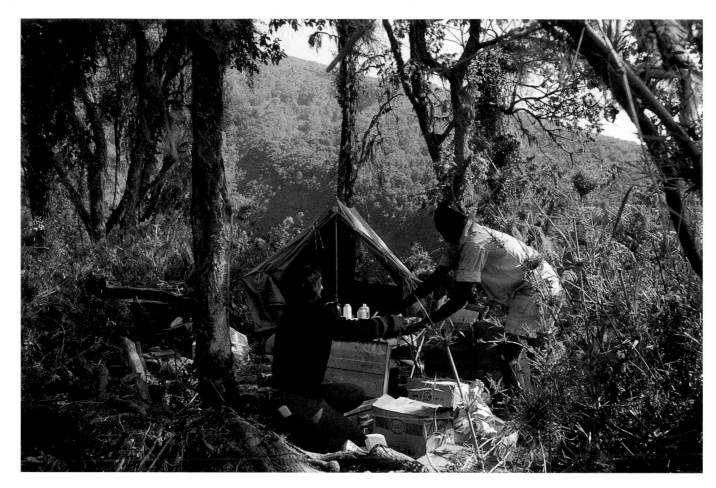

*clinging to the very top ridges near the summit which means a climb of at least 3 hours
.... At any rate we will have plenty of cattle to show him as the place is full of them.
Also have the wire ends of more than 200 snares which we broke last week in one hill
area! While following this trap line we were able to rescue three duiker, small red forest
antelope, shortly after they'd been caught so they weren't harmed beyond shock and
bounded off into the forest after we released the wire around their legs. Naturally I had
to start crying just because the scene was so brutal, and naturally Campbell had to take
pictures and I know I just looked lovely!*

Dian kept tabs on "the Bearded Thing," as she called Michael Burkhart, who sent porters
back to the main camp every day with "weird notes and requests." She had reports from
the porters that he spent every day smoking reefers and swimming in a beautiful crater
lake near his camp. She told her parents that she dreaded that "he'll come round the
mountain any time"

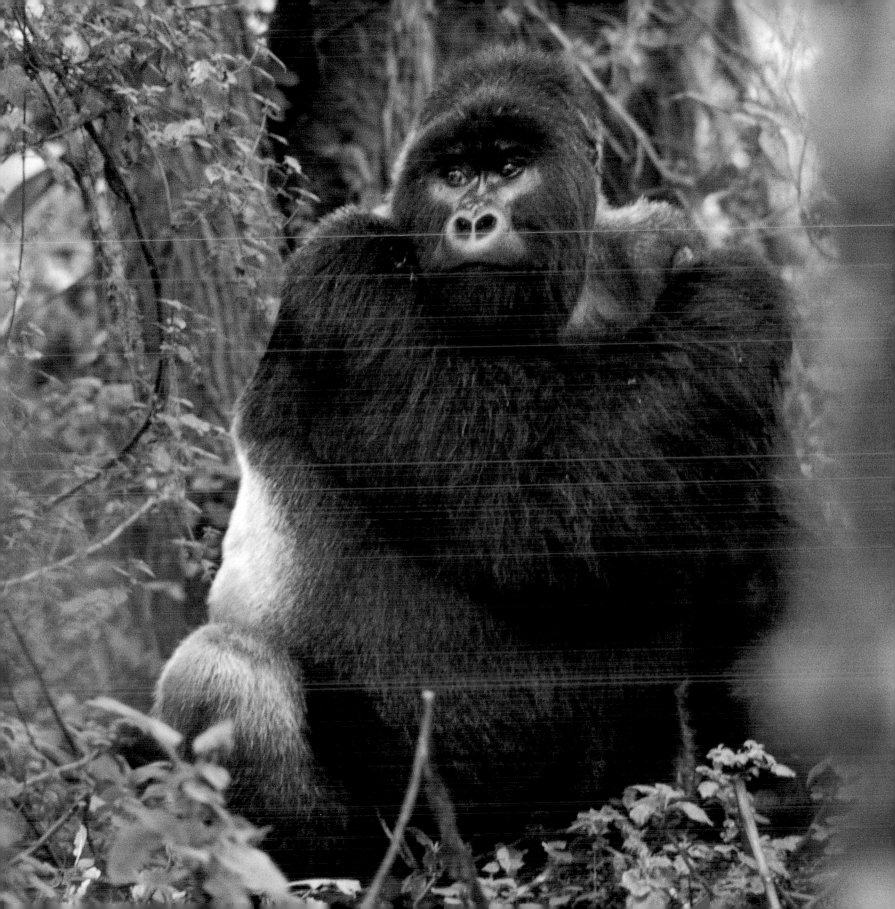





Rwanda: August 28, 1969

Dear Mother and Father,

… Today … we had an excellent contact with my Group 8—you have some recent pictures of them (yes, the silver coloring denotes a silverback or very mature male—in this case I would guess Rafiki to be about 35 if not older.) … Most of the group came right down to me to feed by my side. They and myself were all completely "exposed" (no jokes please) ….

Am afraid I'm beginning to "untolerate" Twinkletoes again, but then it is time for his leave …. At the moment he has become a real authority on gorilla behavior, tracking, etc and all this is a bit difficult to bear. Most of the time I just keep my mouth shut and give an English "hummmm" to all he has to say, but if he gets over-bearing, I say with great enthusiasm, "really, that's very, very interesting," and this shuts him up straight away. The real difficulty is that he is ruining most of my contacts by wanting to [climb a] tree just to get pictures which in turn frightens away the gorilla and ruins the contact although he may get a picture or two before they leave ….

In the meanwhile the "Beard" is still "functioning" on the other side of the mountain —every morning I receive really sick notes from him, costing the equivalent of a dollar a piece of porter and thus far his only report concerning gorilla watching goes as follows: "I almost stepped on a silverback this afternoon. He almost pissed."

Now, how's that for scientific data?

… I've begun singing to my gorilla groups and they can't seem to get enough of it!!! They will tolerate show tunes such as "Hello Dolly," but their favourites are the old Burl Ives westerns such as "Cool, Clear, Water" which really undoes them!

Am thinking I've been here too long!

Much love,
Dian

Bob left Karisoke for a short break in Nairobi. When he returned to camp it was decided that, rather than waste any more time or money on Burkhart's census, work should be halted. Dian and Bob told Burkhart that he was no longer needed, and they drove him to Gisenyi, where he could begin his long journey home. While in the town, Dian introduced Bob to her close friends Rosamond Carr and Alyette De Munck, who lived nearby. Bob

was surprised to witness the transformation that occurred when Dian was "down the mountain;" away from camp she always took great care with her appearance, wearing fine clothes and make-up. They had become much closer, and Bob now found Dian a fascinating individual whose company he enjoyed.

The closeness between the couple developed further; as Bob Campbell described in his book, *The Taming of the Gorillas*, "I was unintentionally caught up in a sensitive and unforeseen affair that split my emotions into different compartments. I was happily married and loved my wife, but nevertheless had to admit I was flattered by Dian's now undisguised interest in me."

THE NATIONAL GEOGRAPHIC SOCIETY paid Dian $2,500 for her article, which was due for publication in January 1970. By the end of September, Dian was beginning to doubt whether the money justified the hassle it was causing her, with each mail delivery bringing more "ridiculous questions" from National Geographic staff. She wrote to her parents:

BELOW On her trip to Nairobi, Dian stayed with Louis Leakey (pictured with his son Richard), who had become infatuated with this striking woman, who showed so much courage and passion for the task he had set her.

ABOVE NATIONAL GEOGRAPHIC, January 1970, the cover showing Bob Campbell's photograph of Dian with Coco and Pucker, and which contained Dian's article about her work with the gorillas.

I have received the new "dummy"—or layout—of the pictures and I know you will want to disown me when you see it. In the first picture … humped back; caved-in chest (can't much help that); black circles under my eyes; hair going in every which way; some 2,065 wrinkles in face, and Alan [Root] took this before I went home last year although it appears that the specimen in the picture would hardly make the next day …. Page 60; at first glance you would think it was Jacqueline Kennedy holding one of the baby gorillas, but at second glance you would know that it must be her grandmother—no one could have that many wrinkles around their eyes and still be able to see …. Pg 64; this is a beautiful picture that Twinkletoes took when I was lugging the babies off for their walk in the late afternoon. He does have an eye for these distant, composed pictures.

Dian had been unwell and was staying at the camp more frequently, dosed up with antibiotics. She planned a visit to Nairobi in October 1969 to do some shopping and see a doctor and a dentist.

Dr. Leakey insists I stay at his house during this time although I should much prefer staying at the New Stanley (Hilton now) but perhaps after spending ten minutes with him, he will want to throw me out, bag and baggage.

Louis Leakey did not throw Dian out—he welcomed her to his home and even took her on a short safari. When Dian flew back to Rwanda she was rested and in good spirits, but she left behind a rather smitten man.

She wrote to her parents from Nairobi, having been "spoiled rotten". She had also bought herself some new clothes; whenever she could, Dian would buy expensive, designer dresses, which she wore to great effect. On this occasion, Louis Leakey had been particularly affected.

Dr. Leakey claims he is going to replace my stolen ring with an authentic ruby, but nice girls don't accept these sorts of things do they! He brought the stone over for my appraisal and I must say it was the most beautiful thing I've ever seen—it was an eight-sided cut with each face reflecting a different color in the sun and throwing out rays of sparkle. It was difficult to decline but believe me I did although I'm far from certain that he is going along with my decision.

Just before leaving for Nairobi, Dian had discovered that Bob Campbell's photograph of herself, with the baby gorillas Coco and Pucker, was to be put on the front cover of the NATIONAL GEOGRAPHIC magazine. She was ecstatic. She was also to be the subject of a television show, so she bought herself some more hair dye in Nairobi to cover the grey hair which now flecked the auburn. Dian's article appeared alongside Bob's pictures of Dian in close proximity with the gorillas, and at home in her camp. Her piece explained how she had come to study the gorillas, and detailed how, by gradually encouraging the apes to become accustomed to her presence, she had won a rewarding familiarity with them. Most importantly, the article highlighted the endearing, gentle and human-like behavior of these extraordinary creatures.

Perhaps too quickly I labeled Uncle Bert a cantankerous old goat. One day, as their rest period was breaking up, a small infant approached him and leaned against his back. I was about to predict an unhappy fate for this baby, but Uncle Bert surprised me. He picked up a long-stemmed Helichrysum *flower and tickled the baby with it. Soon the infant was scampering about like a puppy, and Uncle Bert was lying on the slope, tickle switch in hand and a most idiotic grin on his face.*

Dian finished her piece by commenting on how the fictionalized portrayals of gorilla savagery toward humans were grossly exaggerated.

The gorilla is one of the most maligned animals in the world. After more than 2,000 hours of direct observation, I can account for less than five minutes of what might be called "aggressive" behavior Naturally an animal is going to try to protect itself, and there are a number of recorded instances of gorillas attacking humans when the latter hunted them. And there are the tales of the "intrepid white hunters" who have "courageously" faced the screaming charges of the white-fanged hairy ape-man. The result is the common, and quite false, picture of the introverted, peaceful vegetarian that I have come to know.

During Dian's break in Nairobi, the arrangements for her stay in Cambridge were finalized. She was due to arrive in Cambridge on January 13, 1970, where she would stay with some friends of Dr. Leakey's. Her work at the university would keep her busy until March, when she would return to Rwanda. In October she would go back to Cambridge and stay there until May 1971.

Rwanda: November 7, 1969

Dear Mother and Father,

Your letter of cheer arrived about an hour ago and really made me so happy. Regarding Playboy—there isn't enough foam rubber in the world to make me suitable for their cover!
 I really enjoyed your bit, "mother speaks" concerning the ruby, but honestly he is a very demanding man, or old man I should say. He now has written six times within the past three weeks—is completely intent upon flying here and insists I come down in December to Nairobi so that we can take a safari together to Tsavo, which is a game park

in the south of Kenya. I think he is getting senile, and at the same time I'll think about asking for a diamond set.

My lovely clothes are here, sitting in plastic bags all ready for Cambridge but I do believe there will be a chill in the air when I get there …. Really do dread the departure for this type of life and environment do suit me but obviously such an Elysium can't go on forever. Everything is rushed now—stills and ciné are demanded around the clock by Twinkletoes, with whom I'm getting on quite well, and of course I insist upon pushing observations, pictures, dung washes and plant collecting just as though the world would end tomorrow …

Love,
Dian

Early in November Dian was bitten by a stray dog that walked into camp. Convinced that she would not contract rabies, despite it being common in the Virungas, Dian did not use the rabies vaccines sent by Louis Leakey and set off on a trip to her old camp at Kabara Meadow in the Congo.

At Kabara Dian discovered that cattle were roaming freely through gorilla territory and traps littered the forest floor. Few gorillas were present, and those that were showed obvious fear. Her old cabin had been burnt down so the porters, trackers, Dian and Bob found themselves making a miserable camp with only a small tent and tarpaulins to protect them from the rain.

On her return from the trip Dian developed a high fever—a symptom of rabies—and had to be taken to Ruhengeri Hospital. She was started on the rabies treatment, which involved a daily injection for two weeks. Obstinate as ever, Dian refused to stay in hospital and Rosamond Carr agreed to nurse her at home. Over the next 11 days a member of Rosamond's staff had to drive Dian the 46-mile (74 kilo-meter) round trip over rough roads so she could have the injections at hospital. One day Dian remarked to Rosamond that she had all the symptoms of rabies, including irritability. Rosamond later remarked that "Dian eventually recovered from the dog bite, but she never completely got over her irritability".

As she recuperated from the rabies treatment and prepared

BELOW Rosamond Carr's house and garden at Mugongo, where Dian stayed during her treatment for rabies.

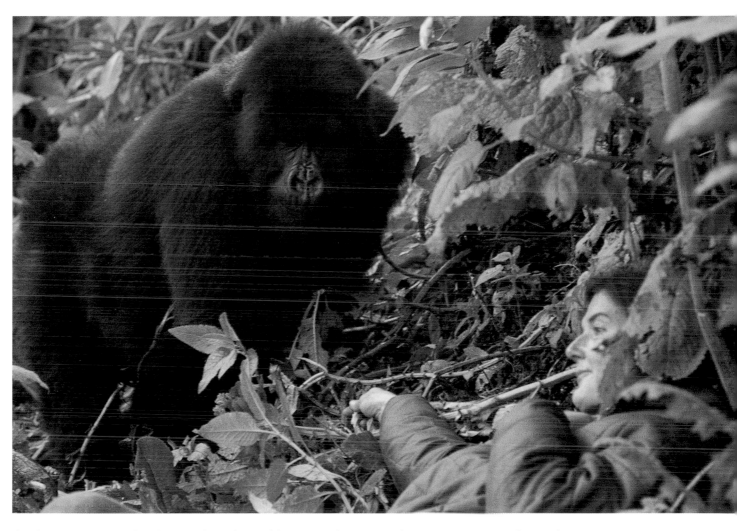

for her trip to England, Dian heard terrible news: the Rwandan Government planned to give 10,000 acres of the Parcs des Volcans to local farmers. The deforestation would mean that even more of the precious gorilla habitat would be lost.

On her last day at camp Dian and Bob Campbell made contact with Group 8 and one of Dian's favorite gorillas, a young adult male called Peanuts, approached her. Dian mimicked a relaxed gorilla's body language: chewing, scratching and lying prone. She stretched her arm toward him and rested her hand, palm upwards, on some leaves. Dian described what happened next: "After looking intently at my hand, Peanuts stood up and extended his hand to touch his fingers against my own for a brief instant."

Thrilled by the experience, Peanuts stood up and beat his chest before joining the rest of his group. For Dian, it was to remain one of her most precious moments and doubtless proved a comforting memory during her unhappy days at Cambridge.

ABOVE Dian with Peanuts of Group 8, shortly before he reached out and touched her hand.

Cambridge and Back

*a*t Cambridge Dian was greatly pleased to discover that her research work was recognized and applauded by her peers—but this did not lessen her homesickness. She missed her camp, the gorillas and Bob Campbell. This first stint at Cambridge was expected to last until mid-March and Bob ran Karisoke in Dian's absence.

Cambridge: January 24, 1970

Dear Mother and Father,

… To briefly resumé my past 13 days in this fog bound, frenzied, fossilized site—spent the first week in a nice hotel that did feature lovely continental food which [I] consumed with great relish. On Monday of last week I moved into a guest room of my college for three days and had a fantastic room over a tributary of the river but wasn't in it for any length of time to relax. Had three meals there, two of which were "formal" (this occurs three nights a week) which means you must wear the gown or robe of your college. Since I haven't been toting about a gown from San José State over the past three years in Africa, or even before that, I went nude the first night and was almost snubbed until I got to talking to people, all of whom turned out to be truly wonderful … . Can you believe that ONLY three years ago were students allowed into the town of Cambridge without their gowns … . I can't get over it, but then this entire way of life seems like stepping back a century at least … .

… My office in Madingley [Madingley Research Laboratory] *is well equipped and I, to keep up with the other research "fellows" there, should spend 7 days a week from dawn to midnight working up data but honestly can't get accustomed to this schedule yet. Have learned how to work the sonograph machine which graphs my sound tapes with regard to frequency and intensity of sound and none of this has been done with respect to gorilla vocalizations previously. Am also learning how to work a simple computer. Rest of time spent in analysis of field data preliminary to writing papers on specific subjects and also in reading vast quantities of material on animal behavior.*

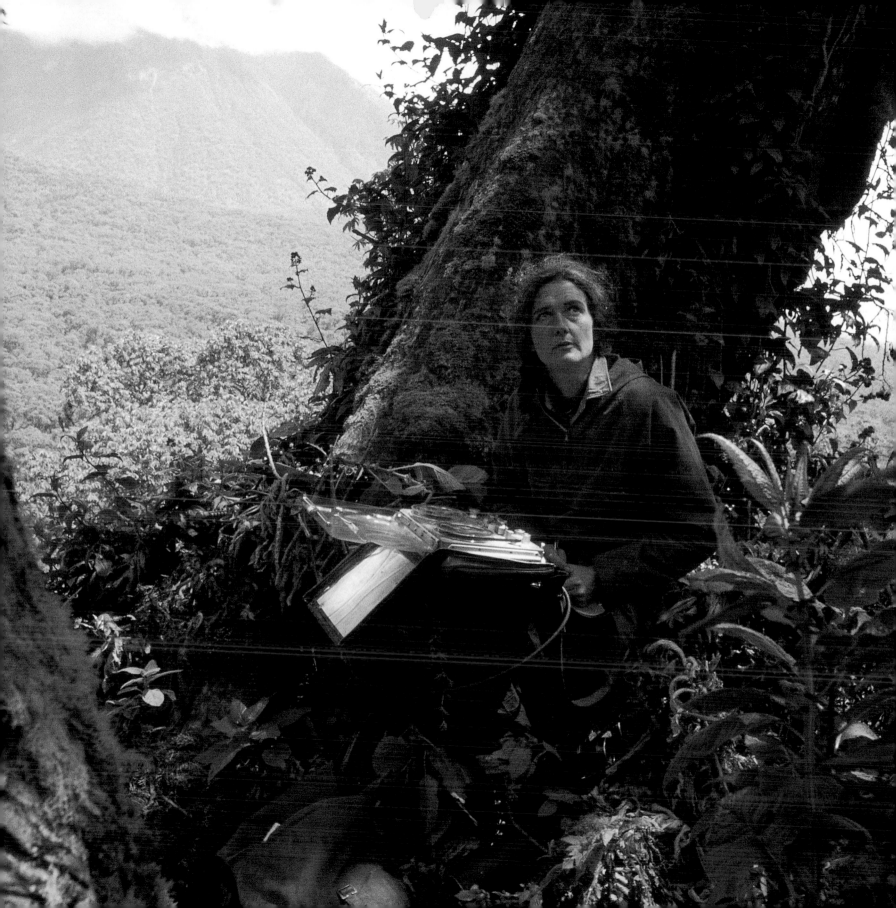

It is a very strange transition to make, especially since I'm now considered to be a pioneer authority (discovered this today in a primate meeting in London) on field studies of apes, yet at the same time I lack the common vocabulary of established authorities in this field. You know it is rather comical for half the time I don't know what people are talking about when they get into earnest conversations with me, yet when I respond in an extremely simple manner they get their notebooks out. Can't figure it out. Must close. Write when you can—amazing how swiftly mail is delivered once within civilization.

Love, Dian

Dian's research center in the Virungas was now established as a permanent study area. A primate research foundation supported Dian's stay at Cambridge with a small grant and the National Geographic Society paid for the running of Karisoke. By supplementing her small income with money earned from her article for the NATIONAL GEOGRAPHIC magazine, Dian was able to afford a slightly higher standard of living than most students.

While at the university, Dian was on the lookout for someone to take over the running of the camp in late August or September; she hoped to travel back to the States for one month before returning to Cambridge for the autumn and spring terms. Her tutor Robert Hinde put her in touch with Alan Goodall, a graduate student from Liverpool University (no relation to Jane Goodall). Alan was trying to find a research project to work on—one that would provide the basis for his doctorate in animal behavior. Dian took to Alan immediately and felt that she had found, in this mature, intelligent man, the perfect assistant for Karisoke.

On February 6, she wrote to her parents:

I did type you both a lovely long letter some three nights ago but it was so blatantly full of self-pity that I tore it up and determined to start anew.

I stand a bit refreshed in that I've discovered the natives of England 1) Hate their environment with regards to cold, ugliness, being crowded 2) Even they cannot figure out their monetary system—i.e. if one buys a packet of cigarettes they can tell you straight away what one packet costs but if you buy a carton they have to go to the nearest shop that has a cash register to add up the "thruppences" [three-pence coins] properly. It's really unbelievable. No wonder I'm confused

… Have found a perfect replacement for camp, who will arrive in July for training. To find such a person was the main purpose of my coming here.

Louis Leakey was in London at this time, recuperating from a heart attack. He met, vetted, and approved Alan Goodall. They decided that Alan would come to camp in late July, and Margaret, his wife, could join him later. He would run the camp so Dian could return to the States in August and then continue her own doctorate at Cambridge in the autumn and winter terms.

When Dian next wrote to her parents she was unable to contain her excitement—she had received word from the National Geographic Society about their next magazine cover.

N.G. just sent me slides of Peanuts sitting next to me the day he touched my hand and they are really dramatic—have been informed this is the next cover! They bloody well better be—fantastic—will have prints made to send to you.

On March 18, Dian finally returned to Rwanda. Bob Campbell met her in Gisenyi, and the next day the two of them climbed up the mountain to camp. It was a further three weeks before Dian was able to make contact with Peanuts and Group 8—this time Peanuts was not so friendly. She later wrote to her parents about the aggressive reception she had received.

BELOW Beethoven and Bartok of Group 5 peer curiously through the foliage. In her NATIONAL GEOGRAPHIC magazine article, Dian wrote how these two silverbacks had a particularly close relationship with their fellows.

No, my gorilla friends weren't spoiled by their publicity. They only charged me en masse again the first day I met them. This was Group 8 of all people! Bob was behind the ciné camera at a safe distance and claims he only saw the foliage moving in the lens! Of course he knew I was being charged because of the screams and roars of the group but he just stood there clicking away.

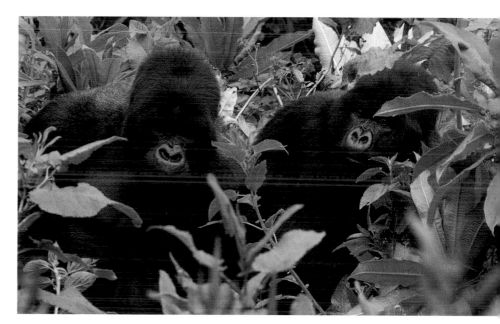

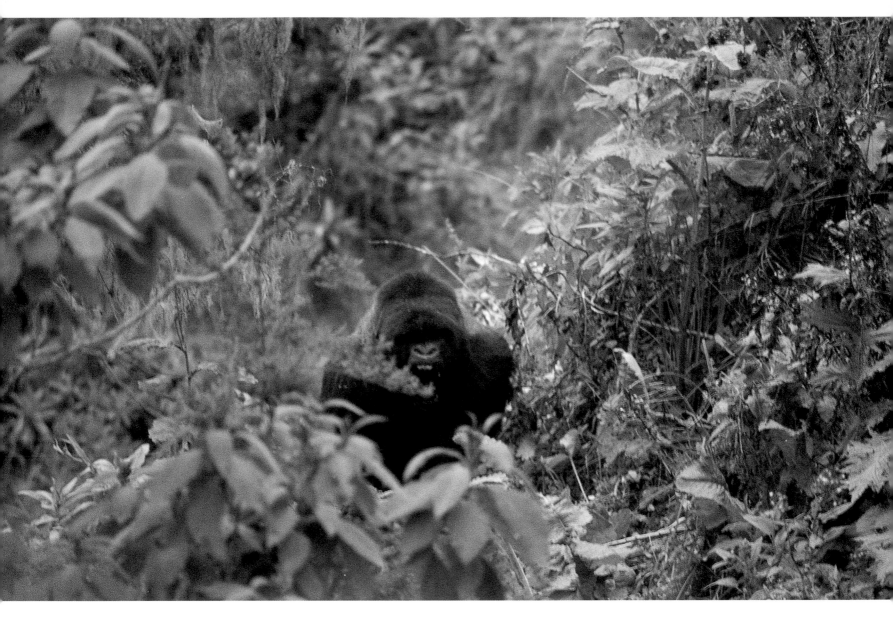

Once it was all over he asked me to advance into the group again at which time we had some rather heated words!

Despite Dian's protestations, she and Bob Campbell were working very well together. The pattern for their emotional relationship was also becoming established—while they could enjoy their affair in the misted air of Mount Visoke, it could not be mistaken for anything more serious. Dian knew that Bob loved his wife, Heather, and had no intention of leaving her. For the time being, the arrangement suited them both.

There were other distractions. While Dian was in Cambridge Bob Campbell had kept the study area clear of poachers and cattle herders, and this work had to be continued. Time away from the gorillas was spent chasing Tutsi cattle back to the borders of the Parc des Volcans and cutting snares. As a result of this—and poor weather—contacts with the gorillas were being hampered. Between March 19 and April 14 Dian had managed just eight days in the field, confined to camp by rain and paperwork. Bob had stayed longer than intended so that he could get more footage of Dian with Group 8, but the gorillas remained elusive. In mid-April, Bob went home to Nairobi—and his wife.

DURING APRIL, Dian expanded her research area and established a temporary camp where Alyette De Munck could assess the gorilla population on the north-western slopes of Visoke. On April 22, Dian wrote a news-packed letter to Bob Campbell:

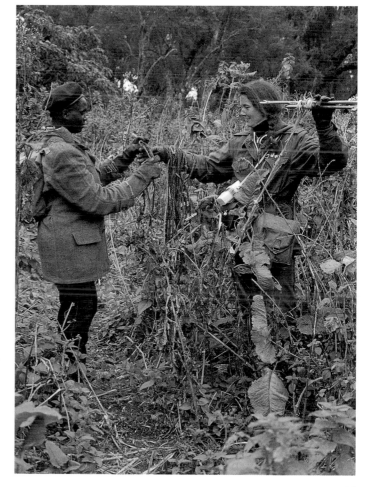

BELOW Dian and her assistant Vatiri gather up the nooses from the poachers' snares. During her absence in Cambridge, Dian left strict instructions that anti-poaching patrols were to continue.

Okay, laugh if you will but maybe, just maybe, it might have happened even if you had been here. We started out yesterday at 10:30 with Alyette's "light" camp-worth of porters (17 in all) to establish her camp on the other side of Leopard Ravine and you know where we ended up at 4:30 the same afternoon—Burkhart's old camp! No, I didn't lose my way. There simply wasn't any water to be found. Can you believe it??? Oh well, I always did want to walk around the mountain but not in the company of 17 porters. The trek must have done these old bones some good as it only took Vatiri and me 2½ hours this morning to return to our own camp from Ngezi which has to be interpreted as an encouraging sign.

Alyette was delighted with the aesthetic aspects of the site and she put up her tent at the edge of the lake, overlooking the mountain. Dian described it as a "spectacular setting" and was delighted to notice

that there were no cattle in the region, and that there was plenty of evidence that there were gorillas nearby. Alyette planned to stay at her makeshift camp for several days at a time, for three to four weeks. Nemeye, one of Dian's regular trackers, assisted her, along with three other men.

I was quite thrilled, in a frustrated way, to find masses of gorilla signs—old and brand new—between 20 and 45 minutes below Leopard Ravine. The place, both saddle and slopes, is over-run by gorilla. Admittedly, and especially in view of the vocalizations we heard some 11 days ago, a lot of these tracks may be attributed to Group 9 or Groups 9 and 8, but still the terrain of the mountain in that area is super for gorilla territory, so perhaps there are other groups as well ….

I assure you that I carried my maps very importantly in one of those brown binders and often took them out with many a flourish pointing out markings of mountains and craters with a great know-how …. By the time we finally arrived at Ngezi … I was lagging a bit behind the group and very tempted to throw the entire damn '&£@$:? of maps and binder into the Lake. What a trek! The porters were terribly nice about it all—even those carrying the sacks of potatoes and tents gave us a little ovation upon finding Ngezi. I'll bet the next time they see the Mlle setting out with brown binder in hand, they'll run in the opposite direction and fast.

ABOVE Dian lights a kerosene pressure lamp in preparation for a long evening typing up field notes.

Back at Karisoke, the foul weather had continued, a blessing in disguise since it gave Dian the opportunity to catch up on more of the interminable paperwork.

BELOW Alyette and Dian oversee the digging of the foundations for a new cabin at Karisoke, in preparation for a new research student.

I am not too ashamed to say that I've spent the days working and finally finishing the clean typing of the Census Workers Manual (that much work demands capital letters) and also finished the charting and all the cross indexing of the … Visoke notes, leaving only the Kabara material to chart. The weather has been beastly with total rain and, or, fog the day long until two days ago when it began to clear slightly. While I've been grumpy and typing the men have utilized the time to finish the foundation of the new house, dig

ABOVE Dian's best friends at camp—her dog Cindy and her monkey Kima.

the trenches, cut the necessary wood and collect mountains of stones and sand for its fireplace.

A minor disaster also occurred; Kima, Dian's pet blue monkey, lost its doll and became "unbearable." She wrote to Bob:

I've been tempted to send you a telegram to ask you to PLEASE send on IMMEDIATELY another "toto" [child/baby] for Kima. Her own disappeared …. Now we are all paying the penalty for the loss …. I spent the afternoon of the day you left sewing her up a "new toto" out of an old sock. The results of this great bit of creativity (it kind of resembles a monkey) absolutely terrified her for the first week, but now she is beginning to take to it reluctantly but still can't carry it about for she continually trips over the tail, legs and other very "realistic" appendages. Please don't guffaw BUT PLEASE DO SEND ON AIRMAIL another toto like the first with bells on its ears so that we can keep track of it. I'm serious.

Dian finished her letter, as she often did, with a shopping list:

One good packet of typing paper … tracing paper … five pounds of popcorn … chewy substances for Cindy would be much appreciated … and only if you have room in your car … a dozen shandies. Yesterday I stole two of yours to put in the knapsack for Alyette and myself …. When we finally did arrive at Ngezi I opened them and just about forgot everything. They are so refreshing and ten times better than beer or alcohol.

While Bob was away, Dian found herself, for the first time, suffering from a "wee bit of loneliness." She had been expecting to enjoy a month on her own before Robert Hinde,

from Cambridge University, came to visit, but was surprised to find herself missing Bob's company. The weather, which continued to be wet and foggy, contributed to her depression. She was, however, feeling fitter than she had done for a long time, as she explained to her parents:

I do find myself in excellent health here in spite of the comparatively meager diet. I guess a lot of this has to do with smoking, which I don't indulge in to a great extent on the mountain, plus the clean air and the tromping about. It is good to feel fit again. For a while at Cambridge I thought I was reaching the pine box stage

One reason I don't get anything done at night lately is due to the elephants. They have been coming in droves in the full moon to play about the cabin. They are hard to ignore!

BELOW Although Dian wrote that elephants were frequent visitors to the camp, this was an exaggeration. These shy creatures were rarely seen around Karisoke; Bob Campbell managed to capture this elephant belly deep in the nettles.

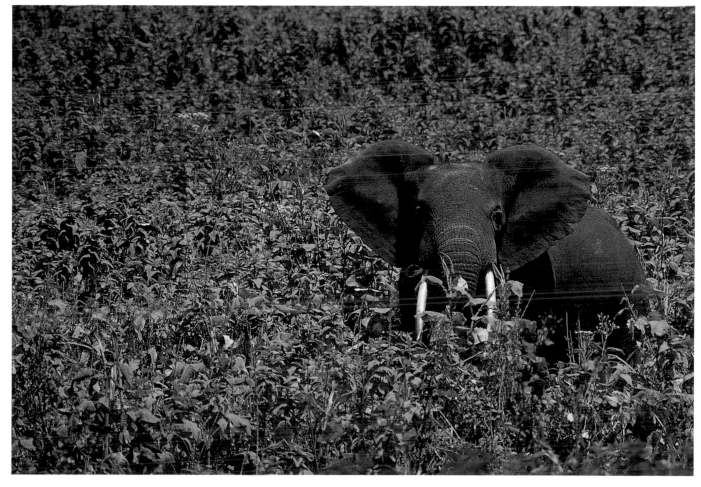

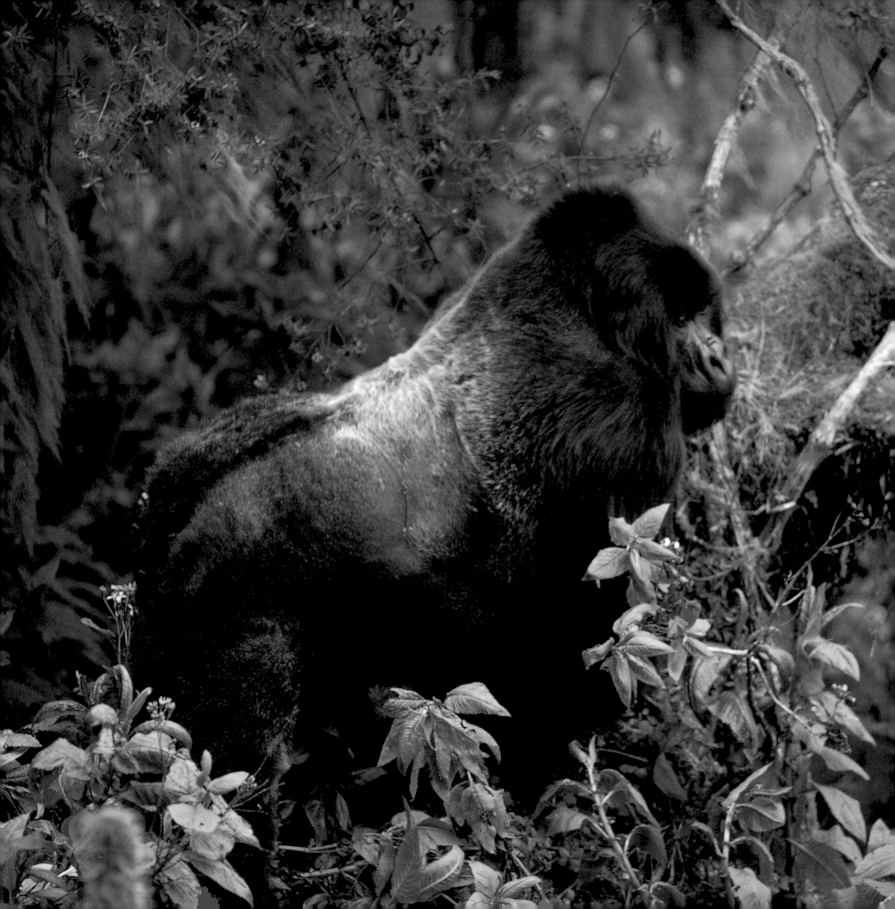

Dian's description of night-wandering elephants was, Bob Campbell believes, another "bit of Fossey fantasy written to impress her parents."

Dian spent time observing Group 4 whenever possible, usually with Vatiri, one of the Rwandan trackers who worked at Karisoke. This family was led by Uncle Bert, a young silverback who reminded Dian of one of her favorite relatives and so was named after him. Dian's own Uncle Bert did not take the compliment as it was intended and never quite forgave her.

Bravado, one of the young female members of Group 4, was unusually forward—hence her name. At the time Dian wrote this note to Bob Campbell, Bravado was thought to be a young male. (It is very difficult to distinguish the sex of an immature gorilla.)

Just a note to let you know that Bravado misses you. He came up a tree I was in today, walking past me as though I wasn't there and reached the top to look for you and eat. On his way down, some ten minutes later, he came walking right up to me with no hesitation whatsoever and pushed me on both shoulders as if to say "Get the hell out of my way." When I didn't budge he had to go off the side breaking a big limb which sent Uncle Bert into a vocal frenzy, but all he did was go and hide ….

I will admit to not holding the camera very steadily! Anyone in the market for black, blurred pictures of gorilla noses?! That little devil is afraid of nothing—he left the group some 60 feet behind just to come and look for you. Instead, of course, he found Vatiri crouching in the foliage trying to hide—his frustration was comical! The weather is still beastly—really horrid.

While Dian made some rewarding contacts with gorillas, she grew increasingly infuriated as the study area around camp was still being regularly invaded by poachers and Tutsi cattle herders. Returning to camp one evening in May, Dian witnessed a sight of such great cruelty that she was provoked into taking extreme action. She wrote to Bob Campbell to explain:

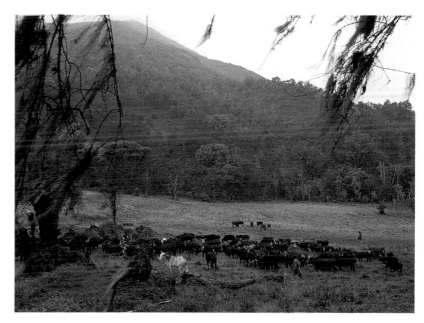

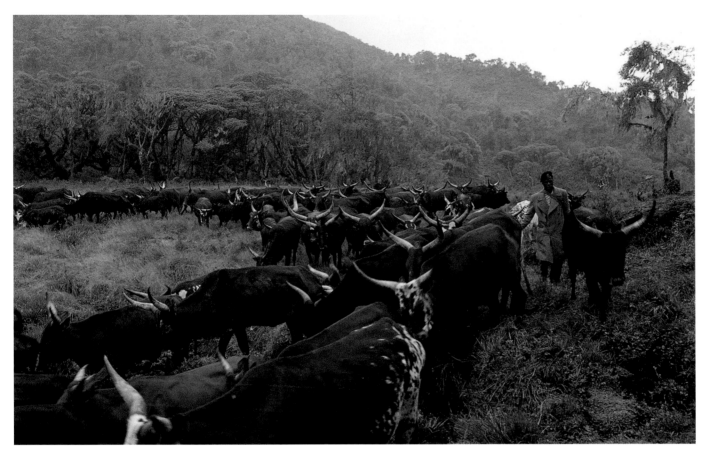

LEFT Munya driving the cattle away. The constant incursions of illegal Tutsi cattle into the woodlands between Visoke and Karisimbi disturbed the gorilla groups and were an endless source of frustration for Dian.

A poor buffalo had gotten itself wedged in a big Hagenia [tree] near camp and someone, not from camp, had come along a few days ago and cut off both its hind legs. How the poor thing had endured this agony and torment for such a length of time is beyond me, but it was still willing to fight for what remained of its life and was so courageous in its final bluffs. I really detested having to kill it, and in true Fossey style, went to pieces while pouring the gun into its skull. I'll never forget those eyes. Then took my wrath out on the men and today they are very submissive, but that's probably because their bellies are bursting.

They figured that Tutsis must have done this so as to sell the meat. In view of the fact that I've not seen or heard a trace of a poacher lately and that there has been a herd of cattle below camp I gave up gorilla today and tracked Tutsis instead. We saw 3 from a distance and I fired a clip at them. We followed their tracks … [I] found behind a nearby

tree a little Tutsi toto [child] so [I] kidnapped him and said I'd hold him for a spear. We had just about returned to camp with the little dirty thing when of all people, Mutarutkwa showed up "saluting" at a vast distance—the brat was his, and he had no spear for you had already stolen it! Naturally I returned the bratWe told them that you were sitting in your tent every day waiting to kill them

Must close for now—I am going to try to figure out a way to make "jerky," for a whole buffalo divided among four men and a dog is a bit much. Hope all is going well at home.

Mutarutkwa was a local, influential Watutsi herdsman. It had been his cattle Dian had confiscated—and threatened to kill—when her dog Cindy was kidnapped. Over time, Dian and Mutarutkwa developed a mutual respect and eventually the Rwandan not only rescued trapped animals from the forest and brought them to Dian for treatment, he even joined her anti-poaching patrols.

The suffering of the buffalo had greatly affected Dian. Each time she witnessed human cruelty to animals a little more of her armor was removed and she became less able to cope with the distress it caused her. Without Bob's calming and rational influence, Dian reacted with anger and violence. When she wrote to him in May she asked him to send her more bullets.

I've been shooting cows to avenge the poor buffalo so have been going through bullets like mad Firecrackers aren't really much good to injure and cripple cattle.

Despite more damp and foggy weather, contact had finally been made with Group 8.

Group 8 [was] finally found, way the hell over near one of the small craters on the other side of the mountain, with Group 9 on this side of the ravine and Group 4 all over the saddle. I think they've all gone

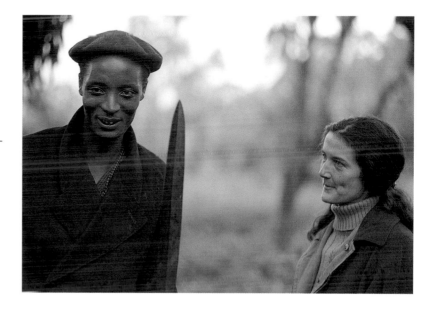

BELOW Tutsi herdsman Mutarutkwa with Dian Although the two got off to a bad start, they developed a mutual respect over the years and eventually the herdsman helped Dian in her anti-poaching patrols.

nuts! Not a sign of Group 5. Alyette is coming up with good notes—when she puts her mind to it that is. I am thoroughly pleased and satisfied with what she has found although today she sent one of her men up with last week's notes—I really had to tease her … for she insists she has seen a female gorilla with 3 nostrils!!

I was rolling on the floor by the time I read her French-styled English and saw the sketch she had made of this animal. I don't doubt her for a minute but would like to see the animal for myself first.

BELOW Pug of Group 8, one of the maturing blackbacks.

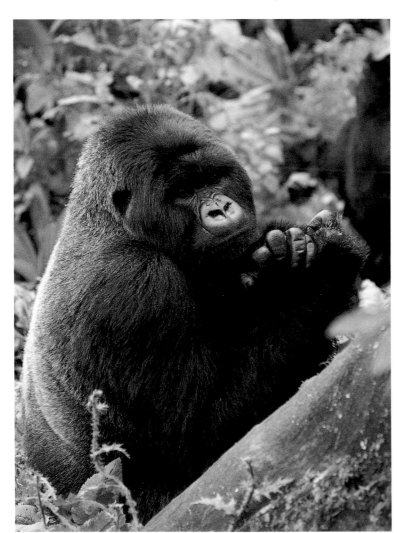

By June the strain of coping with camp on her own was really taking hold. Without anyone to check on her, Dian's behavior had become increasingly rash and her moods were volatile. Although Bob's return date had been decided before he left Karisoke, Dian believed he was due back sooner. Her confusion stoked her fury, as she wrote to her parents.

Am going round the bend trying to get things down—ever so many reports to write in addition to everything else. It's not fair. Campbell will be back next Tuesday. He took it upon himself to spend 2 more weeks in Nairobi than originally planned and, unfortunately for him, this has cost him his job here. I have recommended his dismissal when I leave so that the work and observations of the boy that is coming from England [Alan Goodall] won't be interfered with by photography.

On his return to camp, Bob Campbell did some hard thinking about his assignment. He had come to the conclusion that the best photographs and film footage would only be achieved if he broke away from Dian's

long-standing non-intrusive stance, and purposefully moved in on the animals. This approach ran the risk of upsetting the gorillas, or disturbing their behavior—but it bore the potential of unobscured, close-up photography and Dian agreed he should give it a try. In time, the new habituation technique was to reward Bob and Dian with some emotional contacts with the gorillas and intimate photographs.

As the summer drew to a close Dian prepared to leave, not expecting to return until the spring of 1971. First she would travel to the United States, where she would meet up with staff from National Geographic, give lectures and spend some time with family and friends. Afterward, she would return to Cambridge for two terms to complete her doctorate. Dian decided that Bob Campbell should also leave camp for a while, in order that Alan Goodall could have sole charge of the camp.

Rwanda: July 31, 1970

Dear Mother and Father,

… The new boy [Alan Goodall] arrived on Saturday and we climbed to camp on Tuesday after much shopping, etc while still in civilization. The preceding week was spent building his cabin which I must say is beautiful—big fireplace, etc. I wish I could live in it and certainly intend to one day. The Belgian Ambassador plus the consort of the Queen and King of Belgium climbed up on Wednesday to see gorilla—thank God they couldn't spend the night for I'm losing my cool rapidly. Naturally the new man wants to ask a million questions and learn; Bob

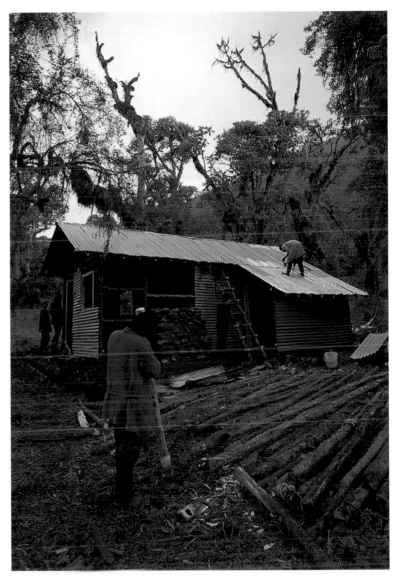

ABOVE The second cabin was built for Alan Goodall, who was to take charge of the camp when Dian returned to Cambridge.

*wants pictures—ciné and stills—and I've tons of packing and sorting to do—temper is
not the best. Now the German and French Ambassadors want to come before I leave and
I had to decline and ask them not to—bad diplomacy but unavoidable*

Must close—will be talking to you within 16 or 17 days. Won't that be fun!

Much love,
Dian

Alan Goodall had only 13 days with Dian before she left to go to the United States. During
that time Bob Campbell took more photos of Dian with the gorillas for NATIONAL
GEOGRAPHIC—a task that took priority over training the new recruit in the art of gorilla

tracking and the techniques involved in studying gorilla groups. Alan Goodall did learn two important lessons though; he was taught to respect the gorillas and never follow them when they had decided to move on after a contact, and he was shown how to chase cattle from the study area. Like many other researchers who came to Karisoke, Alan Goodall found himself wondering exactly what his role would be. He wanted to study the gorillas, not chase local Rwandans away from their own forest; yet he knew that unless the steady encroachment of poachers and herders was stopped, there would be no gorillas left to study.

BELOW Dian points out a silverback's night-nest to Goodall

This dilemma might have been easier to resolve in Alan Goodall's mind had he been able to discuss it with his companions. Instead, he discovered that after writing up their notes every day, each member of the camp was expected to cook their own meal and then eat it alone.

BACK IN THE STATES DIAN was overwhelmed to discover that she was, in small measure, a celebrity. Louis Leakey had arranged for Dian to be the featured speaker at a fund-raising dinner for the Leakey Foundation, and her talk was a huge success.

Dian Fossey now had the authority and respect she deserved. Her meetings with the National Geographic Society went equally well; they approved of the census work undertaken by Alyette De Munck and were enthusiastic about Bob Campbell's photographic achievements in the field. It began to look as if the Research Centre in Rwanda had a long-term future.

After giving a speech in Los Angeles, Dian wrote to Bob:

I have no right starting out on a letter to you tonight as I've just returned from L.A. and SPEECH—urks—so am tired but not a bit cranky as it is all over. I found your wonderful letter awaiting and do want to answer it straight away

You simply cannot believe the response in America—from all walks of life, (including two top-notch people within N.G.) that this study has received. I think it is all rather comical although at the same time I am ever so grateful because it may mean the salvation of the gorilla and this is what really matters

In this letter Dian urged Bob not to go to Washington and visit their National Geographic Society sponsors, a plan he had been mooting. She had also insisted that he leave Karisoke during the period of Alan's management at camp; Bob later attributed both of these dictates to Dian's desire to be associated with his increasingly successful habituation techniques: her plan ensured that he would be away from Karisoke for the entire duration of her trip abroad. Dian's insecurities about her ability to perform the research project she had undertaken had only been partly mitigated by the praise she was receiving.

Dian was mixing with influential people and she used the opportunity to advance the cause of active conservation. The more time she spent in the Virungas, the more convinced she became of the necessity to patrol the park boundaries and physically remove

ABOVE The Rwandese park guards and the conservateur, dressed in uniforms that Dian had obtained in Washington.

invading poachers, herders and cattle. Her campaigning began to get results:

The Leakey foundation gave me a tidy check for equipping the guards. I went to an army surplus [store] *in Washington and bought 13 pairs of combat boots; 20 pants; 20 shirts; 20 berets; 20 insignias.*

While Dian was enjoying herself in the United States, there were troubles at camp. Bob Campbell had left Karisoke and Alan Goodall was finding it difficult to settle in; not least because his mother had died shortly before and his wife, back at home, had just given birth. Eventually his wife and baby daughter would join him at Karisoke, but until then he was the only European at camp—and very lonely.

Contacts with the gorillas were difficult too; Dian had suggested that Alan choose Group 8—a unit of just five males—as his study group. Unlike the habituated Group 4, which promised many good contacts, Group 8 were always on the move and tended to trek both further and faster than any of the other study groups. Even with the skilled help of Nemeye, an experienced tracker, Alan was faced with a real challenge.

He set about his work, but like Dian and Bob, found the presence of poachers and cat-tle herders a constant worry. Dian had been shooting at cattle after the buffalo incident, and Bob had accidentally shot one Tutsi herder (without causing serious injury). Alan wrote to Bob Campbell to describe an encounter he had had with some poachers. He wrote that he had been trying out Bob's technique of firing over the heads of the poachers and the Tutsis—but when this had failed to scare them away he had resorted to shooting two men, both poachers, in the leg. In his

BELOW Nemeye (on the right) was a skilled tracker and proved an invaluable help to Goodall throughout his tenure at Karisoke.

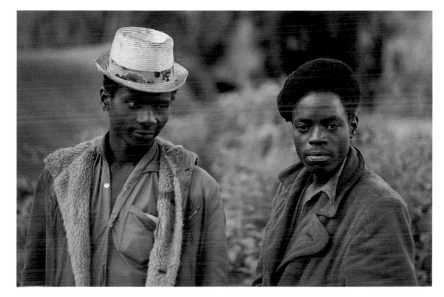

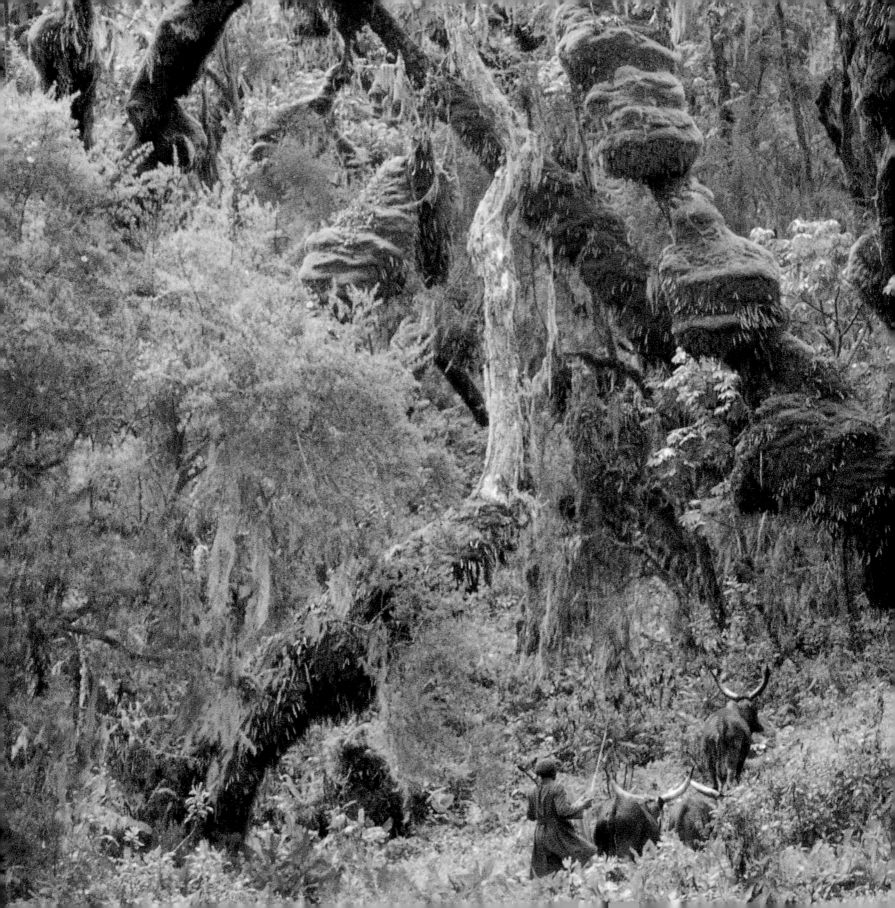

letter, Alan then described how he had found a camp of about 12–15 poachers, where
he had taken hold of a selection of their weapons and narrowly avoided being stuck with
a spear by one of the men. "The dramatic action of shooting someone in the leg seems
to have worked," Alan finished, "but unfortunately so far all Tutsi legs have evaded my
aim. This is a pity for we still see odd cattle around …."

Dian and Bob were both horrified when they heard about the shootings and neither of
them could be sure that they were told the whole story. There was some later disagree-
ment over how many people were shot, and where: Alan later said he only shot one and
that it was in the leg—but a poacher was treated at Ruhengeri hospital for a bullet wound
in his back. The Rwandan authorities turned a blind eye to the incident, and Alan Goodall
escaped without punishment.

After her enjoyable sojourn in the United States, Dian returned to England in October
for the beginning of the autumn term at Cambridge University. She wrote to Bob about
her misery at returning to the country she disliked so much.

Cambridge: October 3, 1970

Dear Bob,

*… Arrived in Cambridge today after two days in London with Leakey and Jane and
Hugo. I didn't mind the latter so much as I greatly enjoyed seeing Jane again and also
found Dr. Leakey extremely fit and relaxed. Have never known him to look or sound so
well.*

*The nice secretary from Madingley met me at the train this morning and we've spent
some time looking at cars since then. I hadn't realized what would happen once I
returned here—everything is just as though it were yesterday and it is all most unbearable
—can't believe that I'm that inflexible. These next few weeks, providing I can stick them
out, are going to be sheer hell ….*

Not much more to say at the moment, or at least nothing that can be said.

Yours ever,
Dian

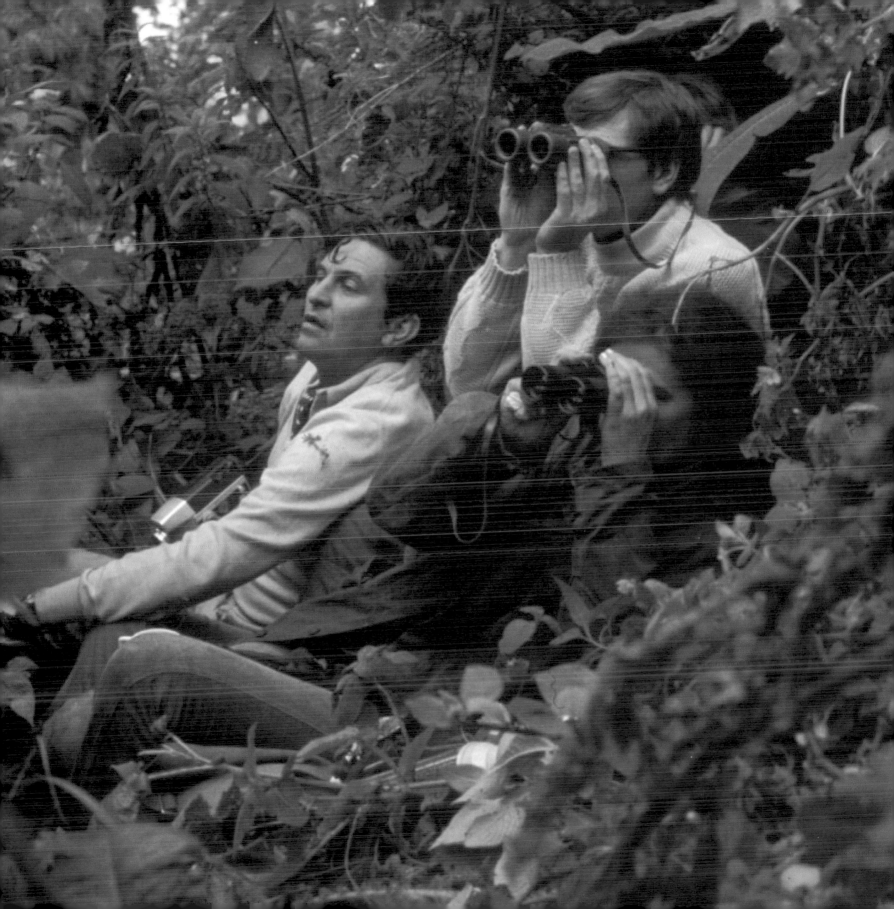

When she wrote to her parents three weeks later, Dian was clearly homesick and felt out of her depth in an academic environment.

Thank you so much for the pictures—I think that they are super and I am so very, very happy to have them. You both would be kind of embarrassed if you knew what they meant to me. I think my favorite is the one of you both in the kitchen on chicken frying day!

… I am having … trouble adapting to this horrid country …. [I] toured the southern part of England … for five days which was a total waste of time. Practically 80% of the roads in this country are only two-lane and are filled with lorries (trucks) and road repairs which make driving a real chore and agony. The countryside may be beautiful but you are so busy getting around the next truck that you can't look out the window of the car to appreciate [it] ….

These past six days of touring drove me to distraction simply because of the work that is piled up in front of me—it is unbelievable. I've been working on a calculator some 5 hours a day, have been introduced to my own programed computer one hour a day and then must work on statistics concerning field data another three hours a day. Where the National Geographic article will fit in I just don't know for I go to bed each night filled with mathematical formulas and toss and turn all night long trying to solve them in my sleep. Am afraid I'm just not cut out to be a scientist. Was really almost hoping that the grant for two more terms wouldn't come but don't you know, they couldn't wait to get it in the mail and not only that, they increased the size of it!!!!

BELOW A letter from Dian on Madingley headed paper. The time she spent on her Ph.D. at Cambridge was unbearable for Dian; she couldn't wait to get back to Africa.

UNIVERSITY OF CAMBRIDGE
(Department of Zoology)

SUB-DEPARTMENT OF ANIMAL BEHAVIOUR
MADINGLEY, CAMBRIDGE CB3 8AA

Telephone: MADINGLEY 301
(STD Code: 09 542)

Director: DR. H. W. LISSMANN, F.R.S.

October 31

Dear Mother and Father,

I was deeply saddened by the news of Connie's death and can only imagine your own sorrow in loosing a friend of so many years. I wrote the Knowles a note but cannot find the address you enclosed so am enclosing the note in this letter if you think that it can be sent on at this late date. I hesitate to ask the cause of her death as it seems a rather crude question, but I do wonder about it. I remain grateful for her insistence upon spending the night so to visit with her again and then to correspond with her after that. She seemed so very pleased about the newspaper article concerning her accomplishments and success in her work - she really was happy in that work, don't you think?

Thank you so very much for the pictures - I think that they are super and I am so very, very happy to have them. You both would be kind of embarassed if you knew what they meant to me. I think my favorite is the one of you both in the kitchen on chicken frying day! Say, by the way, it was my expression - "Salvation Army Look" - that described my outfit - Mr. Gompert could never be that original!! However, in way of afterthought, when you look at these pictures, it does seem the only obvious conclusion.

I can well assure you that the bill you sent on to me wasn't my own which had long since been paid from Kentucky. I returned the lot to Spiegel's office with the suggestion that they reprogram their computer or hire an efficient secretary. That same evening I also wrote to my dentist asking for a refund on two fillings - have yet to hear from him! I'm sorry but inefficiency will always bother me, especially if it is my own and secondly when someone else is to blame.

Last Saturday Roger Baert came for a week's visit - left yesterday. I really wasn't in the mood to entertain a guest in view of the fact that I am having enough trouble myself adapting to this horrid country. He gave me very little warning and I was on my way to see Mrs. Caldwell who was stuck in London with a severe strep throat after the African excursion but she was being well looked after by friends. I ended up not seeing her at all (although talked to her via phone for a lengthy period) and toured the southern part of England with Roger for five days which was a total waste of time. Practically 80% of the roads in this country are only two lane and are filled with lorries (trucks) and road repairs which make driving a real chore and agony. The countryside may be busy getting around the next truck that you can't look at the country. While in London (only to see

When Dian received a letter from Alan Goodall in November she expected to hear news of camp. Instead, she discovered that Alan had been contacted by the Park Conservator on October 27 and had been given some terrible news: a group of six gorillas had, apparently, been stoned to death near the park boundary after wandering into a village. Alan was not sure of the details but had been told that a child had been bitten by a gorilla and that the villagers had massacred the group in retaliation. Alan had collected the decaying bodies of five of the gorillas (the sixth was never found) and brought them to camp for research purposes.

Dian did not believe that the gorillas had been stoned to death, and immediately suspected that this group (probably Group 10) had been killed by poachers in order to capture an infant on behalf of a foreign zoo. This could explain the missing sixth animal. She wrote to Bob Campbell:

I can't tell you how happy I was to receive your letter for like yourself I also feel very remote from the project. That, in addition to being so far removed from everything I know and love is making life almost unbearable ... today marks eleven days past the half-way mark of time spent in purgatory!

No, Alan is not the best correspondent in the world, nor does he answer pertinent questions when asked. I try to remain cognizant of his newness to the country, which, when coupled with his obligations to family and study, must obviously put correspondence to the bottom of the list

I am enclosing a part of Alan's letter pertaining to the deaths of the mountain gorillas —this I typed up from his written letter and have sent to quite a few authorities connected with conservation. I have since found out that one young gorilla—no further details—has left the port of Nairobi for Europe from Rwanda within the past month. Obviously Alan's account of the slaughter is entirely false for no group of gorillas could be stoned to death by a bunch of irate natives. I wonder about Alan's sense of observation— stones are not to be had within our section of the mountains—I'm afraid I really damn him for his innaccuracy while at the same time I applaud him for getting the remains up to camp. That was a herculean task.

I don't much like even thinking about this massacre ... it has just destroyed what was left of me. The group was killed in approximately the same area as Coco and Pucker were captured—and I am convinced they were killed to obtain more infants.

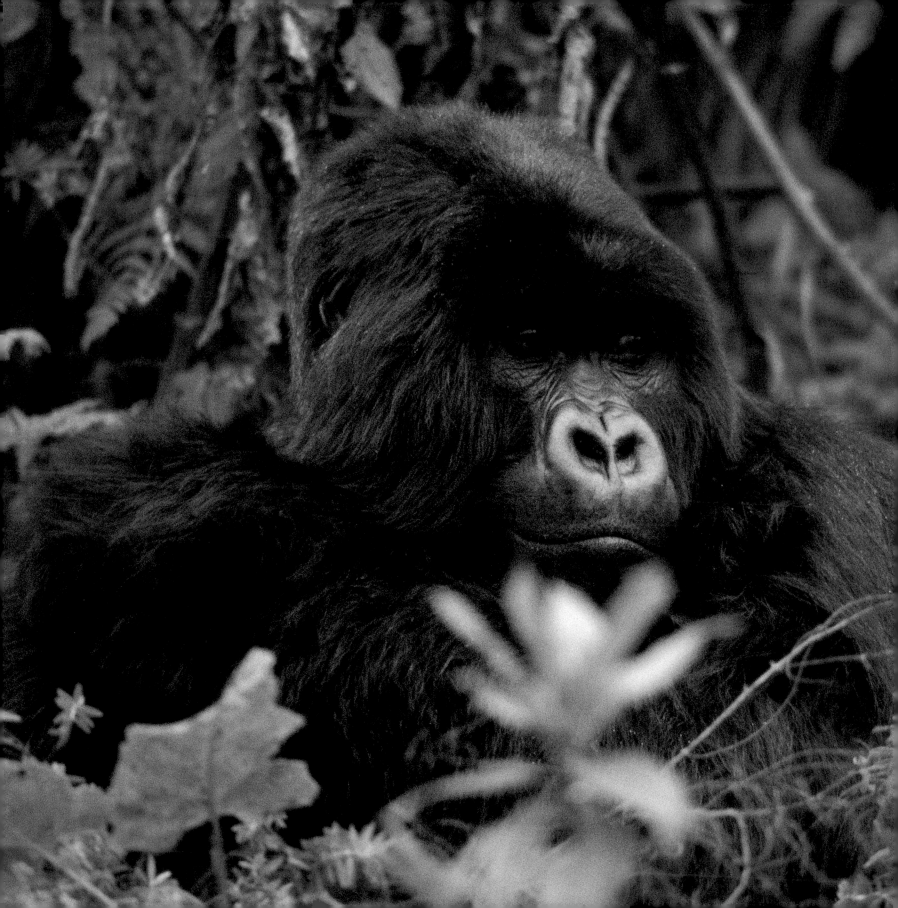

Alyette De Munck later visited the site of the massacre and confirmed Dian's suspicion that the gorillas could not have been stoned. The stones in the area were all too heavy to be handled, and she believed they had been attacked with spears and arrows. She was told that the killings had been carried out in retaliation for Alan Goodall's shooting of the poacher—and possibly also as a result of Dian's aggressive and sometimes violent behavior toward cattle herders.

There was evidence that a notorious game hunter was in the area at the time, so it is not implausible that the gorillas were killed in order to capture an infant for a zoo or collector. Nor is it improbable that the people, whose livelihoods depended on the forests of the Virungas, wanted revenge for the way they were being treated. If there were no gorillas, after all, there would be little interference in their use of the natural resources the forest offered.

In either event, all those involved in the management of the park shared some culpability. Mountain gorillas were, and remain, an endangered species, yet the Rwandan authorities showed little interest, at the time, in protecting them. That task had fallen on to the shoulders of Dian and her staff—who were only able to patrol a tiny portion of the vast national park.

ABOVE Dian photographs her growing collection of gorilla skulls.

As another eventful year for Dian Fossey drew to a close, she was given some exciting information that lifted her spirits; she discovered that she could leave Cambridge earlier than expected, on March 6, and would not have to return in 1971. Work on a second NATIONAL GEOGRAPHIC article, however, was not going well. She wrote to Bob Campbell:

I'm having a really desperate time with the N.G. story—it just won't work. I never dreamed that I couldn't write it here but that's the way it's turning out—I simply can't write. I am really defeated about it. The words just won't come and I've tried so hard. This will be the first time I've let them down which is even more distressing and makes my efforts even worse.

OPPOSITE Dian felt that the responsibility of protecting the mountain gorillas from extinction had fallen solely on her shoulders; the authorities in Rwanda had other priorities.

The more time Dian spent in England, the more peculiar the country seemed to her. During the winter of 1970 she tolerated an extended Christmas break and also witnessed national strikes, the three-day week and a country on the brink of apparent social and economic collapse.

Cambridge: December 26, 1970

Dear Mother and Father,

I met the most wonderful Santa Claus yesterday—not only has he removed all the wrinkles from my face but he has also warmed up my feet for the first time since I came to England. He also saw fit to attire me in a wild but perfectly fitting blouse which has already caused some controversy whenever I wear it. He has fitted me also in a perfectly wonderful pair of warm gloves and also saw fit to complete the attire with a fringed handbag that must be seen to be believed and will undoubtedly make the cover of the N.G. I feel that I'm a very fortunate "young lady" and do want to thank you for all the wrapping and packing that you went through on "his" behalf. You have no idea how your parcel made my Christmas, in fact was my Christmas ….

Christmas in this country is a rather prolonged affair … everything closed down on Thursday and Saturday was what they call "Boxing Day"—the day after Christmas which … from what I can gather from these ridiculous, decadent people, is more of a celebration than Christmas …. Monday is also a holiday—total five days in all with no grocery stores open and very, very few gas stations. It's really quite unbelievable. Far more uncivilized than Africa. I haven't really minded all the strikes within the last six weeks—no coal, no electricity, no buses, no post, no garbage collection ….

News from Rwanda has been increasingly bad and it's taken all the discipline I can muster up not to return straight away …. At the moment I am really depressed about the way camp must be going. I know that if I had been there these gorilla wouldn't have been killed ….

All my love, Dian

Dian took French lessons at Cambridge in preparation for her return to Rwanda, where French was the lingua franca of the administration. She was kept busy with her

vocalization paper, which was nearing completion in January, and caught up with all her correspondence—for the first time in two years.

News of Goodall's shooting of poachers and the subsequent gorilla massacre had reached the National Geographic Society in Washington. Not surprisingly, the Society did not want to be associated with a research project where such things happened, and the renewal of Dian's grant was put on hold. Bob Campbell went to Washington and, unknown to Dian, argued her case, pointing out that she had neither shot anyone, nor been present while the shooting had occurred. The grant was approved for another year and shortly after Dian returned to Karisoke, in spring 1971, Alan Goodall and his family went home to England.

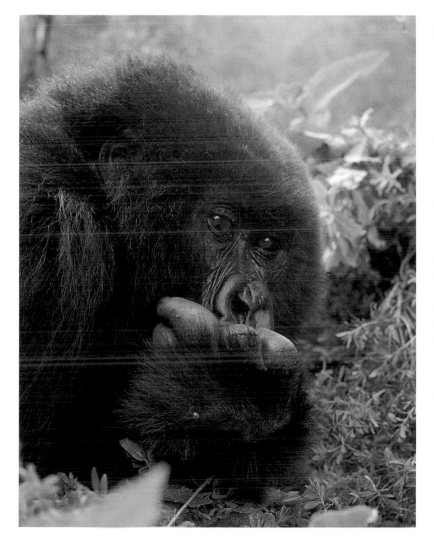

BELOW A portrait of Dian and Bob's favorite gorilla, showing the damaged finger that inspired his name—Digit.

BACK AT CAMP TOGETHER Dian and Bob Campbell continued their affair and their assignments. While Dian trained new census workers and completed ever-more paperwork, Bob built himself a cabin and finally moved out of his rotting tent. He spent many more hours in the field: the gorillas grew to accept his presence and he was able to take extraordinary photographs at close range. Every evening he would report aspects of the gorillas' behavior to Dian, who would write them up.

There was one gorilla, Digit, whom both Bob and Dian particularly favored. Dian had first encountered Digit, a young male of Group 4, in 1967 when she estimated his age to be five years. In 1969 he was given his name "Digit" by Bob, because he had a damaged finger on his right hand. In the latter half of 1971 the couple spent many contented hours watching and photographing the antics of the boisterous and

playful youngster. Their habituation techniques had worked spectacularly well in Group 4, and Digit increasingly found the regular contact with humans especially enjoyable. In *Gorillas in the Mist*, Dian wrote:

Digit really looked forward to the daily contacts with Karisoke's observers as a source of entertainment He could tell the difference between males and females by charging and whacking men but behaving almost coyly with women. If I was alone he often invited play by flopping over onto his back ... looking at me smilingly as if to say "How can you resist me?" At such times, I fear, my scientific detachment dissolved.

Karisoke became home to more research students and census workers, including Alexander (Sandy) Harcourt—who was to figure greatly in the future of the research center and gorilla conservation—and Graeme Groom. Dian was immediately taken with Sandy, who was efficient, serious and committed. Not all workers at the camp were as diligent. Many of those who worked with Dian at Karisoke, staff and students alike, suffered her wrath; Dian was quick to vent her anger when people's efforts or achievements fell below her expectations. In July, Bob had gone back to Nairobi for a break, and Dian and her staff were building a new cabin. Dian wrote to him:

Sandy seems to be getting on alright although he does send quite a few notes over! He has found a lone silverback on the edge of Ngezi Crater where Alyette also noted one yet he pursued [it] until he got nose prints of it—within 30 yards if I recall correctly.

He then found 2 adults, one he thinks is a silverback ... he then found 2 more and got nose prints. I think he is doing quite well. Says that he sees elephant and buffalo frequently now, has raided several ikiboogas (!) [temporary shelters] and has found all types of snares and traps that I've only read about.

BELOW Porters help set up camp for Sandy Harcourt at the little lake below Ngezi crater, close to where Michael Burkhart had stayed earlier.

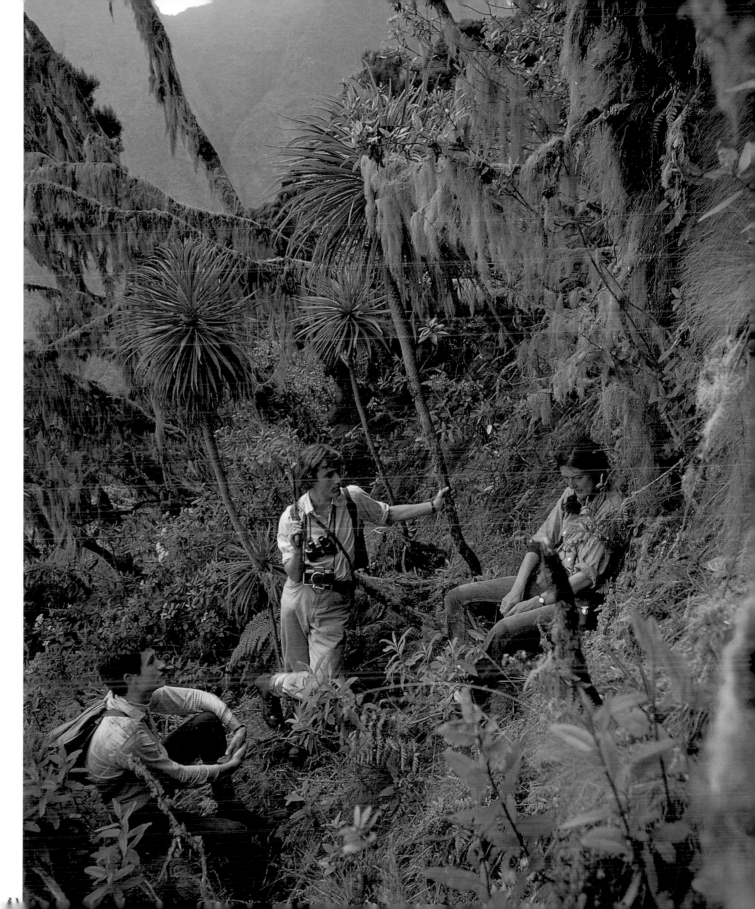

RIGHT The arrival of two new research students, Sandy Harcourt and Graeme Groom (pictured on Mount Sabinio with Dian) gave Dian renewed hope for the future of the camp. Sandy in particular was a dedicated and intelligent worker.

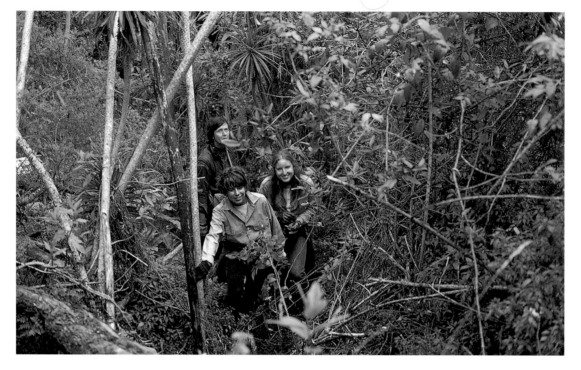

Two girls who were supposed to be continuing with the long-running census were not so impressive.

They arrived shortly after you left. They said they'd left all their money and reports outside the tent. Could I pay their men and wait for their reports until they returned? Instead I sent their men back over for everything which made everyone mad. They've brought a goat "to love" and told me in leaving that they'd forgotten to lock the car!

I've done the work up on their notes and am not at all pleased with the conclusions. They feel they've a total of 50 animals but I can only allot them 23 which is quite a substantial difference!

In October NATIONAL GEOGRAPHIC published the second Dian Fossey article, entitled "More Years with Mountain Gorillas," and Dian busily worked on a chapter for a National Geographic Society book on animal behavior. Sandy Harcourt and his colleague, Graeme Groom, had returned to England to continue their studies at Cambridge—much to Dian's sorrow, as she described in a letter to her friend, Rosamond Carr, on October 15, 1971.

I can't tell you how sorry I was to see Sandy go, and Graeme was also a fine worker, but Sandy had that extra special quality of dedication and complete honesty that seemed to make him appear of special worth, at least to this study …. Both boys want to return next summer, Sandy … in the hopes of doing his Ph.D. here … I am doing all I can to get them both back, especially Sandy whose will-power, stamina and objective observations make him an outstanding person for field work.

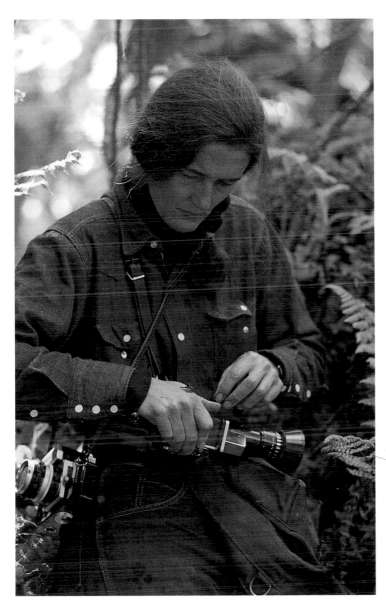

BELOW Dian with her little ciné camera—capturing the gorillas on film helped Dian and Bob immensely in their behavioral studies.

Dian and Bob had been getting extraordinary behavioral observations and ciné footage of Group 4, which had lost some members to Groups 5 and 8. Group 5 had reappeared near the camp, and the young female (who was still thought to be a young male at this time), Bravado, left the group and walked up to Dian and Bob, coming within 1 meter (3 feet) of them.

He looked at us intently while he approached, then gave a show-off type of chestbeat, stared for a few minutes as if to say, "where have you been?" and slowly rejoined his new group. It was a very poignant experience. Bravado was the animal who once tried to playfully rush me out of a tree. We had long since given him up for dead ….

Have finally caught up on a tremendous backlog of correspondence and manuscript work so am able to go out daily with the gorillas (just like old days) and couldn't be happier ….

P.S. Since writing the above I've had another fantastic contact with Group 4—I finally had the chance to put a mirror in front of one young adult's face!!!! [This was Digit] He preened like a teenager getting ready for a prom—twisting his

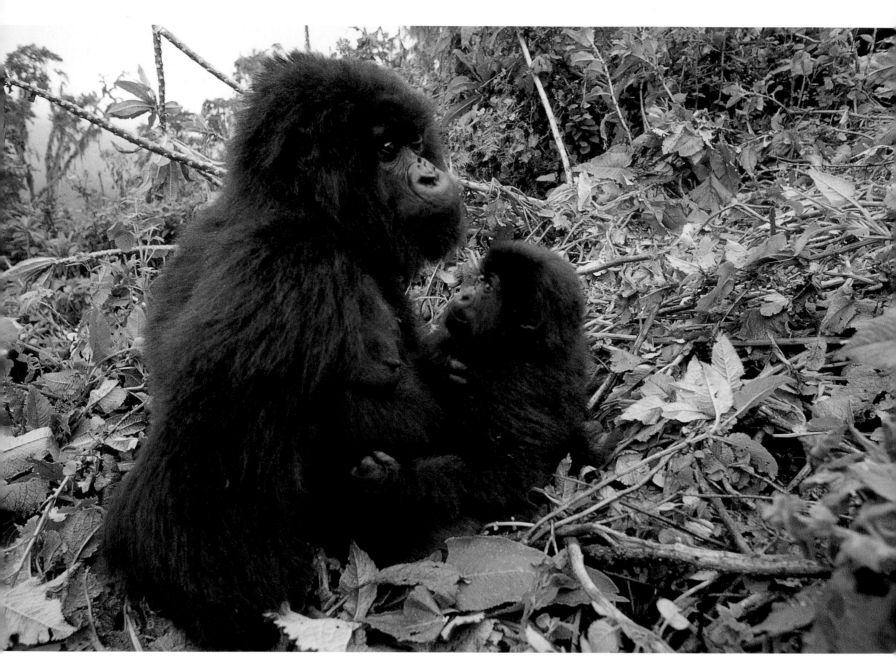

ABOVE Two gorillas from Group 4: Petula and her baby Augustus.

head from side to side with rather pursed lips at first and then lying down on his forearms to first smell the glass and then stare directly into it intently with a gentle, somewhat quizzical expression for 4 minutes. In all he looked at himself for 15 minutes and toward the end of that time reached behind it twice to feel for the animal that wasn't there! Once it slipped slightly so he had to assume a new position in order to recapture his reflection. This was too comical to believe—twisting his body around on the ground with one hind

leg or the other up in the air to keep his balance. This action attracted another animal who couldn't understand what Digit (the young black back) was up to …. What a day.

By the end of the year all the census workers and research students had left camp. Bob went home to Nairobi for much of December and January. When he returned to Karisoke he told Dian that he had made plans to join an expedition at Koobi Fora, in Turkana, northern Kenya, led by his close friend Richard Leakey. This was a continuation of the work Bob had been doing before he came to Karisoke in 1969, and he had always planned to return to it.

Dian and Bob had been in a relationship for over two years, and it was drawing to its inevitable conclusion. Bob was married and had never given Dian any reason to believe that their affair would develop into anything more permanent. Nevertheless, Bob had been a true friend and companion to Dian, supporting her when no one else would. Together, they had grown closer to gorillas than anyone else ever had before. She did not want to let go of this man, whom she dearly loved; Dian told Bob that if he went to Turkana he would not be welcome back at Karisoke. She went to visit her close friends, Alan and Joan Root,

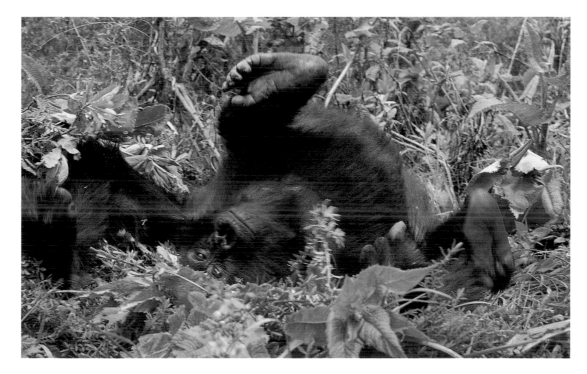

LEFT Digit shows why he was Dian's favorite, rolling around and showing off in front of the camera, quite undisturbed by her presence, or that of Bob Campbell, the photographer.

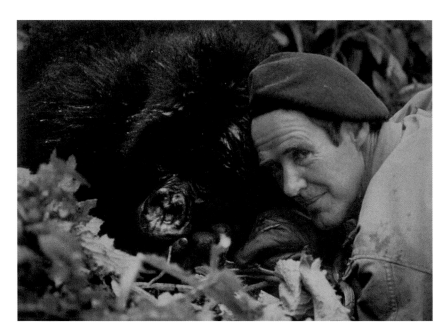

ABOVE Bob Campbell
with Digit—a shot taken
by Dian.

seeking advice and solace, and wrote to her parents in April 1972:

I've had a good cry over your letter and then—wiped my tears … am not brave enough to say I haven't been "hurt," for a while I thought irreversibly so, which is one reason I went on to Kenya. It was either that or go out of my mind (again???). I returned rather well bucked up with Alan's philosophy on life which suits my own—was beginning to get a bit tattered by the time Bob left for Nairobi on March 22nd. Richard Leakey had asked him to be present at Lake Rudolph [now Lake Turkana] during the visit of the Duke of Edinburgh. Bob, of course being Bob, was thrilled by the prospect. Alan was also asked, and in fact demanded to go by the head of the BBC, thus refused!

At any rate, Bob will be returning in some 4 days' time and I've had nearly 3 weeks of solitude to think things over. The first week was grim, to put it mildly—rather like being widowed, but now again, I hope I have a stronger hold on myself. Am more resolute than ever that Bob cannot possibly return after the end of May when he goes on to Rudolph to film for Leakey and N.G. I had given a small hint concerning this the night before he left which wasn't very wise and thus he left in a bit of a huff. As you have stated, "it was fun while it lasted" (the under-statement of the century) ….

Still, I simply can't believe that the life we have shared so fully in every way together, without pretense (so I thought) will shortly be coming to an end. There really can't be any other recourse for it is no good gearing your life around someone if their life is obligated to someone else or if they cannot make a decision one way or another. I hope to be able to hold off the finality of my decision until the latter part of May. In this way Bob can go on thinking things are fairly okay. Unfortunately for Bob anyway, it is solely my decision as to who comes to this camp and N.G will not dare buck it. I am deeply sorry for him if only because he can't seem to be true to himself—a fact that he has often stated.

Dian wasn't just nursing a broken heart; she had been bitten by a poisonous spider and, two weeks later, her foot was still swollen and sore. She had also been attacked by her pet monkey, Kima.

She really made a hash out of my left hand and one finger on my right hand …. [I] worry a bit about a partial severance of one muscle on my left hand—ring finger of all things!

OVERLEAF Dian sets out for a day of gorilla tracking through the mists.

BELOW Digit carefully examines a glove.

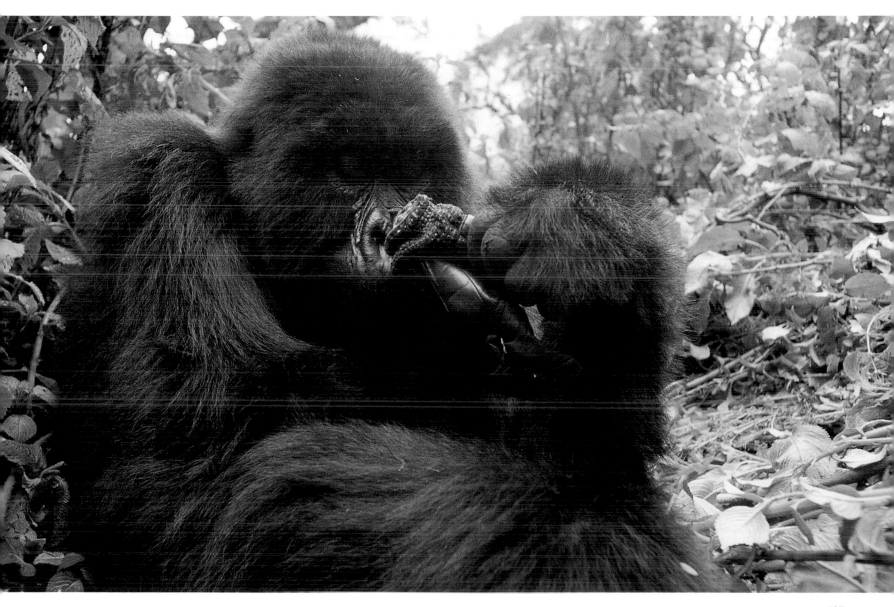

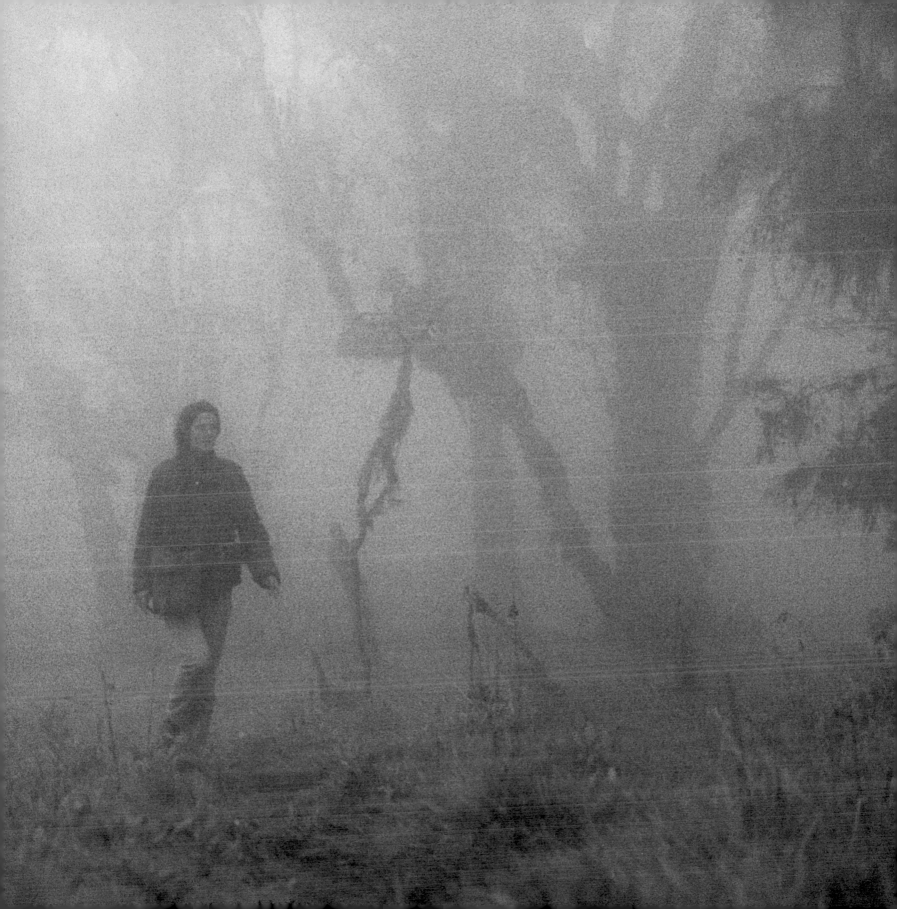

For these reasons ... I've not been following the gorilla daily since Bob left and have returned to thesis work and camp maintenance work and correspondence The weather is beginning to improve vastly with lovely sun pierced suddenly by hail storms of short duration.

A few days before his departure from camp, Bob Campbell took Dian into the forests for a final contact with Group 4. After nearly three years' work in the field, Bob was finally rewarded with a close-up footage of Dian and a gorilla. Dian had tentatively moved forward to lie next to Digit, who chose to remain despite her close presence. He took a notebook and pen from Dian's hands and then replaced them gently before slumping casually next to her, displaying complete trust. This peaceful interaction was recorded and was later used to introduce the affable Digit to television viewers. Bob left camp on May 29, 1972, after a farewell he describes as "restrained and difficult."

RIGHT Nemeye slashes through the bamboo rods of a poacher's noose snare.

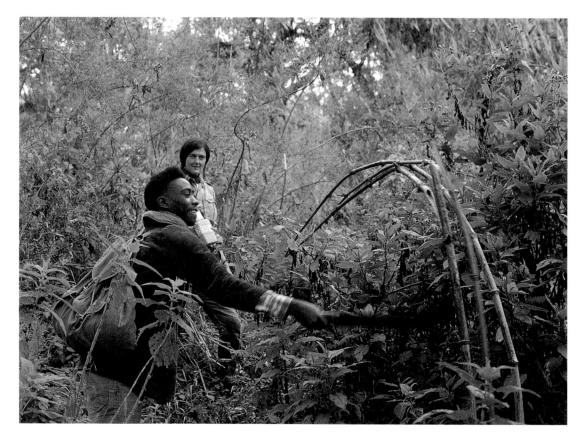

Often alone at camp, Dian began to drink to numb her pain, relying on her trackers Nemeye and Rwelekana to continue the field observations. New research students continued to come out to Karisoke, lifting Dian's spirits for a while, but it was not unusual for them to return home after only a brief stint in the field: the living and working conditions were spartan. Sandy Harcourt, who had so greatly impressed Dian the previous summer, returned to camp in June 1972. He appeared to delight in long treks through muddy forest trails and was not deterred from his research by the meager diet, social isolation and persistent damp. Dian wrote to her parents on July 22, describing the induction of new students at camp:

Last week I came down to the bordering town in Uganda to pick up my four Cambridge students—2 of them new to me. I've had a very busy week "training" them in gorilla approach, contact observations, local foliage etc and trying to pretend that I was 20 years of age for 7 days was a bit difficult. Happily one of them sprained his ankle during the trip from England and another had very bad diarrhoea so while in their company I was "forced" to climb very slowly coming up the mountain and during the times we went after the gorillas—sheer providence.

The other two were full of vim, vigor and vitality and really wore me out going after the gorillas daily and then half way around the mountain simply to explain terrain etc. Still, they are exceptionally fine boys, very intelligent, eager in a refined manner, conscientious and will do good work. One of the new ones is fantastic to look at—over 6'5" and ever so handsome—my goodness I am beginning to regret my age!

Sandy Harcourt could, for a while, do no wrong, showing equal diligence in recording gorilla observations and tackling poachers and cattle herders. Having young researchers at camp temporarily rejuvenated Dian and fired her enthusiasm—but it was not to last. During late 1972 Dian received word that her Aunt Flossie had died, leaving her beloved Uncle Bert a widower. (Dian had named two gorillas in Group 4 after the couple). Louis Leakey, Dian's mentor and one of her greatest admirers, had also died. Dian was approaching her own fortieth birthday and researchers who were with her at the time maintain that she was drinking more heavily—perhaps to blot out her grief and loneliness. The next few years saw no improvement, as Dian's relationships with her students deteriorated, and she began another doomed love affair.

Power Struggles

At the end of 1972 Dian returned to the United States to work on a National Geographic film that contained footage shot by Bob Campbell and Alan Root. Karisoke was left in the care of Sandy Harcourt and Ric Elliott, another Cambridge student. The young men worked tirelessly: they had to collect data for their own research projects and protect the gorillas' habitat from poachers and cattle herders. Harcourt and Elliot regularly battled against the proliferating hordes of cattle that roamed freely through the study area, and cut the traps and snares littering the forest floor.

Dian's extended absence from Rwanda included a visit to her parents, her Uncle Bert and a three-month stint at Cambridge University to work on her own thesis. Her return to Rwanda in 1973 got off to an inauspicious start. Her suitcase had been prised open at Nairobi Airport and $700 cash had been stolen. She wrote to her parents that she was "not too happy about the way things have been going in camp," having discovered that not only had one of the camp vehicles been damaged and needed $300 of repairs, but also that a student had lost $500 worth of signed travelers' checks.

In May Dian received a cable from America, bearing even worse news: Gaynee Henry, mother of Dian's friend Mary White, had died. Mrs. Henry had been a surrogate mother to Dian during her years in Louisville, Kentucky, and her death was another blow to Dian, who was still in mourning for her aunt. Dian wrote to her mother on May 23:

I felt such a sense of loss upon Flossie's death—I simply can't get over that. Now this news as well.

July 1973 heralded many changes at camp —and for the country. A group of army officers overthrew the regime of the country's first president, President Kayibanda, in a

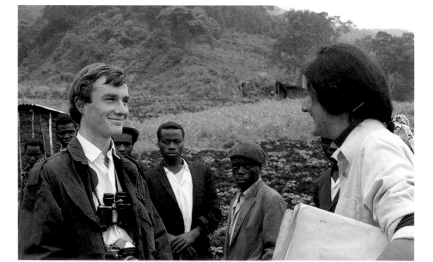

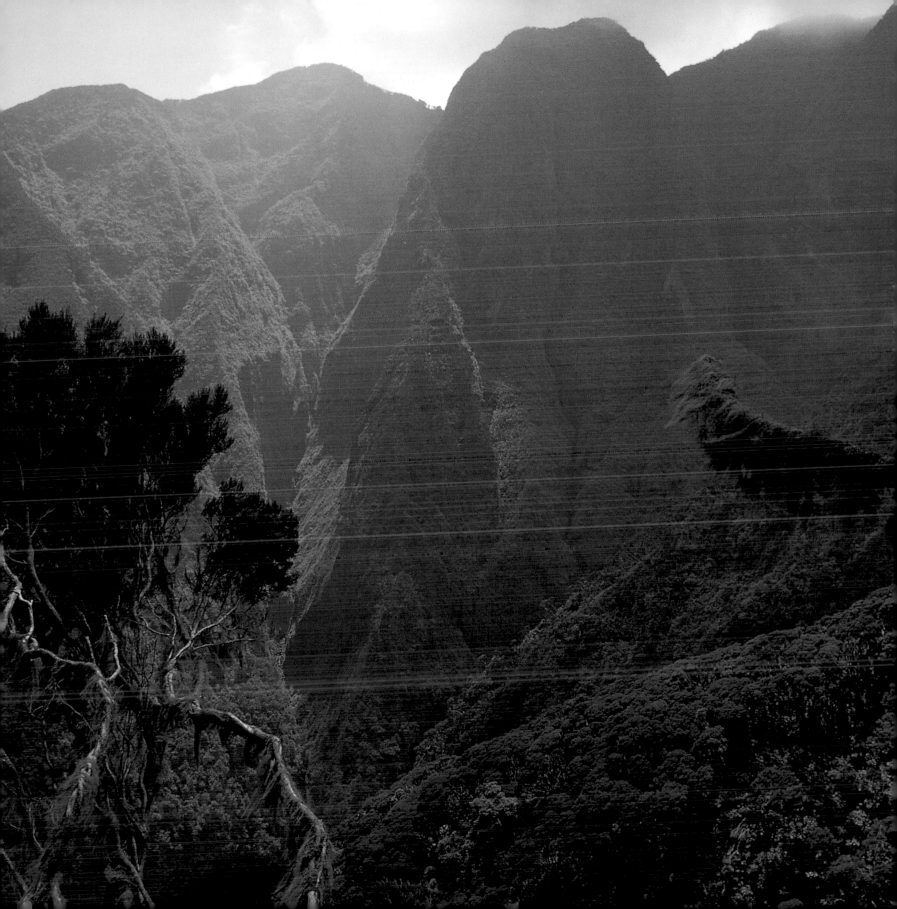

bloodless coup. A new president, Major General Juvénal Habyarimana, was installed and ruled Rwanda for the next 21 years.

The summer brought more students to the camp, notably Kelly Stewart, who had worked with Bob Campbell at Koobi Fora in Kenya. Kelly, the daughter of Hollywood actor James Stewart, was bright, witty and as grittily determined as Dian.

Rwanda: August 4, 1973

My Dear Uncle Bert,

I am sorry not to have written before now but have been rather busy settling down the new census workers—students who count the gorillas on other mountains—and dealing with the new government officials of Rwanda.

The five new boy students seem a bit afraid of everything. Jimmy Stewart's daughter is getting along very well! She is a super person and isn't afraid of anything. I only wish the 5 male students … were more like her. She keeps up with her daily observations and typewritten summaries of same; never complains about anything—she has huge, bad blisters on her feet; and, like the rest of us, has been without kerosene. Thus, she hasn't been able to cook or use a lamp at night-time. I guess we are all getting a bit skinny … my blue jeans … are many sizes too big.

The census workers were a week late in arriving as their charter flight had been "captured" by General Amin of Uganda when it landed at the airport in Kampala, Uganda. Once the 5 boys finally showed up, I had to take them straight away—climbing over the mountains—to Zaire (formerly Congo) to begin their work …. I took them to the place I began my gorilla work—KABARA—and it was, for me, a very poignant journey. I found two of the old groups with which I used to work ….

The new government here will present no problems to me. I had to meet quite a few of the new Ministers and their assistants two days ago in Kigali …. We all got along very well since I now speak the native dialect ….

Much love, Dian

The census to which Dian referred in her letter was the same one she had been conducting, off and on, for six years. Graeme Groom, who had been at Karisoke with Sandy Harcourt the previous year, had come back to supervise a group of census workers as

the gorilla count neared its end. Groom noticed a great change in Dian's personality; he had always considered her a strong and courageous woman, but now her moods were unpredictable. Three of the new census workers gave up on their task almost immediately, leaving the mountain without a word, and Dian dissolved in tears. When Groom finally completed the census he tabulated the results and estimated that 278 gorillas remained. Dian disagreed, insisting that there were only 270, and refused to pay Groom for his time. Eventually she sent him $200 of the $600 she owed him.

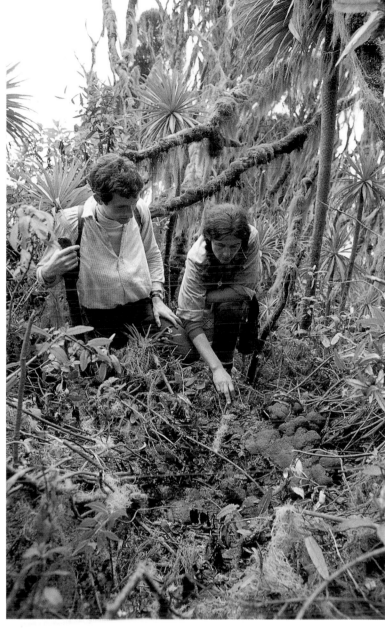

ABOVE Graeme Groom and Dian examine an old silverback nest found on Mount Sabinio.

BELOW Dian's actions against the poachers and the cattle herders became increasingly harsh as time went on. It was against Dian's nature to harm innocent animals, but she and her assistants would not hesitate in shooting over cattle if they found them in the forest.

Either way, the census revealed that there were approximately one hundred fewer gorillas in the study area than Schaller had estimated in 1960. Such news was hard for Dian to bear; she was the self-appointed guardian of the gorillas, and under her care their numbers were declining. Her frustration and anger were shared by most of the students with whom she continued to work. Together, they carried out anti-poaching patrols and, when armed with guns, they shot over cows they found in the forest. With little outside intervention the camp at Karisoke was able to operate under its own set of rules, which were becoming less and less conventional.

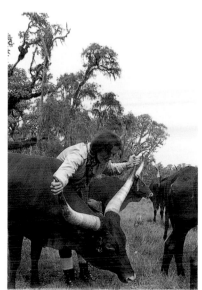

At the end of the summer, Sandy Harcourt went back to England to continue his doctorate at Cambridge University. Kelly Stewart and Dian found themselves alone at camp for two months, during which time they shared many stories and confidences as they became firm friends.

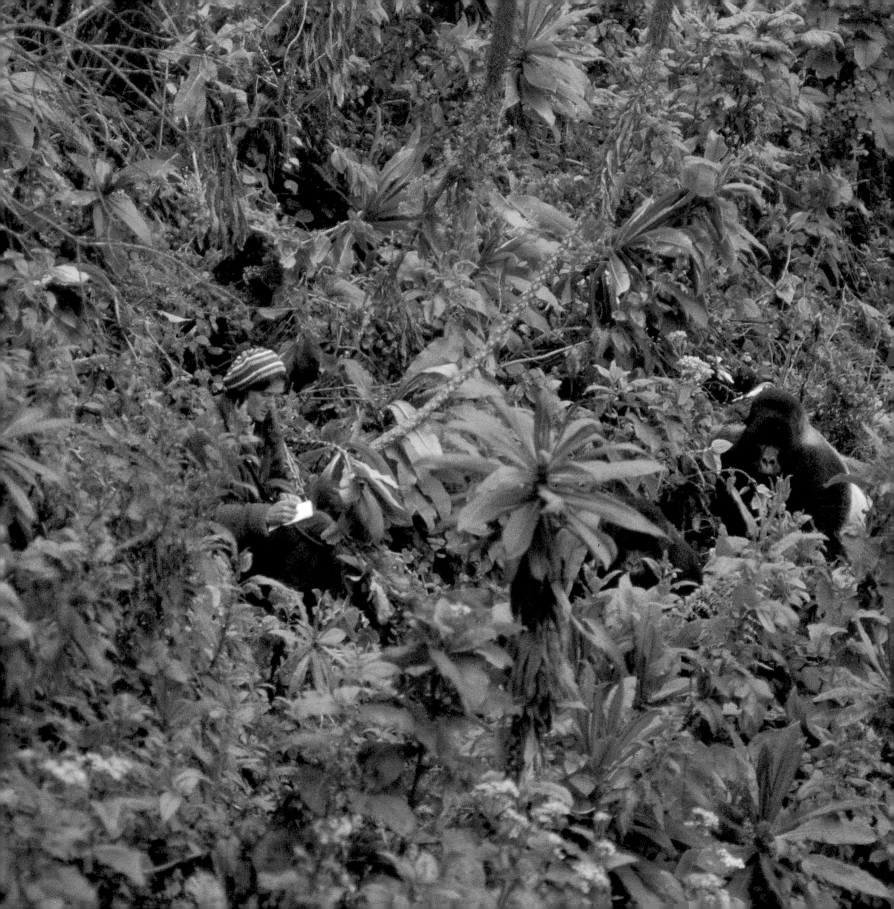

In October the National Geographic film was completed, and Dian embarked on a lecture tour to show it across the United States, followed by a four-month stay at Cambridge. Sandy Harcourt returned to run Karisoke in Dian's absence, aided by Kelly Stewart. From Cambridge, Dian wrote to her parents. It was March 1974, and Dian was still working hard on her thesis—and was no more disposed toward England than before. She had been ill again, but antibiotics had helped clear up an incipient bout of pneumonia.

Only a brief note to say I'm still here plugging away 18 hours a day now on my paper concerning the maturation process of the infant gorilla up to 3 years. It is a rather complex paper, to put it mildly …. It is so complex that I now need eye-glasses simply to walk across the room!

… England is obviously a socialist state, and the writing is on the wall for their total downfall.

Dian returned to Africa in May but was forced to stay in hospital in Kigali, Rwanda's capital, to recuperate; the pneumonia that had threatened her health in London had taken hold. Kelly had also had a brief spell in Cambridge, working on her own Ph.D., but had returned to camp before Dian. She was quite unprepared for the turnaround in Dian's feelings toward her and Sandy Harcourt. For some reason Dian had developed a deep animosity toward Harcourt while she had been away. She imagined that the two students had begun a relationship and were now conspiring to take Karisoke away from her.

It was true that Kelly Stewart and Sandy Harcourt had become close; they later married. It was also true that Harcourt had been running the camp with efficiency and enthusiasm during Dian's break from Karisoke. Perhaps some measure of professional and personal jealousy came into play at this time: to see the young, active couple running "her" camp with great success must have been difficult for Dian, struggling with her deteriorating health, feeling alone and excluded.

Ironically, the silverback from Group 8 and one of Dian's favorite gorillas, "a friend for seven years," had died of pneumonia while Dian had been suffering from the same illness. She wrote to her Uncle Bert:

The old silverback gorilla, Rafiki, has died of pneumonia. He is pictured in your NATIONAL GEOGRAPHIC *magazine. Remember, one of the silvered animals leaning on*

OPPOSITE Illustrating the difficulty in observing gorillas in luxuriant undergrowth, Rafiki and Geezer pass by a half-concealed Dian. Rafiki had been one of Dian's early favorites, and his death from pneumonia in 1974 affected her deeply.

his elbows with me standing down below him. He was one of my favorite animals and I shall miss him very much.

In June, Dian fell and broke her leg but delayed going to the hospital for several weeks, during which time she was bitten again by a poisonous spider, and a nasty infection developed on her good leg. She wrote to her Uncle Bert with humor and not a trace of self-pity, but there can be little doubt that Dian was in a great deal of pain.

Guess what I went out and did on June 8th?? I just broke, right in two, one of the lower bones of my right leg—the fibula! I had a guest here and about 5 o'clock in the afternoon I looked out of the window of the living room and there was a big forest buffalo and her calf walking by. Naturally I wanted to follow them, so went out at a run, told the guest to watch out for the huge drainage ditch that surrounds the house … and of course fell right into it with a big crack. My, that did smart a bit. I didn't go down the mountain until 3 weeks later and then with 4 Africans kind of half carrying me down the mud ….

The hospital in Ruhengeri … found it quite broken … they wanted me to stay in hospital a few more days, but I had to go pick up a student [Richard Rombach] … some 2 hours' drive away, so I left … NUTS.

Typically, Dian did not rest her broken leg as her doctor, Peter Weiss, had instructed. A few weeks later, she flew to Vienna to attend a conference for primatologists. After waking one morning in severe pain she was whisked to hospital, where doctors had to reset the bones in her leg and put it in plaster. From Vienna Dian flew to London and on to the States to visit her family. Every time she went abroad, Dian worked to advance the cause for the conservation of mountain gorillas. Her reputation and worldwide celebrity continued to grow.

There was also a great deal of respect for Dian among her many friends who lived in Rwanda, and who showed her hospitality whenever she came down from the mountain. They would later describe her generosity, kindness, and wit. However, Dian's reputation as a stubborn, aggressive, wild woman of the forest was certainly known in polite circles.

When Dian returned from her trip abroad, the American ambassador arranged for her to show the completed National Geographic film *Gorilla* to a select group of friends and dignitaries—including the Rwandan president and his cabinet ministers. She arrived in

filthy jeans and camp boots but emerged from the bathroom in a long, flowing black lace skirt and white silk shirt, looking every inch a glamorous, beautiful woman. She worked the room like a professional publicist and charmed everyone with her humour and love for the gorillas. Rosamond Carr, who was also present, later recalled how the event had, in a moment, turned from success to diplomatic embarrassment. After the film was shown, the audience was invited to ask questions, and the topic of a suitable punishment for poachers was raised. Dian declared that all poachers should be hanged and, with her hands around her neck, mimicked the breaking of her own neck. A deathly quiet descended on the room.

Dian was developing into a woman with two distinct public personas: fascinating and delightful on one hand, and fierce, violent and unforgiving on the other. Relations at camp with Kelly Stewart and Sandy Harcourt continued to sour, and Dian often turned against her loyal camp workers, berating them or withholding their pay when their work displeased her.

Spending long periods of time in the field, with minimal human interaction, can leave research scientists vulnerable to personality changes, feeling isolated and fearful of engaging in social situations. Dian Fossey recognized this, and gave the phenomenon a name: she would tell her students to go down the mountain regularly, so they would not get too "bushy." Whether she recognized the changes the lifestyle wrought in her own personality is open to question—but she was well aware that she often went too far.

As always, the gorillas got to see the real Dian Fossey and, when she could, she would spend hours with Group 4, and particularly the young silverback, Digit. By 1974 Digit had developed into the secondary male of Group 4, and performed the role of lookout and sentry. Photographs of Digit had been used on posters for the Rwandan Tourist bureau, which had circulated at home and abroad; it carried the tempting caption "Come and Meet Him in Rwanda."

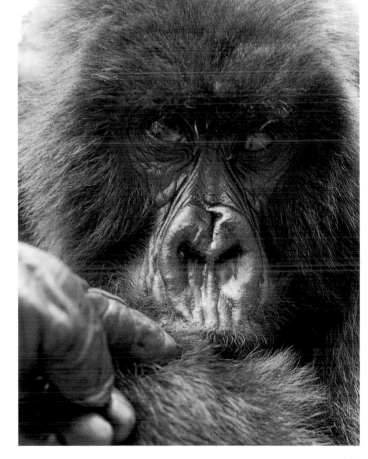

BELOW By 1974, Digit's responsibilities in Group 4 had increased as he matured from a blackback into a young silverback, the secondary male in the group, and its sentry.

NO ONE LOVED GORILLAS MORE

Dian's relationship with the gorillas had long since transcended that of scientist and subjects. She sought comfort from her "family" when she was low and played with the youngsters, allowing them to sit in her lap while she tickled them. Undemanding and childlike social interaction with the gorillas was much easier for Dian than the complexity of human relationships. Dian had always adopted an anecdotal approach to her records and brought a feminine and, some would say, anthropomorphic view to gorilla behavior. Her continued interaction with gorillas, though, would lead to the suggestion that she was altering their behavior rather than being a detached observer of it. Sandy Harcourt, who was achieving many hours of objective scientific study in the field, was fast becoming an accepted authority on mountain gorillas. He criticized Dian's approach, favoring more logical, statistical and objective methods.

AT THE END OF THE SUMMER, Sandy Harcourt and Kelly Stewart prepared to leave camp; they were both going back to Cambridge to work on their doctorates. Sandy was taking a last walk in the forest, when he was attacked and gored by a buffalo. Dian cleaned his

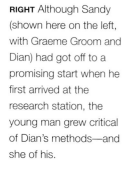
RIGHT Although Sandy (shown here on the left, with Graeme Groom and Dian) had got off to a promising start when he first arrived at the research station, the young man grew critical of Dian's methods—and she of his.

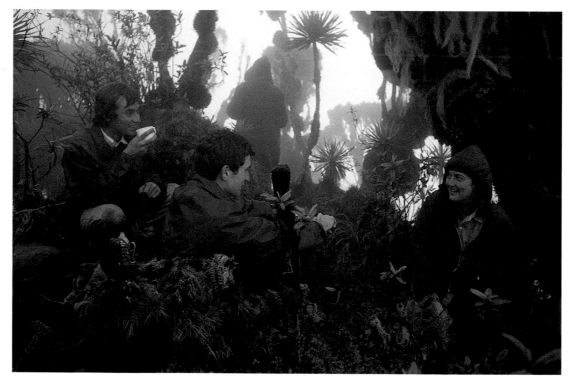

140

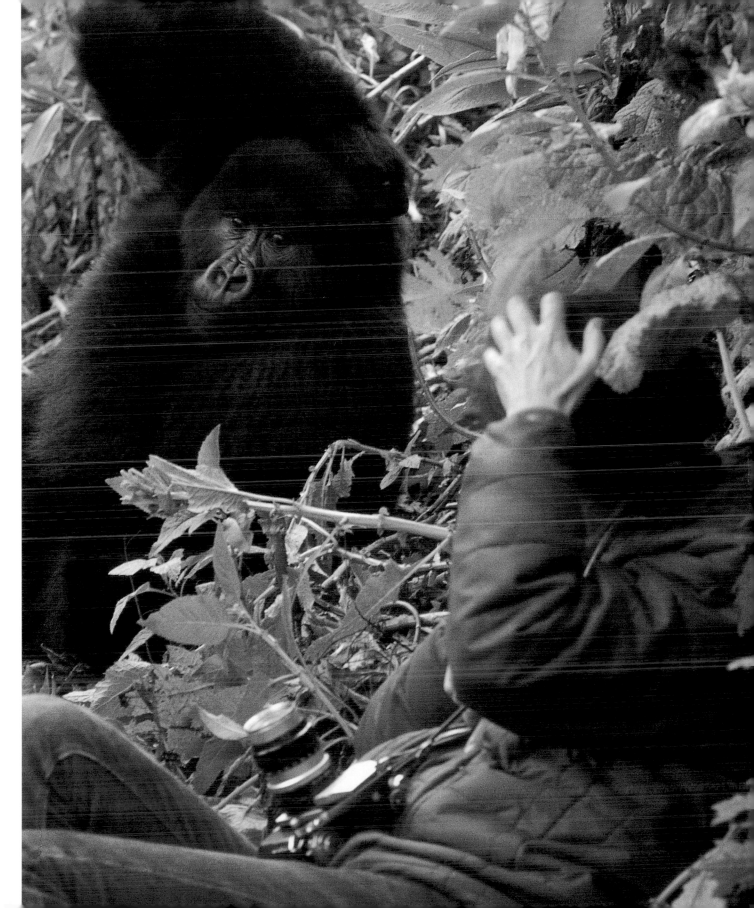

RIGHT Dian's habituation of the gorillas brought criticism from some quarters. Some believed that interacting with them to the extent she did would affect their behavior and render studies of their habits meaningless.

wounds, which were severe, and nursed him for three days and nights until he was fit enough to be taken to hospital, where he was treated before going back to Cambridge. Dian and the new student, Richard Rombach, were alone at Karisoke.

Shortly afterward, Rombach also required hospital treatment and Dian took him down to Ruhengeri. The attending physician was widower Dr. Peter Weiss, who had treated Dian's broken leg earlier in the year. While Rombach stayed in hospital for observation, the doctor invited Dian to his home for a meal—where she met Weiss's African partner, Fina, and his five children.

Family commitments notwithstanding, Dian and Weiss began a relationship, which was conducted in great secrecy. The couple were in love, and Dian was more settled and contented than she had been since the break-up of her relationship with Bob Campbell: by spring 1975, Dian and Weiss were thinking of marriage. Dian considered handing over Karisoke, and moving into the Weiss home in Ruhengeri. In a letter to her parents, written in April 1975, Dian discussed plans to find a replacement for her at camp, but shielded them from the truth—she stated that Peter was "divorced." In fact, he and Fina had never married, but they were still living together.

Peter has 5 children; the 2 youngest will go to their mother whom he has divorced; the three eldest, 9, 12, and 13 … will always stay with him as their mother is dead ….
I want them to go to school in Europe as there is certainly no way for them to get a proper education here ….

I will not give up camp or the work until I have it going as perfectly as possible. Everything is going beautifully at the moment but I want to plan ahead so as to make it absolutely secure for the future. It has been difficult for Peter to realize this, but we have finally come to grips with the situation after a bit of unpleasantness. We are going to both have to do a lot of compromising to make everything work out ….

He continues to be ever so thoughtful and considerate of me; he thinks nothing of climbing up the mountain at 9 p.m. or so (after the children are in bed) and going down at 5 a.m. the next morning ….

I think the ultimate solution to everything is that I find the right person or couple to manage the place while I'm away. You have no idea how big this center has become or how much data is coming out of it. I can't believe it myself and I'm the one who started it all!

Must stop—have been writing in the "front yard" watching the forest antelope feeding in the meadow right by the cabin in the late afternoon sunshine ... whilst all kinds of new birds ... have been hopping around my feet. The volcanoes are magnificently outlined, against a deep blue sky; the moss and ferns on the huge trees are every color of green and gently changing colors in the wee bit of breeze that has come up. It truly must be one of the most beautiful spots in all of the world, especially on a day like this.

The relationship continued, but no firm arrangements were made for living together. In September Weiss returned from a month's vacation and Dian went to pick him up from the airport. They drove back to Ruhengeri where Fina, who was still living in Weiss's home, met them. Dian wrote to her parents about what happened next, but failed to mention that the person who attacked her was her lover's partner.

ABOVE For all its hardships, Dian loved life up the mountain and was never happy elsewhere. The beauty of her surroundings was a recurring theme in letters to her parents.

I had a little run-in some 2 weeks ago. They took a club after me—I very ungracefully ran like hell as it was so unexpected; they then broke every single window in my Volkswagon, and the side mirrors and the rear light; don't ask me why they spared the front ones. I don't call that very neighborly! The culprit is in prison and has to pay for the damages. I was really lucky on that.

In November a second cabin at Karisoke burnt down (the first had been burnt earlier in the year by a botanist drying his samples) with the loss of Kelly Stewart's data. Dian's

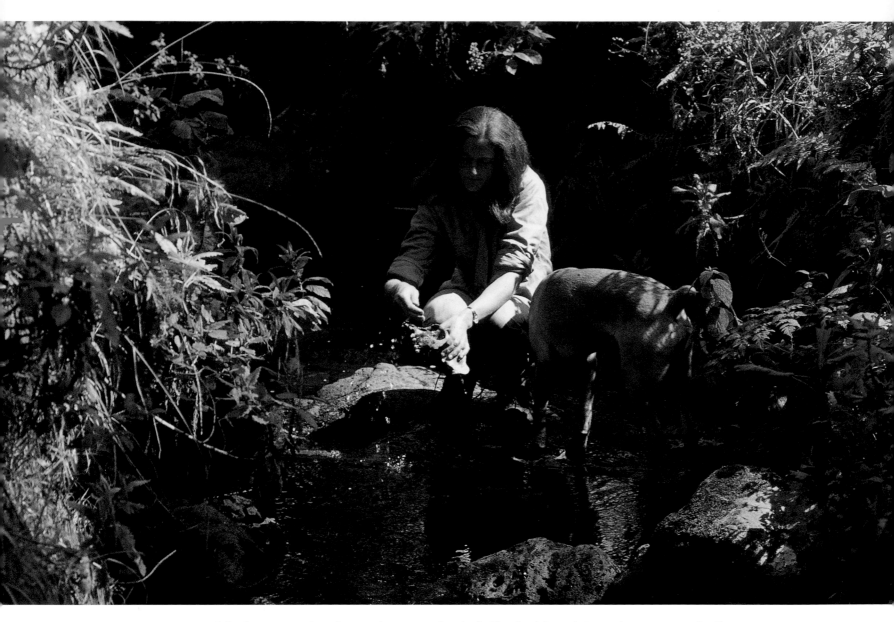

mood had once again taken a downward spiral. She had loved Peter but was gradually realizing that, while he loved her too, he was incapable of the type of commitment she sought; he was still with Fina. Dian began drinking heavily. She was lonely and unable to work on her thesis.

When Dian wrote to her Uncle Bert, who was unwell and elderly, she kept her tone upbeat, describing the "super weather," with "sun most of the day," and the beauty of her surroundings, She desperately wanted her family at home to believe she was successful and content. It was Christmas Eve, 1975.

Things are going well here with regard to the gorillas and camp. I don't have any more nutty students to burn down the cabins for the time being. I think, for this reason, everything seems much calmer and nicely quiet

This isn't very well put, but it is the little things that count—like a beautiful sunny morning or a lovely sunset. I keep seeing new things in the forest everyday now that I'm going out to the gorillas so much after breaking my leg. I wonder how I could ever have missed them previously. Well, I'll grow green mould if I stay here too much longer without a decent break Like yourself I think I have the most comfortable bed in the world, I love my home and my pets (all 400 pounds of them!) and I hate leaving, but I should every now and then.

Christmas passed surprisingly successfully; there were no students, just Dian and her camp staff with their families. Dian supplied banana beer, plenty of food and gifts for everyone. She described the day to her parents:

I wish you could have been here today—truly you would have loved it I ended up with 48 [people] in all!!!!! What a time they all had but all simply in happiness—not wild or greedy. To make the whole day, they danced the worms out of the woodwork

When the fog lifted a bit I took them outside for pictures. Two of them hated me and there was nothing I could do to make them smile though I all but stood on my head After that they ate, and ate and ate I was told they had a gift for me. Well, it was beautiful and took over an hour, if not more. They had made up songs ... one man took my ... drum and one woodman ... began to dance and strummed a homemade banjo The wives were singing and hand-clapping; then the wives started dancing—wow, I've never, never, never seen anything like it

I couldn't get over it; kept hearing "Mlle. Dian" and cheers or whatever—didn't understand a bloody word of it ... it was beyond my wildest expectations.

Christmas offered only temporary happiness. In early 1976 Dian injured her arm and was in great pain, which she dampened with alcohol and

BELOW Nemeye fans the campfire to heat water. Despite dedicated service to their sometimes-difficult employer, Dian never really trusted or felt comfortable around the local men who worked for her.

PREVIOUS PAGES Dian's bad lungs made it particularly difficult for her to track the gorillas at altitude. Here she takes a rest at 11,000 feet (3,350 meters) on Mount Sabinio, and scans the area for signs of gorillas.

painkillers. She continued to struggle with her thesis and her relationship with Weiss dripped on. Her depression and ill-health left Dian exhausted, as she wrote to her parents.

I am going out with the gorillas nearly every day now and find it quite tiring when they are over an hour and a half from camp. The other day I came home about 4:30, did chores until 6:30 and lay down for just "a moment" still wearing some of my wet clothes from the field. I awoke at 7:30 the next morning! All I can think of with any relish is sleep, sleep, sleep. It really is shameful.

Spending time with the gorillas continued to be one of Dian's favorite pastimes. Her presence was accepted by Group 4, and she even began to "stage" photographs of them with props.

Everything is going okay here, especially with the gorillas. I've also finished a lot of scientific crap—papers and book chapters—and am able to go out into the mountains every day as before

 NATIONAL GEOGRAPHIC *magazine wants a new story so I am taking lots of photos for them. The gorillas are so habituated now that "setting them up" is very easy. I've taken pictures of them "reading" the N.G. Magazine and "taking pictures" of me with the long lens—it has been fun.*

In May Dian left camp for another trip abroad and collected her doctorate from Cambridge University: she was now Dr. Fossey. She then flew to the United States to attend a symposium on primates and visit her parents. Afterward, she then traveled to Washington to meet up with her sponsors at the National Geographic Society. She returned to Karisoke in June and described her homecoming in a letter to her Uncle Bert.

The gorillas gave me a great welcome, in fact, too great. One 6 year old male (not small) came running and tumbling down the slope when he saw me; whacked me on the back, pulled at my knapsack and then sat down beside me and began gnawing on my leg! Now, how's that for a reception!

 Even though he was one happy gorilla, judging by his facial expressions and his vocalizations, I couldn't help but think of those big old canines of his, even though he was

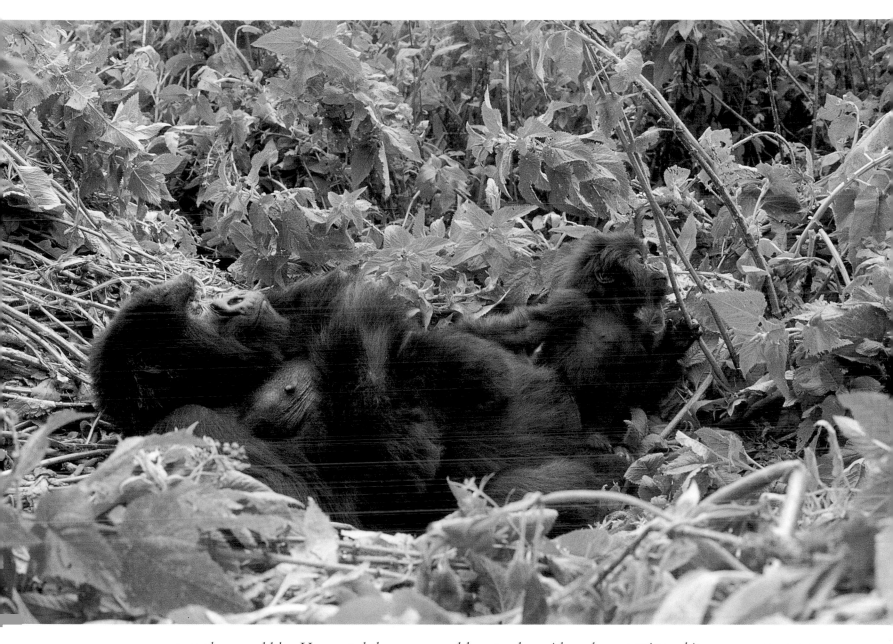

as gentle as could be. He wanted the camera and lens to play with and was getting a bit rough in "asking" for them so I had to hide everything in my knapsack until he went off to play with those his own size—and color. Yesterday his Daddy, and this is a BIG Daddy, came running over to my side to whack a lot of tall foliage down on my head. He then strutted back to his previous seat some 5 feet away, and on his way gave my sack a little side kick with his hind leg. He was wearing the funniest facial expression as if to say "Aren't I the one!"

ABOVE By 1976 the gorillas in the research groups were very relaxed in the company of their observers. Here, Flossie of Group 4 dozes in her day-bed, while her daughter Cleo plays at her feet.

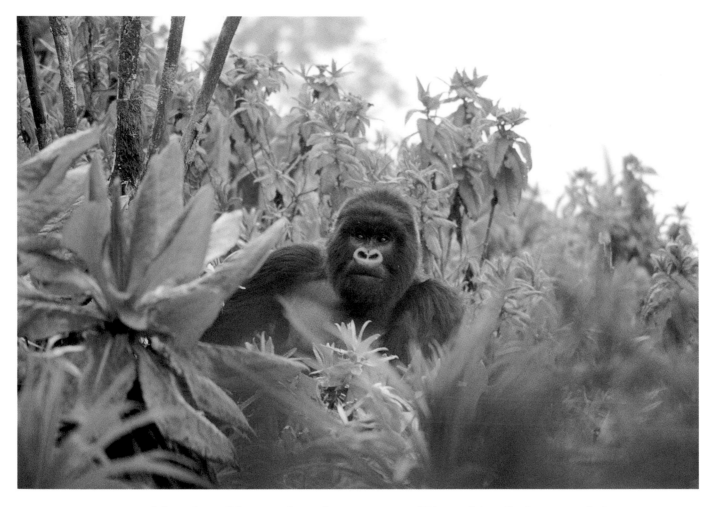

LEFT A rare photograph of a truly wild and unhabituated silverback gorilla; his staring eyes and pursed lips are very different from the relaxed expressions seen on the faces of the study-group gorillas.

Many hopeful research students wrote to Dian, asking for her permission to come to Karisoke. She had received just such a letter from a young Englishman, Ian Redmond. In her reply, Dian pulled no punches.

Rwanda: July 1976

Dear Mr. Redmond:

You write a good letter, okay, if you really have an "enthusiasm and a great love of wildlife," then you might work out here. I am not interested in your previous travels nor your "academic" qualifications. You state that you are "a fairly good all-rounder

with an intense desire to study gorillas." If that is true, then you are welcome to come to this camp.

I can tell you this—the solitude, the lack of good food, the bloody weather, etc. (paperwork, fatigue) has defeated 15 out of 18 students. The three that made it loved it because of the gift of being with the gorillas. The other 15 students had complexes of one kind or another and could not cope with the work. As far as I'm concerned, the gorillas are the reward and one could never ask for more than their trust and confidence after each working day.

There is one hell of a lot of work to be done here. I must contact one of 4 groups within 4 km of camp each day and write summaries of each day's contact that same night. Also, at least once a week there are patrols to be made outside of the immediate working area against poachers. There is also census work … which should be done every 6 to 12 months ….

Sincerely,
Dian Fossey

P.S. you do your own cooking!

Ian Redmond duly turned up at Karisoke in November, joining Kelly Stewart, who had returned from Cambridge in October. Redmond continued the work on the internal parasites of gorillas which had been started by another student, Ric Elliott. Dian, affectionately, called Ian "Worm Boy" and he became, without doubt, her favorite student. He had a passion for wildlife, was dedicated to his research and active conservation and, most importantly, never complained about the hardship of life in the Virungas. In fact, he seemed to relish it.

The Christmas of that year contrasted starkly with Dian's successful celebration in 1976. Despite having seen little of Peter Weiss since her return from abroad, Dian accepted his invitation to spend Christmas Day with him. It was not a good time; their romance was clearly over. Dian returned to camp with gifts for Kelly Stewart and Ian Redmond and organized the African Staff's Christmas party, which somewhat brightened her mood.

The Death of Digit

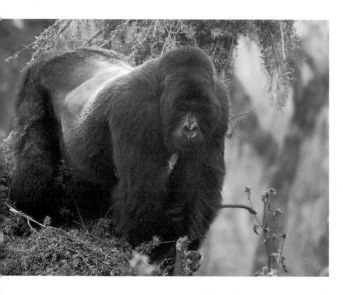

ABOVE Silverback leaders like Uncle Bert would fight to the death to protect the younger gorillas and females from hunters and poachers.

The New Year got off to a damp start. Dian was suffering from emphysema, and her scarred lungs could not cope with treks through the cold, damp mists that hung in the forest. Before long she was confined to her cabin, battling with another bout of pneumonia, tackling paperwork and writing drafts of her book, *Gorillas in the Mist*. Ian Redmond and Kelly Stewart continued the research work and anti-poaching patrols.

After a brief lull, the poachers had attempted to reclaim their territory. Ian Redmond and camp trackers "Big" Nemeye, "Little" Nemeye, Rwelekana and Vatiri tramped through the forest's incessant rain in sodden clothes, cutting snares and breaking traps.

The danger posed by the poachers was two-fold. The wire snares that they laid for catching small forest mammals, such as antelope, often trapped gorillas. Young gorillas lacked the strength to break them and, as the wire tightened around the animal's wrist or ankle it caused infection and gangrene. Sometimes the infected limb would drop off, leaving the gorilla maimed for life. In the worst cases the infection spread, taking the youngster's life.

The second danger posed from snares was more immediate: as the poachers laid their snares they could, unintentionally, disturb a family of gorillas. The silverback would seek to protect his family by charging an intruder who, armed with a panga, was likely to defend himself.

Dian could not accompany these anti-poaching patrols, but spent time with Groups 4 and 5 whenever she felt well enough. The African staff also became involved with the scientific research, collecting data for Dian to write up, and gorilla dung for Ian to examine. His study of the internal parasites of gorillas continued alongside his active

RIGHT The poachers' wire nooses could maim adult gorillas and at worst could spell death for young gorillas, who didn't have the strength to break free.

BELOW Tracker Vatiri investigates a silverback's night-nest.

conservation work but, like Dian, he became determined to save the gorillas and not just to collect data on a dying species.

The park guards, whose duty was supposedly to prevent the activities of poachers and herdsmen, were worse than useless. They were paid bonuses for any poachers they captured, but they soon turned this system on its head: they would arrange to "capture" the poachers, collect the bounty and then release them, sharing the cash. It was a scam that served to reinforce Dian's belief that it was only her efforts that protected the mountain gorillas.

IN APRIL, KELLY STEWART RETURNED TO ENGLAND to prepare for her marriage to Sandy Harcourt. Dian and Ian ran Karisoke alone, aided as always by Kanyaragana and Basili, the camp's indispensable "housekeepers," who alternated in fortnightly shifts.

Dian and Ian rarely ate together and they could spend days without seeing each other, corresponding by notes:

April 30, 1977, p.m.

Dear Ian

… Can understand thoroughly why you've no reserve of strength to stay awake til all hours—I used to do it all the time and thought nothing of it and couldn't understand how people here could go to bed before midnight at least! Wow, things have changed since then. The altitude is as exhausting as is the work. Also, am thinking you should go down for a break … one usually gets a whole new lease on life by lower altitudes, food and especially company and it's not much fun for you here now with only the fossil around ….

Hope you had a good contact today with Group 4 and that they aren't too far away. Many interesting things with Group 5, among them being that I believe Liza is pregnant!!! I must check notes, but I give her about 4 months, may be 3 months along ….

Dian

At the end of May the distinguished film-makers Genny and Warren Garst came to Karisoke to make a film for a popular American television series, Mutual of Omaha's *Wild Kingdom*. Their arrival heralded warm, dry weather, and their presence helped dispel the gloom at camp, bringing the "new lease of life" Dian knew was needed.

On June 17, 1977, Dian wrote to her Uncle Bert:

Well, the Wild Kingdom photographer and his wife, who is doing sound, are here now … and are lots of fun to have around. They are planning to make two shows … so will probably be around longer than the expected month ….

Unfortunately the gorilla are quite far away from camp which means a lot of extra work for the two of them …. Since we are now going so far away we are encountering many traps as the poachers don't expect us to be that far from camp. Day before yesterday, we found one dead antelope in a trap and, a few minutes later, one live one which we were able to release unharmed. That was a good feeling.

Had a new student up here shortly before the Wild Kingdom people came, but he only stayed 4 days before quitting! … I was really disappointed.

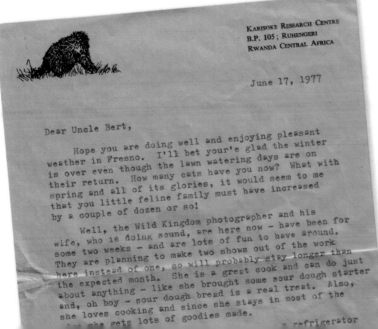

KARISOKE RESEARCH CENTRE
B.P. 105; RUHENGERI
RWANDA CENTRAL AFRICA

June 17, 1977

Dear Uncle Bert,

Hope you are doing well and enjoying pleasant weather in Fresno. I'll bet your'e glad the winter is over even though the lawn watering days are on their return. How many cats have you now? What with spring and all of its glories, it would seem to me that you little feline family must have increased by a couple of dozen or so!

Well, the Wild Kingdom photographer and his wife, who is doing sound, are here now - have been for some two weeks - and are lots of fun to have around. They are planning to make two shows out of the work here instead of one, so will probably stay longer than the expected month. She is a great cook and can do just about anything - like she brought some sour dough starter and, oh boy - sour dough bread is a real treat. Also, she loves cooking and since she stays in most of the ... she gets lots of goodies made.
... refrigerator

BELOW A letter from Dian to her beloved Uncle Bert, written on Karisoke Research Station headed paper.

During July Dian's cabin was regularly visited by a group of giant rats. She tried to take a photograph of them by leaning out of her window, but lost her balance and fell. Although she did not realize it at the time, the accident had left Dian with a splintered rib and torn cartilage in her chest.

The Garsts were coming to the end of their filming when the weather turned; the blue sunny skies were replaced with grey clouds and rain. Gloom, once again, fell at Karisoke. Dian struggled to take the Garsts to the gorillas, enduring a new but constant pain in her left hip as well as pain in her chest from her fall. She had also heard that, on July 1, Peter Weiss had married his partner, Fina.

ABOVE Dian gathers poacher's plaited and wire snare nooses after destroying a trap line.

ABOVE After a hailstorm, a scene of domestic tranquillity: Dian in the doorway of her second cabin, with her chickens in the foreground.

Dian sank into despondency, and her black mood was exacerbated by the pain in her chest. Unaware that she had broken a rib in her fall from the window, Dian attributed the pain to tuberculosis or cancer, and she became obsessive about tidying and record-keeping. Dian was preparing lest this latest "illness" be fatal, and she burned many private papers, letters and records in her diary that she felt no one should see.

In August Dian finally went to the hospital in Ruhengeri, where doctors discovered that her hip joint was inflamed, but x-rays of her lungs proved inconclusive, and she was advised to seek medical attention abroad. Fortunately, Dian had been invited —expenses paid—to attend an anthropological convention in Germany. From there she could travel to Belgium to consult with a Belgian doctor who had worked in Rwanda.

No matter where she was, though, Dian's mind was always on Karisoke.

Hamburg: September 21, 1977

Dear Ian

In 3 hours' time am due to give the "big talk" here in Hamburger-stein-kraut-merde-shitsville. I knew I wouldn't like it, and I don't. That's what is called an open mind

Needless to say I've done little but think about camp—specifically how you are getting along with all of "your" new students, my Kima, tourists and Cindy. I believed you had the confidence to take the task on your own shoulders; I worry that you won't pursue the paper work end of it on your own, or ask others to do the same. Please, just pretend that the fossil is still in her mausoleum ready to pounce on people who don't get their paper work done on time.

Please don't socialize to the point that you are losing work output. I know how much you like to talk—like ad nauseum (!); me too, sometimes, but the only permanent outputs are done on paper—words come and go in polite society

Eat well, take care of yourself, don't spoil the new students, brush Kima and don't burn down my house. Thank you sincerely for taking care of camp during my absence.

Love,
The Fossil

The doctors in Brussels discovered that Dian's chest pains were due to the splintered rib, which had caused shards of bone to travel through the pleural cavity. There was a build-up of fluid in one lung and she had also contracted hepatitis. The doctors planned to operate on Dian's chest, and she wrote to Ian:

Tomorrow meet with surgeon at 4 p.m. to plan for hospital entrance, but don't expect to be there long and can take my own stitches out. Forgot to mention, we went to the Brussels Museum of Central Africa this afternoon—19 mt. gorilla specimens represented both stuffed and skeletal. It was terrible. In one glassed enclosure they had 10 animals ranging in age from Uncle Bert to Poppy, and all with open mouths glaring at the "visitor" in threatening stances. I stood on the side for an hour and watched people watch the gorillas in awe.

After surgery Dian was instructed to rest. She had nowhere to stay and knew that a return to the high altitudes of the Virungas was out of the question. In October, defying medical advice, she flew to the United States. From Washington, where she met her National Geographic Society sponsors, Dian wrote to Ian.

Arrived in Washington last night—kind of a basket case with popping stitches etc and today upon arriving at the N.G. found your letter of September 27th and several others I am truly grateful for your letter and all of the detail about camp. You've no idea what it meant to me, and it sounds like you are doing an excellent job in keeping everything going well; I simply read and reread everything you wrote over and over again.

By the way, I don't say anything anymore when their [camp workers'] friends/relatives die causing them to be late coming up for work as I reckon they have it worked out between themselves. I once blew my fuse when Vatiri's mom died for the

second or third time! So, Basili was probably having you on, but keep in mind you are the boss there now so they will respect you in addition to liking you.

Dian's final destination in the United States was Chicago, where she did one day's post-production work on the Garsts' *Wild Kingdom* film. Afterward, she met three potential researchers for Karisoke: David Watts, Bill Weber, and Amy Vedder. Dian returned to camp in November 1977, having arranged for all three to join her at Karisoke in the New Year.

ON JANUARY 1, 1978, Dian was organizing camp in anticipation of the arrival of British naturalist and broadcaster David Attenborough, who was bringing a BBC film crew to Karisoke for his groundbreaking new series *Life on Earth*. Nemeye was tracking Group 4, but had been unable to find them. Instead, he had come across a great deal of blood on the trails and diarrhoeic dung—a sign that gorillas had fled the trails in distress. The following day Dian, Ian, Kanyaragana, and Nemeye went in search of the group, fearing the worst.

It was Ian who found Digit's body; his head and hands had been removed, and his body was covered in spear wounds. Ian rushed to tell Dian, hoping to protect her from the grisly vision. She wrote about that moment in *Gorillas in the Mist*:

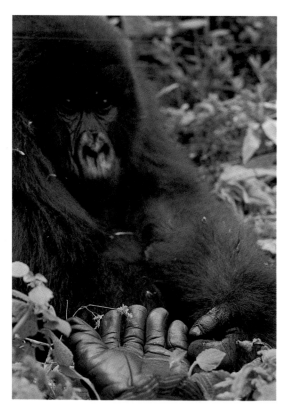

There are times when one cannot accept facts for fear of shattering one's being. As I listened to Ian's news all of Digit's life, since my first meeting with him as a playful little ball of fluff ten years earlier, passed through my mind. From that moment on, I came to live within an insulated part of myself.

Dian believed that Digit had been killed protecting his family. There was evidence, from snares, that poachers were operating in the area and if they had happened upon Group 4 it would be have been Digit, as the group's sentry, who would confront them. While Digit took five spear wounds to his body, his family—including his pregnant mate Simba—escaped to the higher slopes of Mount Visoke. He had done his duty.

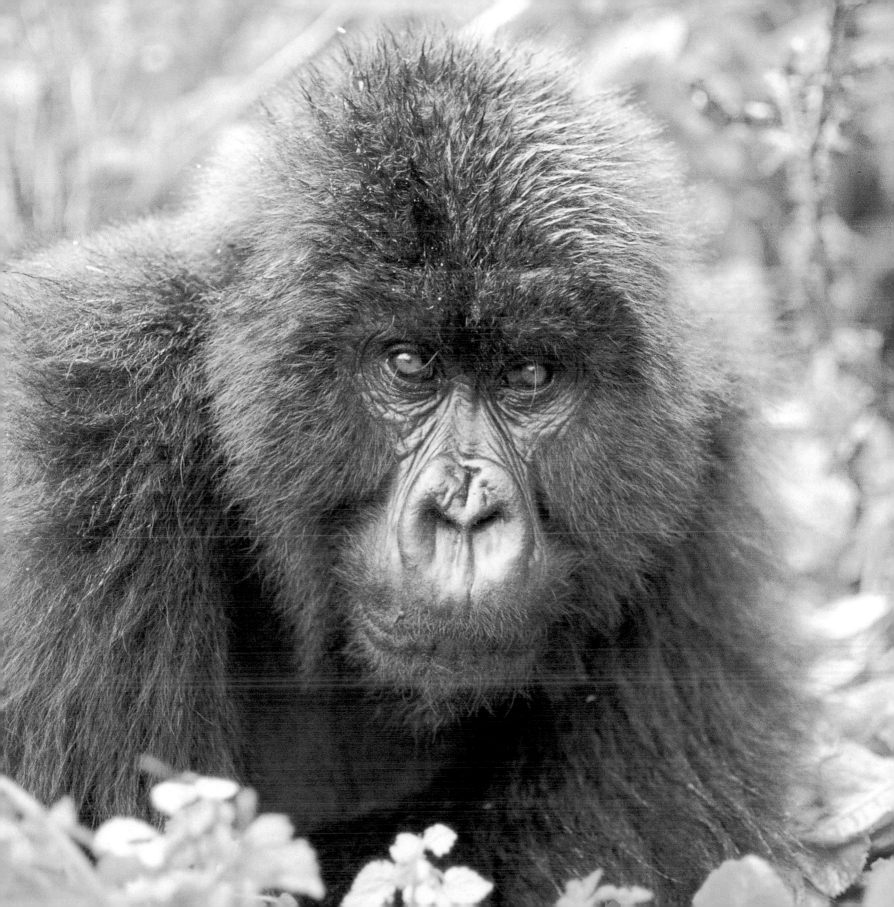

When further disasters befell the gorillas in Group 4 later in the year, Dian Fossey's detractors claimed that the death of Digit was her fault—recompense for her meddling in the ways of the local Rwandan people. Ian Redmond, however, supported Dian's view; he pointed out that the evidence clearly showed that the young silverback's killers were laying traps at the time of the attack, and it was while following the trap line destroying the snares that he and Nemeye found Digit's mutilated body.

As THE INITIAL SHOCK WORE OFF, Dian entered a long period of bereavement. She had loved Digit and had many precious memories of the times she had spent with him—enjoying the mutual trust, reliability and companionship she had failed to find in her own kind. Ian suggested that they use Digit's death to bring the world's attention to the gorilla species, which was at greater risk of extinction than ever. At first reluctant, Dian realized that Digit's death might not have been in vain.

When David Attenborough arrived at Karisoke he introduced himself to Dian, who was once again in bed with pneumonia. He later described how a blood-splattered handkerchief lay on her bedside table as she told him "with white hot passion" about Digit's murder and the dangers facing the remaining mountain gorillas.

Over several days, the film crew was taken to Groups 4 and 5 and, in a small clearing of flattened grass, David Attenborough sat next to a large female gorilla, and he succinctly explained, to camera, why it mattered that gorillas were protected: "There is more meaning and mutual understanding in exchanging a glance with a gorilla, than with any other animal I know."

Dian and Ian Redmond's plans for their fund-raising campaign were developing. It was decided that the charity would be called The Digit Fund and that its aim would be to raise money to finance anti-poaching patrols. Dian was concerned that none of the funds should be channeled through Rwandan officialdom. The body responsible for preserving the park borders was ORTPN, a government department that employed the ineffective park guards under the supervision of the Parc Conservator. While Dian recognized that the Rwandan government ought to be involved in The Digit Fund, she had no faith that the money would be used to stop poaching activities in the Virungas: she wanted to control the patrols herself.

On February 3, 1978, American newscaster Walter Cronkite announced the death of Digit on CBS news. Much of his audience knew exactly who Digit was: millions of

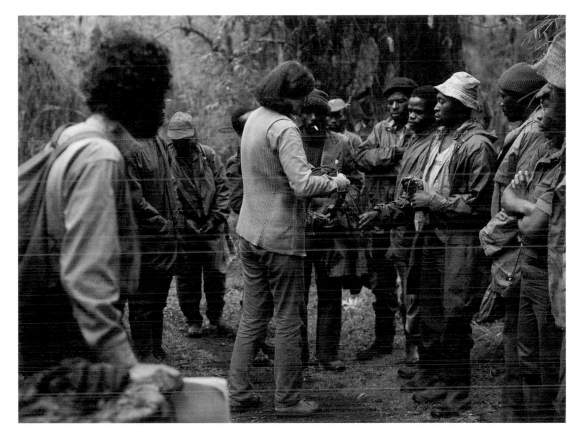

people had watched the National Geographic film featuring the young silverback. In the United Kingdom and elsewhere the news was also making headlines; the world's attention was focused on the tiny African country of Rwanda and its famous primates. The Flora and Fauna Preservation Society established the Mountain Gorilla Project (U.K.) to support Dian's work.

Dian had to get The Digit Fund established, and at the end of January she headed to Kigali. Two new students arrived at Karisoke: Amy Vedder and Bill Weber. The young couple had met Dian in Chicago the previous year and were coming to camp with several years' experience of working in Africa as teachers and conservationists. Bill was aiming to start the next census, and Amy hoped to research gorilla behavior by studying Group 5—a task made difficult by tourists. The ORTPN had decided to raise park revenues by letting tourists visit the habituated Group 5, but without proper supervision or controls the burgeoning tourist trade was becoming a nuisance to both researchers and gorillas

In the middle of February rumors reached camp of a young gorilla being held in Zaire, reportedly seized from poachers. Amy Vedder and Bill Weber (whom Dian called "the V-W couple") were sent to Rumangabo, in the Zairian section of the Virungas, to bring it back to Karisoke for medical attention.

The female gorilla, named Mweza, was estimated to be four years of age and in poor health owing to an infected snare wound. A few weeks later, on March 28, Mweza died. Dian wrote in her diary that the infection was far-spread, and the gorilla also had severe pneumonia. She claimed she had arranged for a friend, a local leper surgeon, to come to camp and amputate Mweza's leg, but at the last moment the surgeon had postponed. Amy Vedder and Bill Weber remember the whole episode differently. In their book, *In the Kingdom of Gorillas*, they maintain that Dian refused to let them take the infant to Ruhengeri Hospital. On the night that Mweza died, Amy and Bill were joined by the newest recruit to Karisoke, David Watts. The three researchers attempted to revive the ailing gorilla and called for Dian's help. They claim she was drunk and that, apart from pouring liquid antibiotics down the gorilla's throat, Dian had left them to cope on their own.

This became the first of many episodes that have become wrapped in a knot of contradictory memories that are now impossible to disentangle. Distraught in her grief, perhaps Dian kept away from the ailing Mweza to protect herself from becoming attached to another gorilla that was doomed to die. The young researchers, with little knowledge or understanding of Dian, saw only the facts of Mweza's death, which might have been prevented, and blamed Dian who had offered them little support in their painful ordeal. Amy and Bill later wrote of their "anger at the deeply disturbed mental state of Dian Fossey." This was to become a recurring problem for Dian: people recognized that her mental health was deteriorating, but few showed her any compassion, or knew how to help her escape from the black depths of her anguish. Henceforth, no love was lost between the "V-W couple" and Dian Fossey.

OVER THE NEXT FEW MONTHS Dian continued to direct the anti-poaching patrols in the Karisoke study area, covering one-tenth (6 square miles/9.6 kilometers) of the park's area. Until Digit Fund money came through she financed these patrols from her own pocket. In April she had heard that Sandy Harcourt was raising funds for the Mountain Gorilla Project in the U.K., but that this money would not come directly to her: it would be used in part to finance projects requested by ORTPN. Dian was furious that money which donors wanted

her to use to cut traps and snares would be used to pay for huts for the ineffective park guards or to subsidize airfares for conservationists coming to develop the Rwandan tourist trade. She called it "Digit's blood money."

There was one piece of good news that spring, however: Digit's mate, Simba, gave birth to a female. Dian named her Mwelu, which means "a touch of brightness and light."

Without Digit's strength and vigilance, Group 4 was unable to defend itself when a fringe group of gorillas, led by the silverback Nunkie, moved into their territory in July. The three adult females of Group 4—Macho, Simba and Frito—were all nursing infants, and the two young males, Tiger and Beetsme, were not sufficiently mature to provide back-up to Uncle Bert during the violent confrontation. Uncle Bert led his family away from their usual territory and into Zaire. David Watts stayed with them most days, always on the lookout for poachers who had been increasingly active in the forest. Ian Redmond was in the U.K.

On July 24, David Watts had left camp early to track Group 4. He returned to camp only an hour later, bearing grim news. Dian wrote to her own Uncle Bert, describing what had happened:

Things are not going very well here as Walter Cronkite again has announced. My beloved Uncle Bert was killed on July 24th by a single bullet into his heart when he went to the defense of his female, Macho. She was also killed by a single bullet into her heart and her baby, Kweli, was pierced through his upper shoulder by a bullet, yet Kweli (3 years of age) lives and will survive.

The poachers want me out of here very, very badly, and I have been told that I am next on their list. This news doesn't worry me very much because I am not afraid of them and am also well armed. To be sure, I am lonely, but never afraid.

To have lost my beloved Uncle Bert after all of these years of getting to know him is a real tragedy. He was a unique individual, not simply another animal. There are only 200 mountain gorillas left in the world which is why I fight so hard for them ….

I have sent you many letters but have not received any answers …. At any rate, please don't be angry with me. I would love so much to receive just a line from you. I need this from you.

The book is going okay, and they want to make a movie out of it!! As of now, I am not interested in any such enticements. To have lost Uncle Bert and his female is just

OPPOSITE Group 4 was
to suffer even further—
the great silverback
Uncle Bert was shot by
poachers in July 1978.

about all I can bear. I know you never liked my naming a gorilla after you, but he was unique and very, very special to me … that's the way it goes.

The reason behind the killings of Uncle Bert and Macho remains a mystery. There was scant evidence. The group was targeted while sleeping, which implies that their killers knew where the gorillas were and had planned the attack; the silverback and his mate were shot with guns, weapons rarely used by the poachers but carried by the park guards. It has been suggested that—since the death of Digit brought money into Rwanda—someone in power surmised that more gorilla deaths would bring more money. Another theory is that Group 4, Dian's favorite, was targeted as revenge for her often brutal treatment of poachers. Ian Redmond, however, points out that since Group 4 was not in its usual territory, it is unlikely that the killers knew which group this was. Dian herself believed that the killers had been after a baby gorilla, perhaps for a zoo or private collector.

Rumors were spreading about Dian's ability to continue at Karisoke. Even those who supported her began to think Dian's reputation had sunk so low that her presence in Rwanda threatened conservation efforts. Dian knew all of this, and worried that the National Geographic Society would not renew her grant. Her beloved Group 4 was also beginning to look as if it might not survive another year. Without the leadership of Uncle Bert, or a mature male to succeed him, the family of gorillas was splitting, and one female, Flossie, had left the group with two youngsters and joined Nunkie.

Dian described the changes to some friends, who had sent her some money to pay for Ian Redmond to return to camp.

Your cheque for $250 for Ian's return trip from Nairobi came today. That's the nicest thing that has happened up here for a long time.

… I only received his [Ian's] cable about returning "as soon as possible" after he'd heard of the news [concerning the deaths of Uncle Bert and Macho] on August 2nd. I was overjoyed. Someone to yell at again!!! Seriously, he is the only one around here who is capable of doing absolutely top-notch patrol work and roughing it in the field. I personally remain convinced that MUNYARUKIKO [a known poacher] is hiding in the forest around Karisimbi. Ian alone plus one or two of my Africans could do more in a week's patrol in the forest than an army of Commandoes ….

Little Frito was killed by Beetsme for apparent purposes of infanticide so that Beetsme

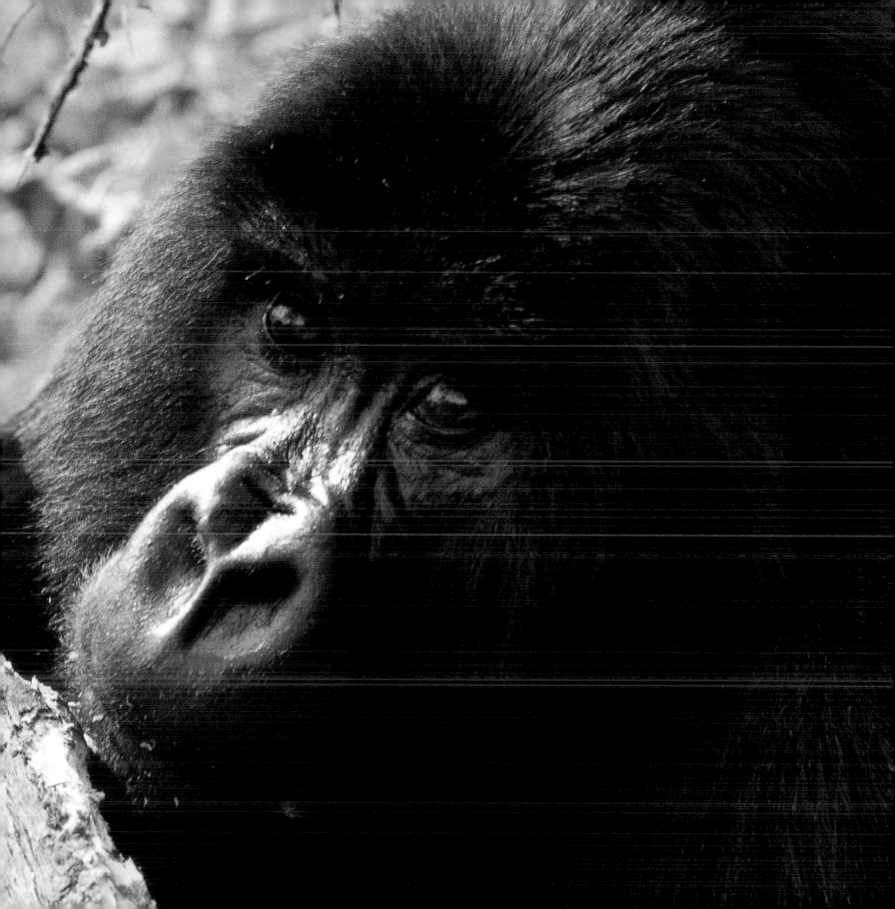

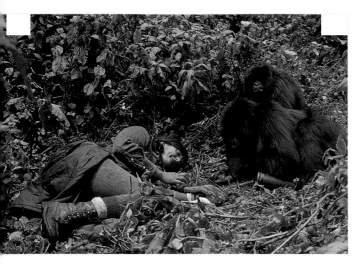

could breed with Flossie whom he was continually attacking. I don't think her old heart could have stood much more of it. Thank God, Nunkie finally took her along with Cleo and Augustus leaving Titus, Kweli, Tiger, Simba and Mwelu in Group 4 with Beetsme who has since calmed down. Kweli, as you probably know, was also shot on the 24th … but is doing okay and is being mothered by Tiger.

ABOVE The happy days with Group 4 (Digit and Tiger pictured with Dian) were over; the group could not recover from the loss of its primary and secondary males.

Ian returned to camp and continued with the active conservation work to protect the gorillas. Sadly, on October 25 Macho's infant, Kweli, died of the wound he had received during the attack on Group 4. His condition had suddenly deteriorated and David Watts had carried him back to camp but, despite prolonged efforts by the three of them, neither he, Ian, nor Dian could resuscitate him. That night Dian suffered a horrendous panic attack following a nightmare that was filled with images of poachers and killing. Ian came and sat with her, and his calming influence and storytelling helped her to dispel, for the moment, the bloody images from her mind.

In December Digit's mate Simba also transferred to Nunkie's group with young Mwelu. Within days the silverback had killed Mwelu: a strategy that would ensure Simba would be receptive to his advances and could, soon, be carrying his offspring. A few weeks later Beetsme, Tiger and Titus left Group 4 to join Peanuts' group. Since New Year's Eve 1977, Group 4 had witnessed the deaths of six members: Digit, Uncle Bert, Macho, Kweli, Frito and Mwelu—and the collapse of the world's most famous family of gorillas.

AT THE END OF OCTOBER 1978, Dian left for the States to participate in a symposium on conservation. While there, she heard the news that her Uncle Bert, who was 95, had died. He left her a large sum of money in his will: this meant that Dian could continue antipoaching patrols at Karisoke even if no more money were donated for this purpose.

In November, Dian sent good news to Ian at Karisoke:

I am still in Washington and will extend my stay here for possibly another week due to affairs concerning The Digit Fund. Complexities of same are immense involving appointment of a board of Directors etc, and it is up to me to do same. [Do not] worry

that there isn't any financial support; on the contrary, there is a great deal, and the more that comes in involves more and more paperwork here. At any rate, this note is mainly to tell you please to go ahead, if you can find promising Rwandese to train, take them to camp to hire per day, which I realize means extra food expenses and probably clothing expenses. Simply to conclude that The Digit Fund is going exceptionally well, and if you can start training new Africans in tracking and nest counts, feel more than free to start straight away.

When Dian returned from the United States, her porters were laden with camping gear, boots, waterproof clothing and other equipment for the patrol staff. She remained pessimistic about the future, though, and in February 1979 she wrote to her parents.

In 1967–69 I estimated the gorillas would be extinct in 20 years, and I'm probably not off more than 2 years at most.

The gorillas are all okay. I don't go to them now because of trying to finish the book and simultaneously working on a new N.G. article. Am up to July '78 in the book—a long way from Dec. '66 but still not done. Reminds me of War and Peace.

In Rwanda, new conservation efforts were being started by Bill Weber, who believed that the future of the mountain gorillas could only be secured if the Rwandan people desired it. He arranged a tour of schools and, using film footage, introduced local children to their gorilla neighbors. Unlike many of the other researchers at Karisoke, Bill was fluent in French and Swahili, and was a trained teacher.

Pressure was increasing for Dian to step down from Karisoke; she was encouraged from all corners to return to the United States and concentrate on her book, which was progressing only slowly. Dian, however, was not interested in leaving: she had friends in high places and believed that only her efforts at active conservation would save the gorillas. She held no truck with the more gentle approach advocated by other conservation agencies and was particularly opposed to the efforts of some of her colleagues, including Bill Weber, his wife, Amy Vedder, and David Watts. They had set up the Mountain Gorilla Project, with the support of ORTPN, with the aim of establishing a supervised tourist program to provide money for the Rwandan economy and control the number of the visitors to the Parc des Volcans. Dian perceived this as a threat to her own efforts

and decided she would stay at Karisoke until August, working on her book and coordinating anti-poaching patrols.

When Bill Weber and Amy Vedder came to write about their Rwandan experiences in their book, *The Kingdom of Gorillas*, they recognized that Dian had succeeded in a remarkable achievement. Dian's single-minded focus, determination and perseverance were the qualities that enabled her to launch the research and conservation practices at Karisoke. These same qualities, however, left her blinkered and unable to move on when it was necessary for these projects to expand.

Weber and Vedder believed that simply tackling poachers was insufficient to guarantee long-term safety for the gorilla population. They knew that the net had to be cast wider: the local community had to value living gorillas. They saw human development and education as an intrinsic part of conservation—a philosophy that is now widely accepted. Dian recognized its validity, but had become too inflexible to incorporate it into her own conservation strategy. Weber and Vedder suggested that Dian was the ultimate pioneer in her field, but that she lacked the necessary personality traits to adapt and build on her own success.

In April 1979, Dian wrote to Ian Redmond, who had been attacked by a poacher and had been forced to return to England for medical treatment to an injured wrist.

Ian, I am not particularly interested in other people's opinions about gorilla conservation—in fact, nothing makes me angrier. I simply have no respect for people who come here for a while, then go away "knowing everything" …. I don't want to hear any more of the round about yak-yak concerning what's "needed" here; you know as well as I do what's needed.

By the way, some good news; I've started patrols the week after Lee's injury using only Africans and thus far 354 traps have been cut and some 8 duiker released alive …. I started with 5 men using Big Nemeye as the "leader" but squabbles broke out when Big Nemeye started taking cuts of the others' salaries and I had to let him go …. I have Vatiri as the leader and things are running beautifully. They work 3 days a week … and they cover unbelievable amounts of terrain, much more than a white person could do. This last week was the first time they came in … with only 9 traps and were so disappointed—usually it's 50 or so. I couldn't let them know how pleased I was for I really think the trap setters are getting discouraged.

THE DEATH OF DIGIT

Lee was the young daughter of the sil-
verback Nunkie and his mate Petula.
She had been caught in a wire trap and
was badly injured. There were differ-
ences of opinion at camp, again, about
how to treat an injured infant.
Removing Lee from the group was
almost impossible because Nunkie and
Petula would fight to protect their
youngster: tranquilizer guns were con-
sidered—but dismissed by Dian because
they had not been used at camp before.
An impasse was reached and Lee's con-
dition slowly deteriorated. She
eventually died of her infections. It was
not until the mid-1980s that Dian finally
found an organization—the Morris Animal Foundation—that was able to help provide
veterinary care for such injured gorillas.

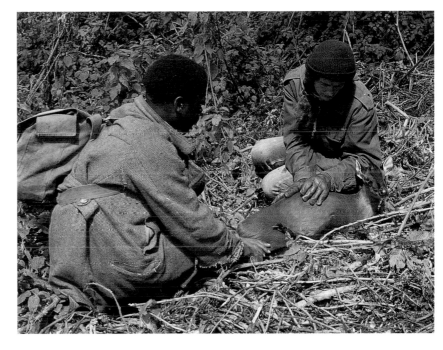

ABOVE Dian prepares to release a duiker freed from a snare. The deaths of Digit and Uncle Bert, and the consequent breaking up of Group 4, only made Dian more determined to put a stop to poaching activity, and she increased her patrols.

Plans were made for Karisoke to be left in the care of Sandy Harcourt and Kelly Stewart when Dian went to the United States, but wrangling over the arrangements caused so many problems and disagreements that, eventually, Dian decided to delay her departure until the New Year. This did not suit Dian: she needed medical attention because she had broken her ankle and was in constant pain from her hip.

A professor from Cornell University had visited Karisoke earlier in the year and sug-gested that Dian might be able to secure a temporary position at his university; he had made enquiries. At the end of October, Dian received the good news that she was being offered a residency as a visiting professor at Cornell from March to December 1980. Karisoke would be left in the care of an American graduate in anthropology.

IN THE UNITED STATES DIAN WAS DIAGNOSED with a kidney infection and emphysema and told that the pain in her hips was caused by irreversible damage to her spine (although she later received successful treatment in Canada). She was keeping in touch with Ian, and in June 1980, wrote:

Many thanks for your letter. It was good to hear from you as I had heard that you were headed toward camp. In fact, I actually get a lot of news about that area and what is going on but, regretfully, little of it comes from Stuart which is extremely disheartening. Well, in my old age, I'm learning to be more discreet, so the less said the better. One thing though, please just for me, give Kima a bit of attention. I'm dreaming of her every night now—it is really weird and all rather like that horrid, unforgettable night at camp which I will never get over [the night of her panic attack].

I really like Cornell, the countryside and the people though I spend most of my time in clinics, the hospital or doctors' offices therefore am working around the clock trying to keep up with everything. Still, it is probably the only place in the world I could have "readjusted" to civilization in.

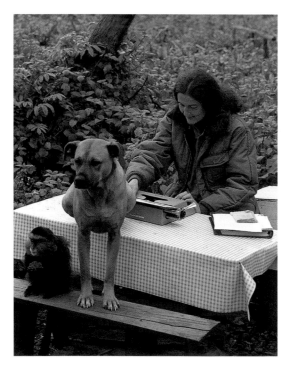

BELOW Dian with her beloved pets Cindy and Kima. Kima died at Karisoke while Dian was away, and she decided to take Cindy with her when she returned to the U.S.

Dian returned to Rwanda, briefly, in July 1980. Kima, her pet monkey, had died while she had been in the United States, and Dian decided that Cindy would be best cared for with her at Cornell, Ithaca, despite the difficulties involved in transporting an aged dog from Africa to America. Dian met up with Ian, who was training park guards, and asked him either to shoot Cindy there and then or help her to transport the dog to the U.S.A. She wrote to him when she got back in August.

I am sorry my time at camp was so limited because I never did get to the point where I could just sit down and hear all that you've been doing, and this made me angry at myself The visit to camp was a most traumatic one for me mainly because of Kima. Everything seemed so empty—I'll never get over her loss, and everything reminds me of her no matter where I go. It seems so incomplete here with only Cindy, for we were always a trio.

I'm ever so pleased I brought Cindy though, as you might imagine, it was one chaotic trip! In Bujumbura, they wouldn't let me see her in the belly of the plane, but I won out in Nairobi. The stewardess took me up to the ramp where they were loading cargo; I climbed up to find Cindy's cage right near the front door … I put in water and crappy food given to passengers for a "snack" … I finally had to leave for the terminal since I was

holding up cargo delivery and didn't see her again until Brussels. Cindy is very, very house-broken and didn't pee between Kigali and Brussels; I'd been very worried about this. At the Brussels airport I ... said I had to get my dog out of cargo ... so I was conducted along with two little boys—children of the American Embassy Aide guy in Kigali—into a special waiting lounge. The boys and I waited forever ... before I could go down into the pits of the Brussels airport ... There, in the midst of it all sat Cindy in her cage without water or anything ... I took her out

ABOVE Dian and Cindy bid farewell to the locals as they set off on their journey back to Cornell University in the U.S.

immediately, but she still wouldn't pee on cement so had to go through immigration to find a bit of grass out in the front of the airport where she nearly flooded the highway. One of the Embassy kids went with me and kept saying, "Wow, look at that!".

... I know [Cindy] will never be as good as new, but I honestly believe I've done right in bringing her back to the States rather than leave her at camp to die of neglect as did Kima

Before I run out of paper, please know how proud I am of you and I deeply wish you all the best Thanks Ian for retaining your integrity.

Interested parties decided that Karisoke should operate under the control of a board of directors to ensure the continuation of scientific research. Sandy Harcourt would become Acting Director of Karisoke Research Centre while Dian was in America and, at the end of 1980, the Digit Fund and the Mountain Gorilla Fund continued to steer money toward their chosen methods of conservation. In the United States, Dian became a popular member of staff at the university, and her enthralling lectures were always well-attended. She worked on the next draft of her book, spent time walking Cindy, and finally began to release the demons that had been haunting her.

Digit's Legacy

Dian spent most of 1981 at Cornell University. Whenever possible, she concentrated her efforts on finishing her book, which, under the close supervision of its editor was finally taking shape.

Ian Redmond had returned to Rwanda, after beginning a study of cave elephants in Kenya, to complete a census of gorillas on Mount Mikeno, Zaire, and found Karisoke to be a shell of its former, hospitable self. Ian wrote with despair to Dian, describing how the park guards were as ineffective as ever: of 102 gorillas counted on Mikeno in 1976, Ian believed that only 50 to 60 remained. Furthermore, he had encountered three people in Ruhengeri who had been asked if they wanted to buy a baby gorilla.

In 1982 Dian celebrated her fiftieth birthday in the U.S. where she had settled, and was more content and healthy than she had been in years, despite undertaking numerous lecture tours to supplement her small salary. In October Dian's beloved dog, Cindy, died. Without Cindy to care for Dian's mind began to turn, once again, to Karisoke. She had heard that the anti-poaching patrols were no longer being organized: she wanted to go back and see what was happening for herself.

Dian wrote to Ian in May 1983, as she prepared for a three-month trip to Karisoke.

Remember that horrid, horrid night when I asked Rwelekana to bring you over to my house? In many ways I am going through those same unearthly feelings now, though certainly to a lesser extent, for it was the animals I was leaving then, and there is nothing here, [in the] U.S.A., to leave except junk food or TV. I hate this country simply because it is becoming more and more of a police state ….

I know that poaching is heavier [around Karisoke], or within the Virungas as a whole, than ever when I was there. I know that young gorillas are being captured for tourists to be entertained by if the crowds get too heavy for the tourists' groups and Group 5. I also know the physical facilities at Karisoke are nearly rotted out because no one cared about the upkeep of the cabins; the car is finished for the same reasons. Everything I worked for nearly single-handedly over thirteen years is just about finished.

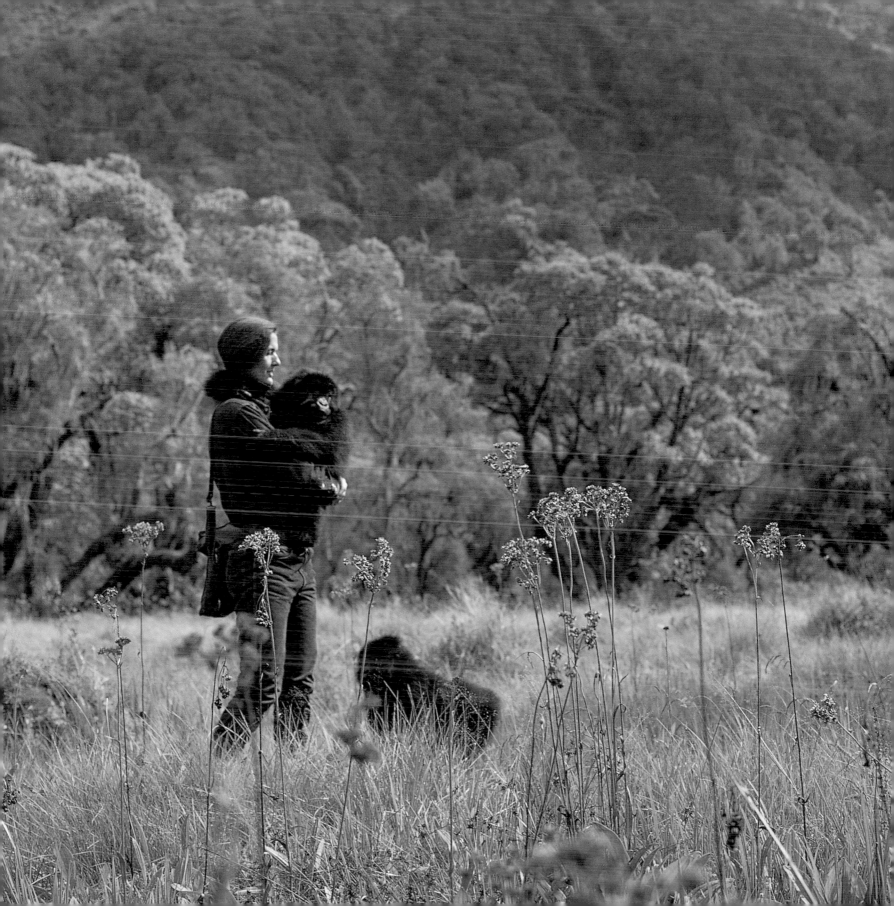

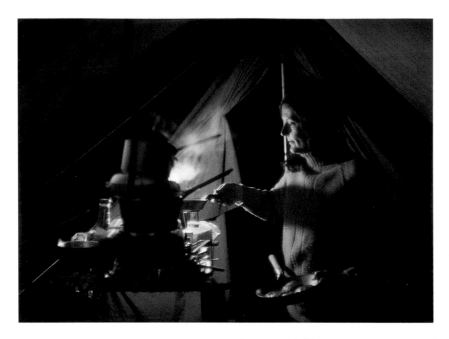

Not everyone would have agreed with this bleak assessment of the situation at the time. Dian wrote that she believed the Mountain Gorilla Project (MGP— by then a consortium between FFPS, AWF and WWF) education program, which toured the country teaching Rwandans about gorillas, was redundant unless poachers were stopped. She pointed out that it took one poacher to kill an antelope or a gorilla but …

No amount of cute ciné film is going to stop the slaughter now going on ….

I close, not in temper, because one can never alter the past …. There is certainly room for both types of conservation efforts—active and/or theoretical. The fact that I shall never participate in the latter does not mean that I do not concur with it going on, particularly in a country where the people can barely understand today, much less tomorrow.

Dian returned to Rwanda on June 19 after "packing up my temper along with my luggage." She was delighted to be back in Rwanda: others were not so pleased, and she encountered great difficulty in securing a work permit. Time spent with Group 5, how-ever, put these bureaucratic and diplomatic difficulties in the shade: Dian decided that Karisoke was her true home, and no one would force her out without a fight.

Gorillas in the Mist was published on August 25, 1983, and Dian spent much of the ensuing six months on a promotional tour. The hectic schedule included lec-tures and personal appearances in the U.S.A., South Africa and the U.K.

The tour was exhausting but beneficial: the book was very well-received by both the public and critics, and has remained in print ever since. Dian had only a short time in which to spring-clean Karisoke and recommence anti-poaching patrols before embarking on the extensive promotional tour.

Karisoke: February 25, 1984

Dear Mother and Father,

Returned to Karisoke 2 days ago following an extremely hectic lecture tour in South Africa and England, a tour required by the book publishers …. The book has sold out both in England and South Africa, likewise, so I am told in America ….

Hopefully you can understand why I must stay here for at least another nine months before again going to America. Whenever I am away people try to take over Karisoke—nine cabins and 12 perfectly trained Africans. I need to re-establish my "clout" here with Europeans who want to take over the camp, the gorillas, and the trained Africans. Since I remain in fairly good health and have excellent rapport with the African officials, I must continue here.

Much love, Dian

By March 1984, Dian's health was in decline, and she was no longer able to go out to the gorillas if they were located more than an hour's climb from camp. Her book was selling well and plans for a film of it were in development. She wrote to her parents:

Now movie people are moving in, competing with television serial people—it is all too much to bear just now when I am so tired and so busy.

There were additional strains: although Dian told her parents that she had "excellent rapport" with African officials she was not being totally truthful. She did have good relations with some senior Rwandan officials, but her relationships with officials at the ORTPN remained acrimonious, and she was being issued with work permits that ran for only two or three months at a time. Each visit to renew the permits took several days, and Dian could no longer climb back to camp without the aid of an oxygen tank. The anti-poaching patrols were, nevertheless, proving successful, as Dian wrote to Ian in August 1984:

Update on Digit Fund results this year alone: 1,587 traps cut down; 212 working patrol days and 5,546.95 man working hours on patrols … plus 16 animals released unharmed from traps. Only 2 poachers imprisoned, which isn't good, but not for lack of trying.

During the following year, 1985, Dian continued with her work at Karisoke. By protecting the remaining mountain gorillas in the study area she was laying to rest Digit's ghost, as she explained to Ian Redmond:

You know, probably more than anyone I know, that it is now possible to walk by Digit's grave without the same, horrid, black aching void … However, if I had my "ruthers," I would rather be given the knowledge that he, Uncle Bert, Macho and Kweli were still on earth, propagating their kind, stripping thistles, pulling gallium vines off old Hagenias, sunning and purring on the rare days, and even shivering and steaming on the long, rainy days. They so belong here instead of us humans.

BELOW The last letter Dian wrote to her parents before her murder in December 1985.

She went on to explain that she was anxious for the future: she suspected that high-ranking Rwandan officials were linked to an illegal trade in ivory, gold and gorillas, and there were rumors that a Spanish zoo was hoping to buy a baby gorilla:

Nov. 7, 1985

Dear Mother and Father,

I guess you can see from the enclosed that you had better be careful how you treat me! Don't I get the craziest mail. Haven't a clue who these people are. The original certificate really impresses the Africans — it is all gold and glittery. Problem is they know I'm not a Saint.

How exciting to be able to spend your money in such a lucrative manner via the lottery. What a head ache it must be for store owners. Well, I wish you lots of luck.

I hope that there is something left of "Leslie's House" by the time her parents get home. I'll bet she had fun and is now wondering when they are going to go away again.

I'm sorry about Maria not working out. It seems a shame just to get them broken in and then have to start all over again. I thought she was supposed to be a good cleaner. Well, if you do get the new Japanese girl, maybe you will be happier. But she will graduate some day and be off and you'll have to start all over again!

My good house man, Kanyaragana, had to have surgery this week for perforated ulcers (no comments on that!). I don't know when, if ever, he will be able to return. I'm stuck with the second man, Basili, who is non-compus. I'm heartsick since I've had more company than

I feel very paranoid, yet this same kind of preparation happened in the case of Kweli, [the infant shot during the attack on Group 4] yet at that time I didn't have the sense to record everything I was told. This time I have at least that much sense and am spending an awful lot of Digit Fund money just on keeping tabs on things down below. Only occasionally does my intuition let me down; I hope this time it fails me completely.

As the year drew to a close Dian attempted to get her work permit renewed at ORTPN. She needed the permit in order to get a new

visa, but no one was willing to issue it. Dian Fossey, a woman who never gave up without a fight, went above the head of the ORTPN director. Just before Christmas—her last—Dian wrote to a friend, overjoyed at her success:

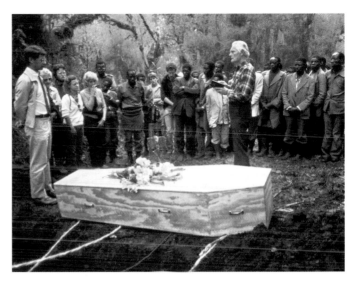

The Head of Sécurité (Secret Police) has stomped on the Park Director and ordered the Emigration Department [sic] to issue me a resident's visa which is good for a minimum of 2 years, a maximum of life! This type of visa is truly difficult to get, so you can imagine how thrilled I was to arrive in Kigali and find that this big man had set the whole thing in order for me …. In this country, as in most of Africa nowadays, one doesn't mess around with the Sécurité or those whom they support. See, it pays to keep your nose clean— achoo!

ABOVE Dian's friends and workers gather round her coffin as she is laid to rest next to the graves of her beloved gorillas.

It has been said that this resident's visa was as good as a death warrant: once Dian's enemies knew that she would be at Karisoke for at least two more years they were impelled to act. During the night of December 26, 1985, Dian Fossey was murdered in her cabin— her skull split open by a panga.

 She was buried at Karisoke, next to the graves of her beloved friends. The inscription on her tombstone bears the words:

BELOW Flowers and a photograph of Dian with Coco and Pucker, left on her grave at Karisoke.

<div align="center">

Dian Fossey
1932–1985
No One Loved Gorillas More

</div>

The Rwandan authorities took all the Karisoke staff into custody for questioning, and eventually arrested Dian's former tracker Rwelekana, but he died in jail a few months later. Wayne McGuire, a new researcher at Karisoke at the time of the murder, was warned that

ABOVE Dian's grave, and those of her most beloved friends, at the Karisoke camp in the Virungas.

he was about to be charged. When after a couple of weeks he reluctantly returned to the United States to complete his Ph.D. research, he was tried *in absentia* for the murder and found guilty. It is commonly thought that these two men were the scapegoats for a crime that has yet to be solved.

Dian Fossey had many enemies and there is no shortage of possible suspects: she could have been murdered by a poacher, a disgruntled member of staff, a colleague or a paid assassin. Dian had admitted to Ian Redmond, in her last letter to him, that she was paying for information: perhaps she had unearthed evidence of illegal trading in gold and ivory or evidence of baby gorillas being sold to foreign zoos. Anybody involved in these corrupt activities would have had a motive to hire a killer, as would those who stood to grow rich from the burgeoning tourist industry, which Dian had wanted to see restricted. There are many theories, but few facts and no evidence. It is doubtful that anyone, except the perpetrator, knows who killed Dian Fossey. What matters more, is her legacy.

Dian's last diary entry read:

When you realize the value of all life, you dwell less on what is past and concentrate more on the preservation of the future.

The day after Dian died, movie producer Arnold Glimcher arrived in Kigali with his son Paul. They were planning to meet Dian to discuss the arrangements for a film, based on her book, *Gorillas in the Mist*. Once they had heard the news of her murder they began making arrangements to alter the focus of the film to concentrate on the story of Dian's remarkable life, and death.

The movie, *Gorillas in the Mist*, directed by Michael Apted, was filmed in 1987 and screened in 1988. Dian was played by Sigourney Weaver, who later received a Golden Globe award for her performance. The film did not give an accurate portrayal of Dian or her work—but it has probably achieved more than anything else in bringing the plight of the gorillas to a worldwide audience. It shows the lengths to which Dian went to save the

gorillas from poachers and their habitat from destruction. Without her, and the continuing work of those whom she inspired, one of man's closest animal relations might now be little more than a collection of stuffed animals, stored in museums around the world.

In 1991, George Schaller and his wife Kay returned to Karisoke after an absence of three decades. Their findings were documented in an article Schaller wrote in 1995 for NATIONAL GEOGRAPHIC. Dian's hut remained, "littered with remnants of her past. Still on the wall was a plastic Santa Claus, a poignant reminder that she died at Christmastime. Beside her cabin, shaded by moss-laden boughs of hagenia trees, was her grave, along with those of 17 gorillas, one dog, and one monkey. But it was not a day for us to dwell on tragedy … Dian harassed poachers with obsessive zeal. And she made the world aware of the gorillas' plight. Her heroic vigil helped the apes endure."

WHEN DIAN FOSSEY ESTABLISHED The Digit Fund her aim, in the first instance, was to use the money for "active conservation"—a term she used to describe the protection of the habitat by enforcement of the park borders and regular anti-poaching patrols. After Dian's death it was decided that the Fund should broaden its goals to continue all aspects of Dian's work; Karisoke should resume its primary role as a research center but The Digit Fund should seek a more collaborative approach to conservation and research—and should support the local park authorities, the Rwandan government and international conservation agencies. Eventually The Digit Fund was renamed The Dian Fossey Gorilla Fund, and was run separately in the U.K. (DFGF Europe) and the U.S.A. (DFGF International), with independent but complementary programs.

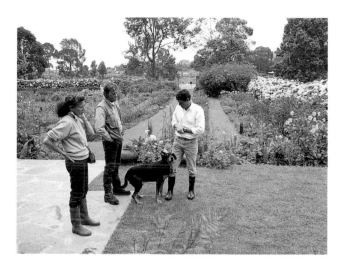

ABOVE Sigourney Weaver, director Michael Apted and camera director John Seal at Ros Carr's home, during filming of *Gorillas in the Mist*, after Dian's death.

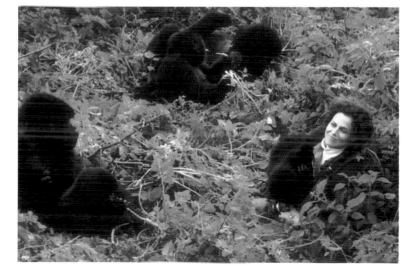

BELOW Sigourney Weaver, playing Dian, in a scene from *Gorillas in the Mist*.

In the years following Dian's death, output of research from the Karisoke Research Center increased, and scientific understanding of the mountain gorilla species grew. Ranger patrols in the Parc des Volcans also produced results, and the gorilla population began to stabilize. In response to Dian's request to the Morris Animal Foundation just before she died, the Mountain Gorilla Veterinary Center was established: this provides medical care for the gorilla population, especially those who have been injured by poachers. The success of these projects was then put in jeopardy by civil unrest in Rwanda.

In 1990 racial tension between Hutus and Tutsis erupted when Tutsi-led rebels (RPF —the Rwandan Patriotic Front) invaded Rwanda from Uganda. Fighting spread into the national park, and conservation work was threatened. In 1992 the civil war was in its final throes, when Karisoke was ransacked by rebel soldiers. As peace was temporarily restored, the DFGF Europe expanded the charity's work to include a major education program to engage the local population in the gorillas' welfare and survival. Local school-children were taught about environmental conservation in the hope that this would engender an understanding and responsibility for conservation initiatives in the area. Medical programs for the local Rwandan people were also established.

The charity's work was halted once again in 1994. Rwandan President Habyarimana's plane was shot down, and his death triggered a massive orgy of killing. An orchestrated campaign of racial hatred had been stirred up in preceding days by extremist Hutus, who were against a power-sharing deal with the RPF. In the genocide that followed, an estimated one million people were slaughtered in just one hundred days, and hundreds of thousands fled through the gorillas' habitat into neighboring Zaire. Karisoke and the local DFGF office had to be closed, but within a few weeks some of the staff were able to return and resume monitoring the gorilla population as and when the military allowed. Their work put them in extreme danger, being suspected by both sides of being sympathizers with the other, whereas in fact conservation must always be apolitical.

In 1995 the Karisoke Research Center was rebuilt, after being totally destroyed, but was not able to function properly: the park was still too dangerous. Landmines littered the forest floor, and armed looters were a threat to the safety of staff—and gorillas. However, gorilla groups were still monitored where possible by committed and courageous conservation workers and park rangers. Conflict in Zaire, which became the Democratic Republic of Congo in 1997, escalated into murderous anarchy, and racial killings spread throughout the country. Conservation work in the area all but ceased

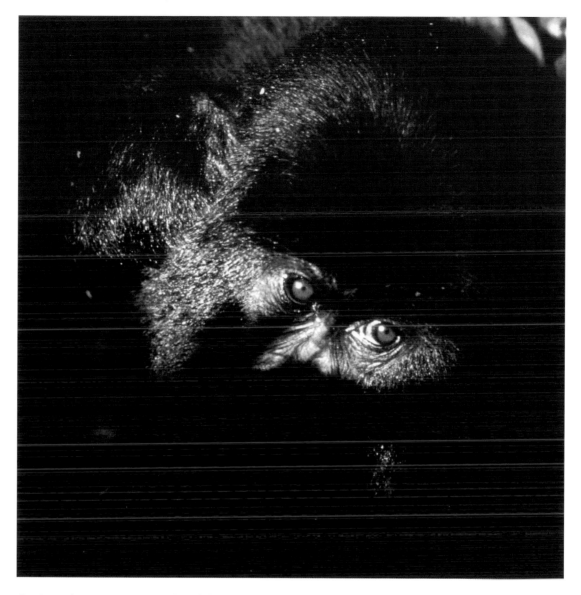

during the worst periods of the 1990s, but despite the dangers, local and expatriate conservationists remained dedicated to their cause.

In his 1995 NATIONAL GEOGRAPHIC article, George Schaller reported on the extraordinary impact The Mountain Gorilla Project had had on the local population, even during these turbulent years:

The people of Rwanda became proud of their apes. The gorillas became part of Rwanda's identity in the world, a part of the nation's vision of itself In spite of the turmoil, with soldiers of both factions traversing the forests, the gorillas have not been decimated. Indeed

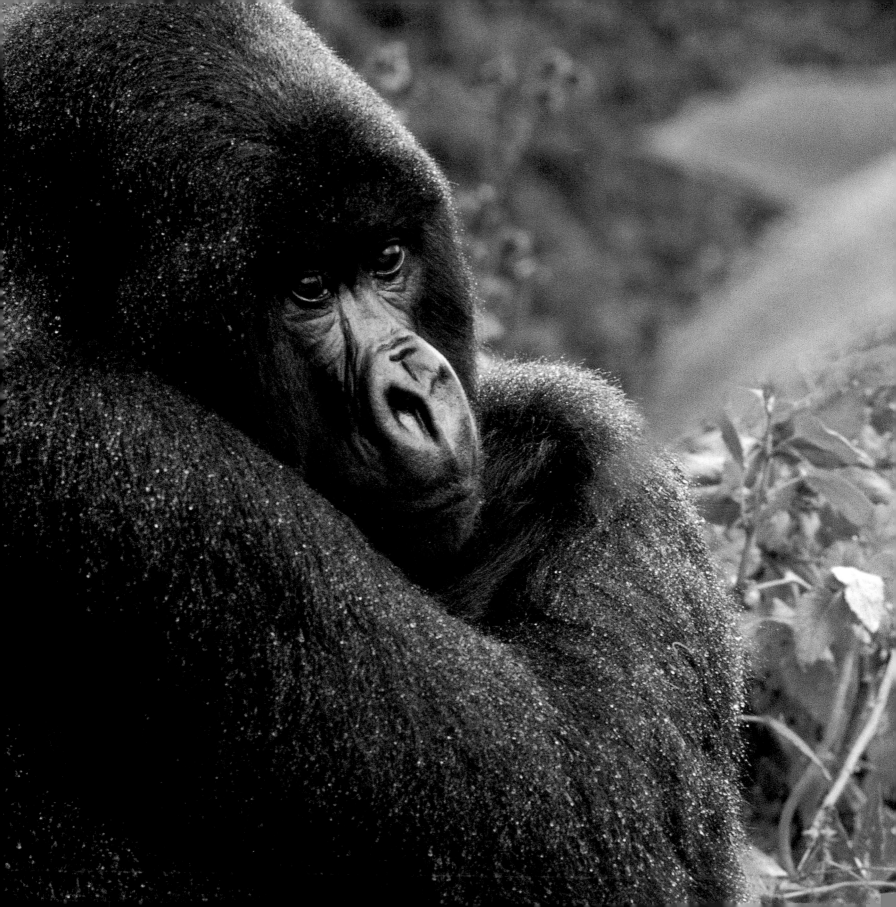

the Rwandan Patriotic Front expressed public concern for the gorillas' safety even while it was fighting. The new prime minister, Faustin Twagiramungu, has affirmed his country's commitment to the apes. Given the urgent and crushing social needs of Rwanda, this declaration is remarkable. For one species to fight for the survival of another, even in times of stress, is something new in evolution. In this, more than all our technology, lies our claim to being human.

Gradually political stability returned to Rwanda and conservation agencies were able to rebuild their programs and return to a semblance of normality. The plight of the Rwandan and Congolese people, recovering from the effects of the genocide, has become integral to the survival of the mountain gorillas and their threatened habitat. The DFGF has committed itself to continuing research into gorilla behavior, protecting gorillas and their forest home, and supporting the local community through small-scale development and education projects. The cabins at Karisoke are no more, and staff are now based in the nearby town of Ruhengeri, entering the forest each day to monitor the study groups.

Poachers and deforestation still pose a threat to the remaining populations of nearby eastern lowland gorillas, found only in the eastern DRC. The mining of valuable coltan— a mineral used in the manufacture of many electrical components—continues apace in DRC and threatens a huge swathe of forest near the border with Rwanda. An estimated 10,000 plant species, 220 bird varieties and 131 mammals are in danger of extinction if the forest clearance and bushmeat hunting continue. The ecological impact on the rest of the region and its inhabitants—humans included—is impossible to gauge.

A recent census of the mountain gorillas, however, offers a glimmer of hope. The census—the first to be taken by teams

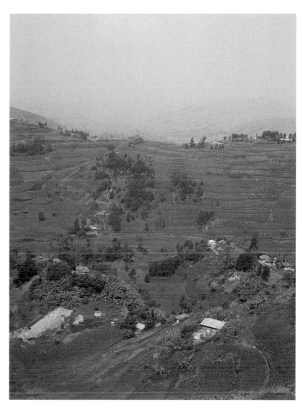

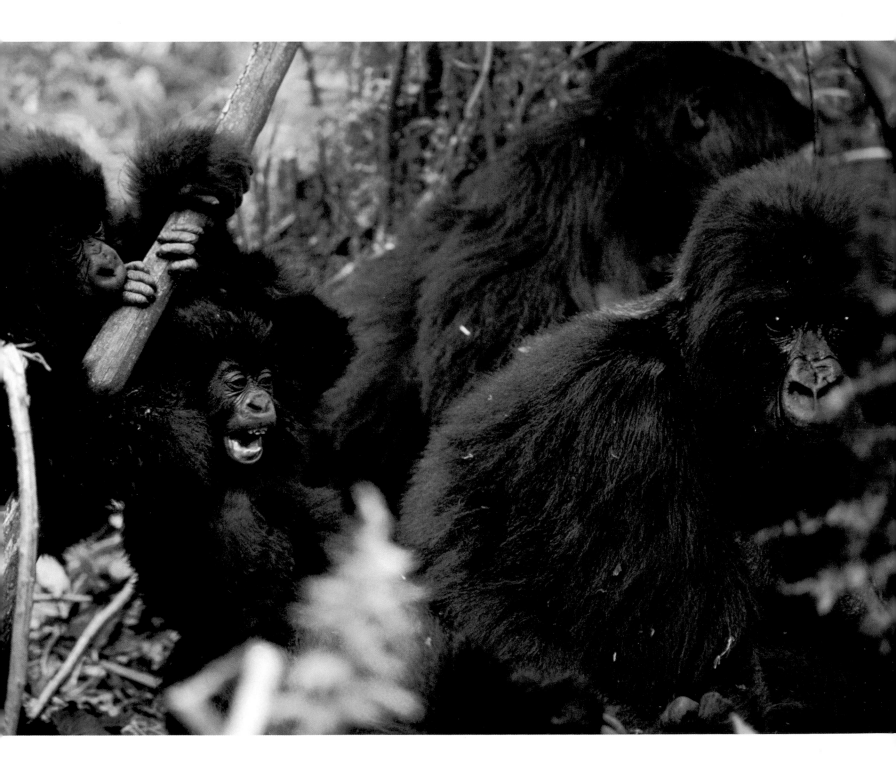

LEFT A census
conducted in 2003
revealed that the
number of mountain
gorillas in the Virungas is
on the increase.

of African fieldworkers drawn from all three countries —was undertaken in 2003 and led by the International Gorilla Conservation Programme (which evolved from the MGP), collaborating with DFGF and the other gorilla organizations. The mountain gorilla populations in the Virungas (including Rwanda, Uganda and DRC) were recorded, and a total of 380 individuals were found. This is an impressive 17 percent increase in the population of the highly endangered Great Ape since the previous census conducted in 1989. Taken with the world's only other population of the mountain gorilla, in the Bwindi Impenetrable Forest National Park of Uganda, the total number of mountain gorillas in the world now stands at approximately 700. Lessons learned from the mountain gorilla story are at the heart of GRASP, the Great Ape Survival Project, a United Nations project to halt the decline in all gorilla, chimpanzee, bonobo and orangutan populations. They, like the mountain gorillas, whom Dian loved to call "the greatest of the great apes," belong on this planet. Their existence tells us much about our own evolutionary past, and their familial groups give us many clues about our how our present, human relationships and societies have developed. How we control their destiny hints at the future of our own species.

The survival of the mountain gorilla is not assured. However, as Dian Fossey believed, it is worth fighting for.

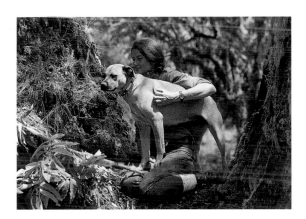

Bibliography

Attenborough, David. *Life on Air*. BBC Books, 2002.

Baumgartel, Walter. *Up Among the Mountain Gorillas*. Hawthorn Books, 1976.

Campbell, Bob. *The Taming of the Gorillas*. Minerva Press, 2000.

Fossey, Dian. *Gorillas in the Mist*. Houghton Mifflin, 1983.

Goodall, Alan. *The Wandering Gorillas*. William Collins Sons & Co, 1979.

Gordon, Nicholas. *Murders in the Mist*. Hodder Stoughton, 1993.

Halsey Carr, Rosamond. *Land of a Thousand Hills*. Viking Penguin, 1999.

Hayes, Harold T. P. *The Dark Romance of Dian Fossey*. Simon and Schuster, 1990.

Keane, Fergal. *Season of Blood: A Rwandan Journey*. Viking, 1995.

Mowat, Farley. *Woman in the Mists*. Warner Books, 1987.

Redmond, Ian. *Eyewitness Gorilla and Other Primates*. Dorling Kindersley, 1995.

Schaller, George. *The Year of the Gorilla*. University of Chicago Press, 1964.

Stewart, Kelly J. *Gorillas*. Colin Baxter Photography, 2003.

Weber, Bill and Vedder, Amy. *In the Kingdom of Gorillas*. Simon and Schuster, 2001.

Acknowledgments

I would like to thank my mother, who brought the natural world into our home, and my father, who has always guided me in my writing. Thanks to Bob Campbell, Ian Redmond, Stephen Orr and Sally MacGill who all read and improved the text.

Many of us have personal heroes, whose achievements and dedication highlight our own complacency. Dian Fossey was always just such a hero of mine. I first came across her work as a child, reading the NATIONAL GEOGRAPHIC magazines my mother bought for us. Dian's writings, and Bob Campbell's photographs, introduced me to the world of the mountain gorillas and inspired me to study zoology. Dian has, I'm sure, been an inspiration to many others around the world. She was, like all of our icons, a flawed character. But her single-mindedness, commitment and idealism were the special qualities that helped bring the plight of the mountain gorillas to the world's attention. My thanks go to Sonya Newland and Colin Webb, who gave me the chance to delve into the fascinating life of Dian Fossey, and to those at the Dian Fossey Gorilla Fund who continue her difficult work, on our behalf.

CAMILLA DE LA BÉDOYÈRE

Unless otherwise stated, all photographs are by Bob Campbell. All Dian's letters are reproduced with the permission of the Dian Fossey Gorilla Fund.

Page 12 (top and bottom): photographs of Carl Akeley, courtesy American Museum of Natural History; pages 20, 29, 174: photographs courtesy the Dian Fossey Gorilla Fund, Europe; pages 80, 171: photographs by Ian Redmond; pages 181, 184: NATIONAL GEOGRAPHIC magazine, October 1995, photographs by Michael Nichols; pages 178, 179: photographs of Dian's grave by Adrian Warren, courtesy Adrian Warren photo library; page 179: film still from *Gorillas in the Mist* (Warner Bros/Universal Studios) courtesy Kobal images.

The publisher would like to thank Elva Oglanby for suggesting the idea for this book.

About the Dian Fossey Gorilla Fund

"The gorillas' destiny lies in the hands of those who share their communal inheritance, the land of Africa, the home of the mountain gorilla."

DIAN FOSSEY

The Dian Fossey Gorilla Fund is dedicated to protecting and saving the last 650 mountain gorillas in their natural forest habitat in central Africa. Founded by Dian Fossey after her favorite gorilla Digit was killed by poachers in 1979, it has evolved to become a world renowned organization at the forefront of community-based conservation.

In its early years of operation, the Fund raised money to support scientific research, anti-poaching patrols and veterinary care. Yet, despite considerable investment, the attitudes of people in the local communities— those who were putting the greatest pressure on the forest—remained unchanged. While it was clear political instability and war would continue to disrupt conservation efforts, the Fund was determined to embrace a more holistic and longer-term approach—one which would take into account the needs of the local people and thereby guarantee their support for the gorillas' survival.

The Fund now manages twenty projects designed to integrate traditional conservation and research with economic development and education. They include gorilla monitoring, ranger patrols, and reforestation alongside projects such as setting up wildlife clubs in all the schools near the gorilla habitat; sustainable agriculture training for poor farmers; support for pygmies, bee-keepers and artists, and micro-credit to help people to set up small businesses. Each project is run by a local partner organization and is backed up by the Fund's staff and network of resource centers in Rwanda, Congo, and Uganda.

This approach is not only cost-effective, it also helps build capacity, empower grass-roots initiative, and facilitate genuine African ownership of the issues. The knowledge that a thriving gorilla population can offer enormous economic benefits to the region has resulted in something of a conservation culture now emerging among the people living closest to the gorillas.

www.dianfossey.org

Index

Numbers in *italics* refer to illustrations

Akeley, Carl, *12*, 12-13, 38
 grave, 13, *13*, 17, 26
Albert National Park, 13, 17, 25, 36
Alexander, John, 22-3, 24, 25
Alexie (gorilla), 40
American Museum of Natural History, 12, *12*
Amin, General, 134
Anne, Princess, 30
Apted, Michael, 178, *179*
Attenborough, David, 158, 160
Augustus (gorilla), *124*, 166

Bahutus *see* Hutus
Bartok (gorilla), *93, 94*
Basili (camp "housekeeper"), 154, 158
Batwas (Twas), 33, 55
Baumgartel, Walter, 14, *14*, 17, 25, 36, 45
BBC, 158
Beethoven (gorilla), *40, 93*
Beetsme (gorilla), 163, 164, 166
Belgian Congo *see* Congo
Belgium, 43
 Government of, 13
Beringe, Captain Robert von, 9, *9*, 12
Berlin, 12
Bravado (gorilla), *59*, 101, 123
Brussels, 157, 171
 Museum of Central Africa, 157
Bujumbura, 170
Burkhart, Michael, 74, *80*, 80-1, *81*, 82, 84
Bwindi Impenetrable Forest National Park, 185

California, 20, 29, 57
 University of, 20

Cambridge
 Dian accepted as postgraduate student, 56-7
 finance for Dian's studies at, 69, 78
 preparations for Dian to go to, 87, 88
 Dian at, 90-3, 105, 112, 114, 117, 118-19, 137
 Dian receives doctorate from, 148
 brief references, 105, 122, 132, 135, 140
Campbell, Bob
 spends caretaker period at Karisoke, 57, 57-9
 takes up offer of photographic assignment at Karisoke, 66, 67
 works at Karisoke, *70*, 70-1, 72, 73-5, 79-80, 81, 82, 84, 88, 89, 93-5, 104-5, 106, 119, 123, *126*, 130
 relationship with Dian, 72, 74-5, 80, 81, 84-5, 94, 119, 125-6
 writes to National Geographic Society voicing concerns, 74-5, 76
 photograph features on cover of NATIONAL GEOGRAPHIC magazine, 86
 plans to join expedition at Koobi Fora, 125
 Dian's letters to, 59, 61, 62-3, 64, 66-7, 69, 95-8, 101-4, 108, 112, 115 117, 120
 brief mentions, 43, 99, 108, 109, 132, 134
 Writing: *The Taming of the Gorillas*, 85
Campbell, Heather, 94
Carr, Rosamond, 43-4, 44-5, *45*, 46-7, 55, 84, 88, 139
 Dian's letter to, 122-3
cattle herds/herders, 53, 64, 95, *101*, 101, *102*, 102, 109, *110-11*, 132, *135*, 135
census of gorillas, 61-2, 134-5, 172, 183, 185

Chapin, Albert (Dian's Uncle Bert), 101, 131, 132, 166
 Dian's letters to, 134, 137-8, 144-5, 148-9, 155, 163-4
Chicago, 158
Cindy (Dian's dog), 8, 64, *98*, 98, 103, *170*, 170-1, *171*, 172
Cleo (gorilla), *149*, 166
Coco (gorilla), 67-70, 71, 72, 86, 115
 pictures of, *8, 68, 70, 71, 85*
Cologne Zoo, 67, 70, 72
Congo (Belgian Congo/Zaire/ Democratic Republic of Congo/DRC)
 Dian in, 36-43
 Dian escapes from, 43-4
 environmental threat, 183
 political events, 43, 180
 brief references, 9, 14, 17, 25, 29, 45, 48, 62, 134, 162, 163, 172, 185
conservation, 14, 72-3, 168, 179, 180, 181
Cornell University, 169, 170, 172
Cronkite, Walter, 160, 163

deforestation, 89, 183
Democratic Republic of Congo *see* Congo
Dezi (cockerel), 39, *39*
Dian Fossey Gorilla Fund (DFGF), 179, 180, 183, 185
Digit (gorilla), 119-20, 123-5, 130, 139, 158, 160-1, 166, 176
 pictures of, *119, 125, 126, 127, 139, 158, 159, 166*
Digit Fund, 160, 161, 162, 167, 171, 176, 179
Donisthorpe, Jill, 14, 17
DRC (Democratic Republic of Congo) *see* Congo

Edinburgh, Prince Philip, Duke of, 30, 126

elephants, 79, 99, *99*, 101
Elliott, Ric, 132, 151
Emlen, Dr John, 14, 17
England, 57, 112, 114, 137 *see also*
 Cambridge; London

Flora and Fauna Preservation Society, 161
Flossie (gorilla), *149*, 164, 166
Forrester, Alexie, 27-8, 48
Forrester, Franz "Pookie", 21, 27
Forrester family, 21-2, 27
Fossey, George (Dian's father), 20, 48, 59
Frito (gorilla), 163, 164, 166

Galdikas, Biruté, *29*
Garst, Genny and Warren, 154-5, 158
Geezer (gorilla), *63*, 136
Germany, 20, 156
Gilka, Robert, 66, 74
Gisenyi, 84, 93
Glimcher, Arnold, 178
Glimcher, Paul, 178
Gombe Stream Reserve, 28
Goodall, Alan
 meets with approval as research assistant,
 92, 93
 at Karisoke, *102, 106,* 106-8, 109, 112,
 113, 115, 117
 returns to England, 119
Goodall, Jane, 28, 29, *29,* 32, 33, 34, 36, 75,
 112
Goodall, Margaret, 93
Gorillas in the Mist (book by Dian Fossey),
 17, 18, 23, 24, 29, 120, 152, 158, 174-
 5, 178
Gorillas in the Mist (film), 178-9
Great Ape Survival Project (GRASP), 185
Groom, Graeme, 120, *121,* 122-3, 134-5,
 135, 140
Group 1 (gorillas), 38, *55*
Group 2 (gorillas), 55

Group 3 (gorillas), 55
Group 4 (gorillas), 55, 62, 101, 103, 109,
 120, 123, 139, 148, 152, 154, 158, 160,
 163, 164, 166
Group 5 (gorillas), 55, 59, *59,* 61, 62, 64,
 66-7, 104, 123, 152, 154, 160, 161, 174
Group 6 (gorillas), 55
Group 7 (gorillas), 55
Group 8 (gorillas), 55, 58-9, 62, 64, 80, 84,
 89, 93, 95, 103, 109, 123, 137
Group 9 (gorillas), 55, 62, 64, 103
Group 10 (gorillas), 55

Habyarimana, Major General Juvénal, 134,
 180
Harcourt, Alexander (Sandy), 120, *121,*
 122-3, 131, *132,* 132, 134, 135, 137,
 139, 140, *140,* 142, 154, 162, 169, 171
Heathrow Airport, 30
Henry, Gaynee, 21, 132
Henry, Mary White, 21, 132
Henry family, 21
Hinde, Professor Robert, 56-7, 78, 92, 98-9
Homo habilis, 24
Houghton, Lord: *Carpe Diem,* 18
Hutus (Bahutus), 33, 180

International Gorilla Conservation
 Programme, 185

Kabara
 Akeley buried at, 13
 Schaller based at, 17
 Dian visits, 23-4, 26
 Dian based at, 36-43
 Dian revisits, 88, 134
 brief mentions, 33, 55
Kampala, 134
Kanyaragana (camp "housekeeper"), 154, 158
Karisimbi, Mount, *25,* 44, 47, 52, 59, 62,
 64, 164

Karisoke
 Dian sets up camp at, 47
 Dian lives and works at, 48-169
 under control of board of directors, 171
 Dian returns to, 172-7
 Dian murdered in, 177-8
 after Dian's death, 179, 180, 183
Kayibanda, President, 132
Kenya, 21, 22-3, 34, 36, 57, 125, 126, 134,
 172 *see also* Nairobi
Kigali, 75, 134, 137, 161, 177, 178
Kigoma, 34
Kima (Dian's pet monkey), *56, 98,* 98, 127,
 170, *170*
Kisoro, 39, 40, *42*
 Traveller's Rest hotel, 14, 25, 26, 36, 42,
 43, 45
Koobi Fora, 125, 134
Korsair Children's Hospital, 20, 21, 27, 29
Kweli (gorilla), 163, 166, 176

Lake Baringo, 34
Lake Rudolph (now Lake Turkana), 126
Lawick, Hugo van, 33, 112
Leakey, Louis
 sees need for research on mountain
 gorillas, 14
 at Olduvai Gorge, 23, 24
 Dian meets, 24
 helps Dian to undertake study of
 gorillas, 28-9, 32
 takes control of Dian's arrangements, 33,
 34, 35, 36
 and appointment of new census worker,
 66, 74
 becomes infatuated with Dian, 86, 87-8
 approves appointment of Alan Goodall, 93
 arranges speaking engagement for Dian,
 108
 Dian visits in London, 112
 death, 131

pictures of, *28, 34, 85*
 brief mentions, 42, 44, 48, 57, 67
Leakey, Mary, 23, 24
Leakey, Richard, 57, *85*, 125, 126
Leakey Foundation, 108, 109
Lee (gorilla), 168, 169
Leopard Ravine, 95
Leopold II, King of Belgium, 43
Life on Earth (BBC television series), 158
Liza (gorilla), 154
London, 30
Louisville, 20, 29, 57
 University, 28
Lucy (hen), 39, *39*

McGuire, Wayne, 177-8
Macho (gorilla), 163, 164, 166, 176
Madingley Research Laboratory, 90
Manual (cook), 26
Manyara, 23
Marin Junior College, 20
Mburanumwe, Anicet, 42-3
Meru National Park, 57
MGP (Mountain Gorilla Project), 161,
 162, 167, 171, 174, 181, 185
Mikeno, Mount, 17, 25-6, 28, 29, 36, 38,
 52, 172
Mobutu, President Joseph Desire (later
 known as Mobutu Sese Seko), 43
Morris Animal Foundation, 169, 180
Mount Kenya Safari Club, 22
Mountain Gorilla Project (MGP), 161,
 162, 167, 171, 174, 181, 185
Mountain Gorilla Veterinary Center, 180
Mugongo, 44, 45, *88*
Muhabura, Mount, 14
Munck, Adrian De, 45, 47, *47*
Munck, Alyette De
 meets Dian, 45
 helps Dian at Karisoke, 46-7, *47*, 48, 52,
 56, 73, *73*, *97*

 disapproves of Dian's actions against
 intruders, 55
 meets Bob Campbell, 84
 establishes makeshift camp, 95, 97
 works on census of gorillas, 95, 104, 108,
 120
 visits site of gorilla massacre, 117
Munya, *101, 102*
Munyarukiko (poacher), 164
Mutarutkwa (Tutsi herdsman), 103, *103*
Mutual of Omaha's Wild Kingdom, film for,
 154-5, 158
Mwelu (gorilla), 163, 166
Mweza (gorilla), 162

Nairobi, 14, 23, 33, 34, 42, 44, 57, 59, 70,
 78, 86, 87, 125, 132, 170
Nairobi Game Park, 35
National Geographic Society
 sponsorship of Dian, 29, 56, 92
 commissions Alan Ross to create ciné
 film, 56
 commissions Bob Campbell to take up
 photographic assignment, 66
 briefs Campbell, 70
 refuses to finance Dian's studies at
 Cambridge, 69, 75
 Campbell writes to Robert Gilka at,
 74-5, 78
 Dian's meetings with, 108, 148, 157
 Dian's grant under threat, 119
 Dian writes chapter of book for, 122
 film, 132, 137, 138-9, 161
 Dian anxious about grant from, 164
 brief mentions, 57, 67, 105
 see also NATIONAL GEOGRAPHIC
 magazine
NATIONAL GEOGRAPHIC magazine
 Dian's articles for, 78-9, 85, 86-7, 92,
 117, 122, 148
 photographs for, 80, *85*, 85, 86, 93, 137

Schaller's article for, 179, 181, 183
National Science Foundation, 17
Nemeye, 'Big' and 'Little' (trackers), 97,
 109, 109, *130*, 131, *145*, 152, 158,
 160, 168
New York, 48
 American Museum of Natural History,
 12, *12*
New York Zoological Society, 17
Ngezi, 95, 97, 98, 120
Ngoronogoro Crater, 23, 24
Nunkie (gorilla), 163, 164, 166, 169

Olduvai Gorge, 23, 24, *24*
ORTPN (L'Office Rwandais du Tourisme
 et des Parcs Nationaux), 55, 160, 161,
 162, 167, 175, 176-7
Osborn, Rosalie, 14, 17

Papoose (gorilla), *31, 60*
Parc des Volcans, 53, 55, 89, 95, 167, 180
Peanuts (gorilla), *54, 63*, 64, *65, 89,* 89, 93,
 166
Petula (gorilla), *124*, 169
Philip, Prince, Duke of Edinburgh, 30, 126
poaching
 activities, 55, 63, 64, 101, 115, 152, 155,
 158, 160, 172
 action taken to control, 61, 64, 95, *95*,
 109, 112, *130*, 132, 135, 152, *153*, 154,
 155, 161, 162-3, 168, *169*, 174, 175-6
 Dian's views on appropriate punishment
 for, 139
Price, Kitty and Richard (Dian's mother
 and stepfather), 20, *20*, 48, 57
Dian's letters to, 30, 34, 35-6, 40, 42, 44,
 48, 52, 67, 70, 71-2, 73, 78-9, 79-80,
 81-2, 84, 86, 87-8, 90, 92-3, 93-4, 99,
 104, 114, 118, 126, 131, 132, 137, 143,
 148, 167, 175
Pucker (gorilla), 67-70, 71, 72, 86, 115

pictures of, *8, 68, 70, 71, 85*
Pug (gorilla), *104*

Rafiki (gorilla), *54, 58,* 58, *83,* 84, *136,* 137-8
Raymond, Fr., 21
Redmond, Ian
 asks to come to Karisoke, 150-1
 at Karisoke, 151, 152, 154, 158, 160, 166
 receives medical treatment, 168
 Dian requests help in transporting Cindy, 170
 return visit to Karisoke, 172
 Dian's letters to, 150-1, 154, 156-8, 167, 168, 169-70, 170-1, 172, 175-6
 brief references, 163, 164, 178
Rhodesia (now Zimbabwe), 21, 27
Rombach, Richard, 138, 142
Root, Alan
 Dian's first acquaintance with, 25, 26
 Dian invited to spend Christmas at home of, 33, 34
 helps Dian to set up camp at Kabara, 36-7
 visits Karisoke, 56, 57
 bitten by snake, 57
 unable to take up photographic assignment at Karisoke, 66, 72
 Dian visits, 125-6
 picture of, *33*
 brief mentions, 30, 38, 42, 85, 132
Root, Joan, 25, 26, 30, 32, 33, *33,* 34, 36, 38, 126
RPF (Rwandan Patriotic Front), 180, 183
Ruhengeri, 142, 143, 172, 183
 Hospital, 88, 112, 138, 142, 156, 162
Rumangabo, 43, 44, 162
Rwanda
 new conservation efforts in, 166
 political events, 132, 134, 180
 pride in gorillas, 181, 183

research station in *see* Karisoke
 brief mentions, 9, 14, 25, 43, 44, 45, 89, 185
Rwandan Patriotic Front (RPF), 180, 183
Rwandan Tourist bureau, 139
Rwelekana, 131, 152, 172, 177
Rwindi, 40

Sabinio, Mount, *133*
 von Beringe's party ascends, 9, 12
Samson (gorilla), *54*
San José State College, 20
Sanwekwe (tracker), 26, *26, 38,* 38, 39, 40
Schaller, George, 14, 17, 38, 39, 40, 61, 80, 135, 179, 181
 The Mountain Gorilla, 17
 The Year of the Gorilla, 17
Schaller, Kay, 17, 179
Seal, John, *179*
Serengeti, 23, 24
Shackford, 66, 74
Simba (gorilla), 158, 163, 166
Stewart, James, 134
Stewart, Kelly, 134, 135, 137, 139, 140, 143, 151, 152, 154, 169

Tanzania (formerly Tanganyika), 21, 28, 34
Tiger (gorilla), *60,* 163, 166, *166*
Titus (gorilla), 166
tourism, 161, 167
Traveller's Rest hotel, Kisoro, 14, 25, 26, 36, 42, 43, 45
Tsavo, 23, 87-8
Tutsis (Watutsis), 33, 53, 64, 101, 102-3, 109, 112, 180
Twagiramungu, Faustin, 183
Twas *see* Batwas

Uganda, 9, 14, 25, 36, 39, 180, 185
Uncle Bert (Dian's uncle) *see* Chapin, Albert

Uncle Bert (gorilla), 87, *100,* 101, 152, 163-4, *165,* 166, 176
United Nations, 185
United States, 20-1, 27, 57, 108-9, 132, 137, 138, 148, 157-8, 166, 167, 169, 170, 171, 172

Vatiri (tracker), 95, *95,* 101, *152,* 152, 157-8, 168
Vedder, Amy, 158, 161, 162, 167, 168
 In the Kingdom of Gorillas (written with Bill Weber), 162, 168
Vienna, 138
Virungas, 9, *10-11,* 12, 18, 24, 26, 29, *32,* 33, 185 *see also* Kabara; Karisoke; names of mountains
Visoke, Mount, *19,* 47, 48, *50-1,* 52, 62, 76-7, 158 *see also* Karisoke

Washington, 29, 57, 108, 119, 148, 157, 167
Watts, David, 158, 162, 163, 166, 167
Watutsis *see* Tutsis
Weaver, Sigourney, 178, *179*
Weber, Bill, 158, 161, 162, 166, 167, 168
 In the Kingdom of Gorillas (written with Amy Vedder), 162, 168
Weiss, Fina (Weiss's partner, then wife), 142, 143, 144, 155
Weiss, Peter, 138, 142, 143, 144, 148, 151, 155
White, Mary, 21, 132
White Giants, 43

Zaire *see* Congo